chicken in the mango tree

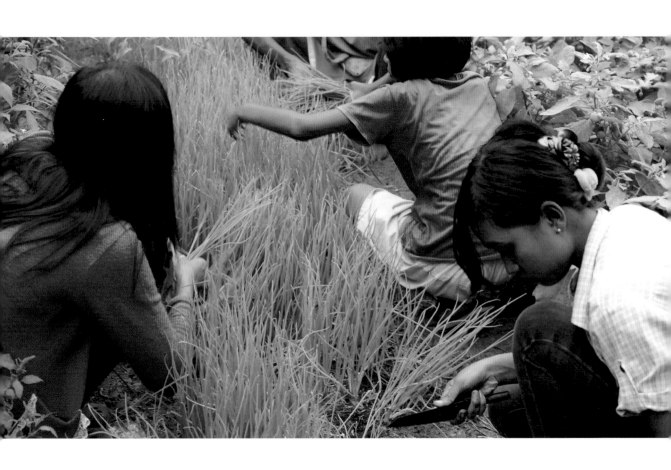

Left: Kwahn, Ngaa and Ang are working in the garden getting ready
for Ang's wedding. Right: Lime leaves and tender shallots.

chicken in the mango tree

FOOD AND LIFE IN A THAI-KHMER VILLAGE

Jeffrey Alford

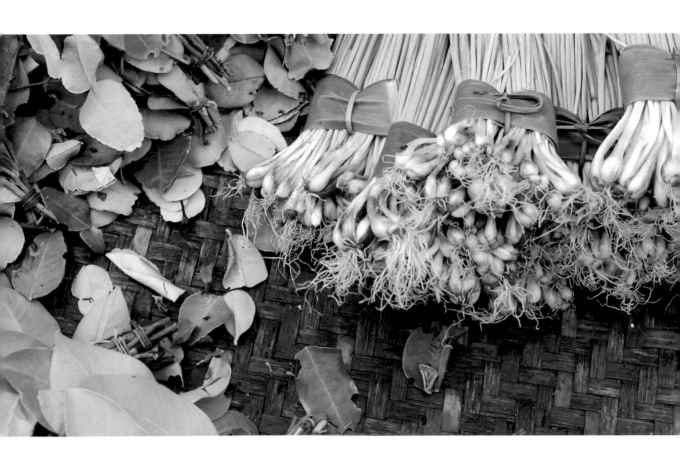

Douglas & McIntyre

Douglas and McIntyre (2013) Ltd.
P.O. Box 219, Madeira Park, BC, V0N 2H0
www.douglas-mcintyre.com

Cover illustration by Abi Stevens
Edited by Derek Fairbridge and Nicola Goshulak
Indexed by Nicola Goshulak
Cover and text design by Diane Robertson
Printed and bound in Canada
Text paper is FSC certified with 10% recycled fibre

Douglas & McIntyre acknowledges the support of the Canada Council
for the Arts, which last year invested $157 million to bring the arts to
Canadians throughout the country.

We also gratefully acknowledge financial support from the Government of
Canada through the Canada Book Fund and from the Province of British
Columbia through the BC Arts Council and the Book Publishing Tax Credit.

Cataloguing data available from Library and Archives Canada
ISBN 978-1-77162-060-4 (paper)
ISBN 978-1-77162-061-1 (ebook)

contents

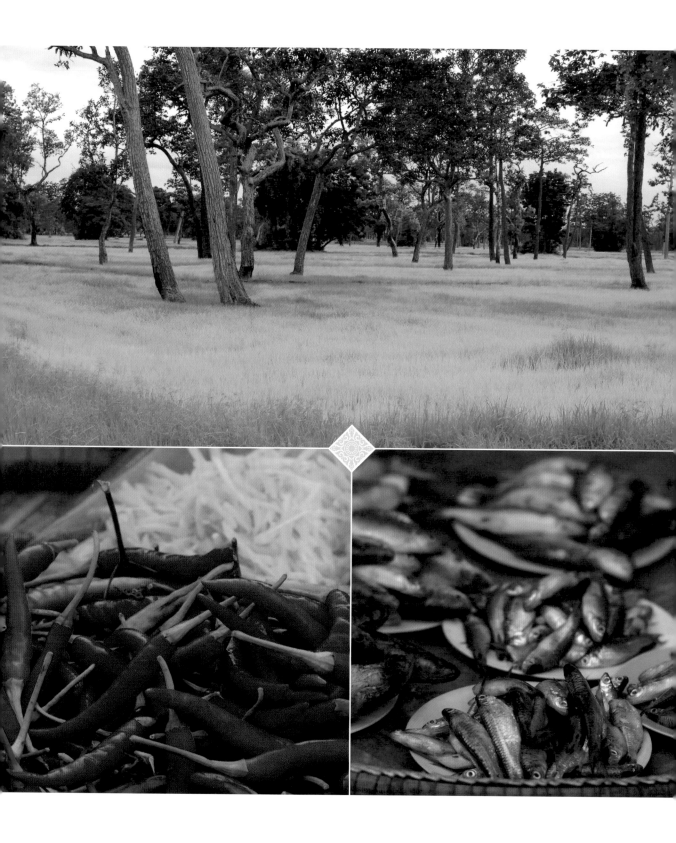

preface

When I fly to Thailand from North America I usually come through Tokyo. It's a long trip. From Toronto to Tokyo is 11 hours, flying nearly over the North Pole. From Tokyo to Bangkok is about eight hours. Flying from Bangkok back to North America—heading east—is thankfully three hours faster.

When I first came to stay in Thailand in 2009, I didn't have a plan. I didn't know if I would be here for six months or for six years. All I knew was that, in my life, I had to do something different. For 24 years I'd lived in downtown Toronto and lived a very happy life. But at some point, and I don't know exactly when, life in the city became almost abhorrent to me: everyone living so closely together, the sidewalks crowded with strangers, eyes cast straight forward or down. I began taking antidepressants, not knowing what else to do. I spent a lot of time watching sports on the TV in the basement, not wanting to go outside. All the things that had seemed so amazing to me on first arriving in the city (having grown up in a small town in Wyoming)—the diversity, the food

shopping, the small ethnic restaurants—lost all appeal. In high school and then in university, my children, Dominic and Tashi, had wonderful friends from all around the world, and the city was a remarkable place for them to discover other cultures. I was happy for my children, but watching their lives made me feel even lonelier.

Naomi—then my partner, my co-author, my co-everything!—was, as is her way, patient and sympathetic with my woes for a long while. "Why don't you take tabla lessons?" I remember her asking one time, a very good idea but I didn't do it. "Why don't you volunteer at a soup kitchen?" Another very good idea. One afternoon I walked over to my sons' high school (a place for which I had great admiration and respect), found their

Top: The unique landscape of southern Surin Province in northeastern Thailand. Rice is planted among the trees, making for a healthier agricultural environment. Bottom left: *prik e noo* chiles and freshly grated ginger. Bottom right: Fish for sale at the Thursday market in the village.

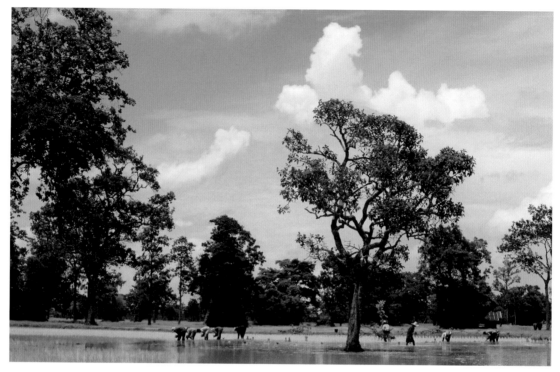

It takes many people to transplant a field. It looks harder than it is, unless of course you have a bad back.

favorite English teacher after classes and asked if I could talk with him. He walked me into his lovely old classroom and we sat down. "Is it possible that I could volunteer for you?" I asked, and then I broke down into tears.

Toronto, I finally realized, was my partner's home, in her heart and in her soul. She loved all the layers of everyday life; she loved every downtown city street. She loved it all like a mystery novel, each day unfolding with an unlimited sense of possibility. For her, I realized, it would never stop being home, and for me, it would never really be home.

So here I am in a small village in northeastern Thailand.

Jeffrey Alford
Kravan, Surin Province, Thailand
November 2014

introduction

When I first began writing this book, I imagined it as a documentary film, only in print. I imagined it as one of those wonderful food reference books—like the works of Alan Davidson and Patience Gray—that people appreciate for generations. Month after month I kept journals of what I ate each day (and the corresponding recipes). I set about compiling botanical information and gathering the local and English names for everything that was unfamiliar, which was, and still is, overwhelming. It was a sort of "culinary anthropology."

But this book isn't the book I first imagined. Along the way I realized that I'm not a documentary filmmaker, I'm not particularly good with a lot of details and I'm not an anthropologist. I'm a cookbook writer and a traveler who lives in a small village with a great partner, a really nice family and a host of sometimes crazy neighbors, and the one thing we all have in common here is the food we eat every day, food that's like no other food I have ever eaten in my life.

This is a book about Pea—my partner—about how she cooks, gardens, forages, eats and farms. She knows more about her natural environment than anyone I've ever known. She raises crickets and frogs, fish, ducks, chickens, pigs, cows and forages for grasshoppers, snakes, red ant eggs, freshwater crabs and shrimp, aquatic greens and leguminous tree leaves. She's also better with a slingshot than anyone I have ever seen.

Pea and I live in a small village named Kravan, in northeastern Thailand, 12 miles (19 km) north of the Cambodian border. We live in Pea's mother's house, five of us, sometimes eight, sometimes ten. Sooner or later Pea and I will most likely find a house to ourselves, but for now, here with family has been good.

Kravan is a village in Thailand, of course, but the food here is not what most Westerners would think of as "Thai food." There's no pad thai, no red curry, no sweet-and-sour spareribs (and no restaurants, and only occasionally a noodle stand). There are foods here that overlap with

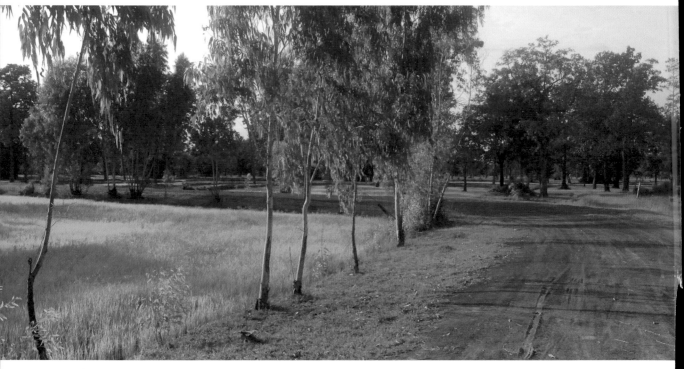

Kravan is not a glamorous place. But a bend in the road on a warm, sunny afternoon, riding on a motorbike with a breeze in my face, is pretty nice.

the rest of Thai cooking, dishes that have been traded back and forth. But the essence of the "cuisine" is, I think, truly unique to here.

Pea is ethnically Khmer, or Thai-Khmer, to be more precise. Her first language is Khmer, not Thai (two languages that are not at all related). Almost everyone in the village is Khmer, as is the case with all the neighboring villages. Most everyone was born in Thailand, and they're all Thai citizens, but their culture and language—and cooking—is Khmer. So what is Khmer? Khmer is Cambodian, but not exactly. If we go 12 mi (19 km) south and cross the border into Cambodia, Pea no longer understands what people are talking about. If we drive two more hours and arrive at

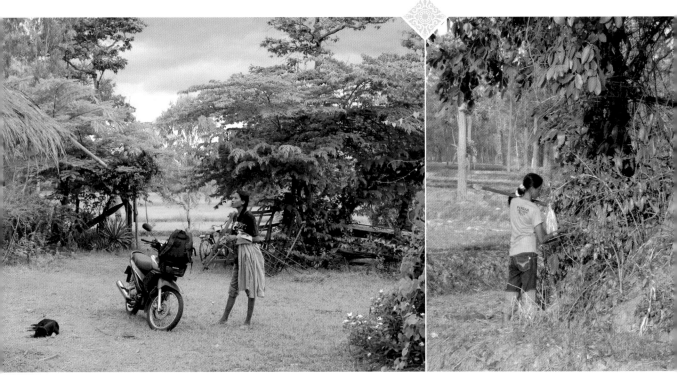

Left: Neighbors rely upon one another when the rice seedlings need to be transplanted and close to a dozen of us help out at Nee's farm. Here, Pea takes a much-needed break. Right: In early April the land is baked hard as clay and the days are extremely hot. Pea forages for tree leaves and red ant eggs.

Siem Reap—home of the temple Angkor Wat—the cuisine bears little resemblance to what we eat at home.

"Kravan food" is not Thai food, nor is it Cambodian food. It's the food of just this small region. Sometimes eating here I'm reminded more of the food of Sri Lanka than I am of Thai food, parts of Sri Lanka being very similar in terms of soil and vegetation. The defining feature of the food here, at least for me, is a dependence on wild and foraged foods—foods I think of as "free food." Before a short time ago, village life here was almost entirely based upon subsistence agriculture (nothing coming in from the outside). "Free food" was not a choice, it was a necessity.

There's almost never a day when Pea doesn't go out foraging for free food (and she is not unique in this, though I think she is uniquely good at it).

When she's working at the rice farm (which is located outside the village like everyone's farms here) she will take a stroll for pleasure in between work and look for free food. Depending upon the season, she'll be looking for aquatic greens and herbs, rice-field crabs, crickets, frogs, snakes, baby fish. No matter what time of year, however, the number one free food on her list is tree leaves.

The agricultural landscape here, like the cuisine, is also unique in that the tiny rice fields are littered with trees. Worldwide, farmers generally hate trees, because trees are a pain. They make

tractor work considerably more difficult. But here there are so many trees that sometimes it looks like the rice is growing in a forest. Many of them come from the botanical family *Leguminosae* (fixing nitrogen in the soil). Most of these trees are very big trees, some the size of mature maples, and have many important uses, one of which is food. The four most common leguminous tree leaves eaten here are *khilek (Cassia siamea)*, tamarind *(Tamarindus indica)*, *cha-om (Acacia pennata)* and *krathin (Leucaena leucocephala)*.

When picking tree leaves, Pea moves patiently from one tree to another, harvesting tender leaves and sometimes flowers. She will collect several handfuls and put them away into a basket, and when it's time to go home, she'll grab her basket of leaves. There's hardly a meal—breakfast, lunch, dinner—where there aren't tree leaves eaten. They are eaten either lightly steamed, or most often, they're simply washed and served raw. They're easy to spot because they usually have a plate of their own, a stack of beautiful green, or if several are put out at once, a plate full of various shades of beautiful green.

Eating leaves is almost meditation for Pea. She will pick up a long thin stem of, say, *cha-om* or *krathin*, and then carefully pull the fresh leaves and stem from the harder bottom stem, discarding the bottom stem as she does it. With the tender leaves still attached to a tender stem, she will begin to fold them in 1-in (2.5-cm) lengths, making a small "bundle" of leaf. She then dips the bundle into a chile paste or sauce *(nam prik)* and then eats it.

Eating leaves makes for long meals! And it's not like these leaves are flavorless, like when eating iceberg lettuce. Just the opposite. All of them have very distinctive tastes and smells, something that I (and I think others) find addictive. Times in the last three years when I have not been here in the Isaan region of Thailand, tree leaves have been what I missed the most. One of our favorite meals is made simply with small fresh Thai oysters, a plate piled high with fresh *krathin*, a large bowl full of slivered shallots fried until brown, and *nam jeem*. No rice, just leaves, oysters, shallots and chile sauce.

Nam Prik and Pak

Before coming to Kravan I would have assumed that rice was the heart of the cuisine, as it is in so many places throughout Asia. And while rice is definitely the staple grain and the essential carbohydrate, I don't necessarily think of it here as the "heart" of the cuisine. Pea makes rice every day, the rice she grows (with a fresh banana leaf on top to seal in the moisture), but she doesn't make a lot of rice. We don't eat a lot of rice. In sheer quantity, we eat twice the amount of raw and lightly steamed vegetables (and tree leaves) as rice. The "heart" of the cuisine may very well be what's called *nam prik* (*nam* being water and *prik* being chile). Long before I get up every morning, I hear Pea pounding away with a mortar and pestle. She has already roasted garlic, shallots and fresh chiles and thrown them into the mortar. She adds a bit of salt to help break down the other ingredients, and then she starts to pound. Garlic, shallots and chiles form the base for almost all *nam priks*, but from this point on there is incredible variety. The consistency of most *nam priks* is a little bit like guacamole, though always fiercely hot. Fish meat can go in, grilled frog or tiny baby frogs, freshwater crabs from the rice fields, scorpions, fermented fish paste *(pla ra)*, fermented shrimp paste *(kapi)*.

Nam prik is not something that is quickly made. If using grilled fish, frogs, crabs or scorpions, the first thing Pea has to do is to build a small

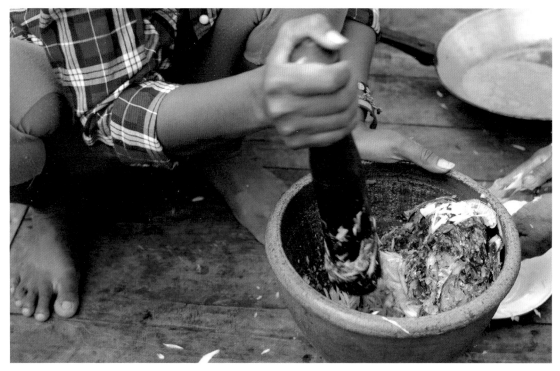
Very few essential kitchen items are needed to get started—a large mortar and pestle is one of them.

charcoal fire (charcoal is made in the village, household by household, a resourceful way of utilizing the constant pruning that comes from the enormous mango, jackfruit and tamarind trees). Thai-style braziers are small and made of clay, brilliant for grilling small amounts without using too much charcoal. She lights the charcoal with small sticks of a particularly resinous tree, but if she's run out of the sticks, she will use a small portion of an old plastic water bottle. She slowly grills the different foods that will go into the *nam prik* until they are done—whether it's a big black scorpion, a fish or simply whole shallots and garlic—and then prepares them before tossing them into the mortar.

She will pound and pound, and then pound some more. And then taste, season and pound some more. When the *nam prik* is at last finished, she takes the sauce out of the mortar and puts it into a bowl. It will be eaten with breakfast, lunch and sometimes dinner.

Stage two of the "essential meal" is to assemble the vegetable platter. If there's enormous variety when it comes to *nam prik*, that variety is nothing when compared with the vegetable platter. The vegetable platter is a tangible expression of everything that is in season. Tree leaves, flowers, vegetables, aquatic greens and roots: it's mind-boggling! Several greens I have come to love especially, like tender sweet *pak wan* (*Marsilea crenata*; "water clover") that grows in water alongside every road. For months we will eat it at least once a day, dipping it in *nam prik*, and then it will be gone, suddenly out of season. Dill is eaten as a vegetable,

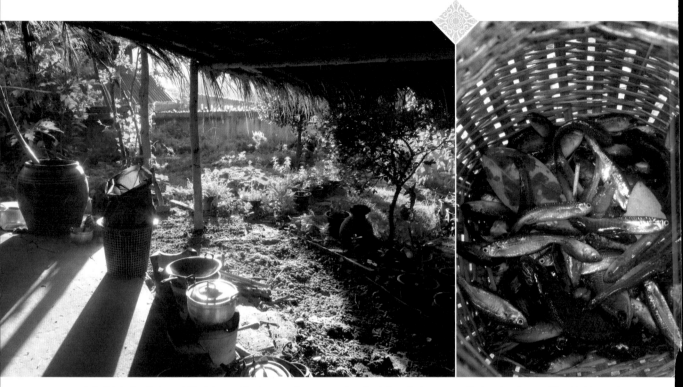

Left: This is the kitchen at Mae's house. The large earthenware pot on the left, called an *ong*, collects rainwater used for drinking and cooking. Right: Fish—big or small, it doesn't matter. Fish, rice and bugs are all proteins that keep people healthy and alive.

not as a seasoning, as are the green leaves of the cosmos plant. Zucchini, a recent discovery for Pea, is steamed when just 3 in (7.5 cm) in length, tender beyond tender. Other recent discoveries are okra and asparagus, both lightly steamed and put out on the vegetable platter. In Thai it is all called *pak*, or vegetable. *Nam prik* and *pak*, the heart of the cuisine.

Getting Started

To cook your way through the recipes in this book, you will need a good strong wok, a Thai-style mortar and pestle, a small grill and grilling basket and a steamer. Not much more. The reason for purchasing a Thai-style mortar and pestle is its size. It's large. I have seen large mortar and pestles

from Mexico, which would work just as well. But a small mortar and pestle, the kind people use to grind spices, doesn't work. Many Asian groceries now sell Thai-style mortars and pestles. They aren't, or shouldn't be, expensive. They are also easily sourced on the internet and received through the mail.

A Thai-style grill is not essential (but wonderful to have if you can find one), but a grill is essential. It can be gas or charcoal, but smaller is better than bigger. The grill doesn't need to cook eight hamburgers at the same time; it needs only to cook a small amount. The easier it is to light the better and the less charcoal it uses the better.

In looking for recipes to start with, I recommend *Hoi Lai Bai Horapa* (Clams with Basil and

Garlic, page 44) a delicious dish easily prepared for guests for a Saturday night sit-down meal. So too are *See Krong Moo Tort* (Shallow-Fried Pork Spareribs, page 28) and *Pla Pao* (Grilled Salted Tilapia, page 60). *Khai Mot Daeng* (Red Ant Egg Salad, page 124) probably won't make it onto your menu (though it would if it could—it's very similar to the taste of caviar). If the *nam priks* are too hot, use far fewer chiles (as Pea does for me). When you put together *Pak* (Vegetable Platter, page 21), think locally, think seasonally. You may not have tiny climbing perch (*pla mo*) or serpent-head fish (*pla chorn*), but it doesn't matter. Use a fish that you have locally, maybe a rainbow trout caught in a Rocky Mountain stream, and make *Nam Prik Pla* (Chile Paste with Fish, page 36).

I don't know the nutritional breakdown of many of the foods that we eat here every day— *pak wan*, *krathin*, crickets, red ant eggs and tiny dancing shrimp—but I know that this is probably the healthiest food I have ever eaten in my life. It's definitely up there with the tastiest!

A Couple of Final Notes

Almost all of the recipes in this book serve roughly three to four people, but it all depends on what kind of a meal it is. Serving sizes and suggestions are provided for each recipe.

And much to my surprise Pea just recently bought a blender and a food processor. She found them advertised in a catalog and ordered them, and then one day a neighbor came walking up the street with a large box containing both items (how it all works I have no idea). They weren't expensive—a fraction of the cost in North America—so I was skeptical. But now, after a month, she loves them! For the *nam priks* that she makes every day, they work beautifully. They work so well, in fact, that now she's started a small business making a different sauce each day, apportioning the *nam prik* out into small plastic bags, and then putting the bags—and bags of raw and steamed vegetables—out for sale on a small table in front of the house: 30 cents a bag.

the end of the rain

This is my fourth harvest (fourth year) in northeastern Thailand, and gradually I feel as if I'm understanding more about the agricultural cycles unique to this place. One of the big mysteries, specifically at harvest, was how quickly the fields change from lush green to golden yellow and from post-harvest yellow to brown. In North America I was used to fields of wheat and barley that slowly change color as the grain matures. I'm used to autumn, to the slow, almost idyllic transformation between summer and winter: leaves changing colors, days getting shorter, the light ever more angled.

Here the months of October, November and December are very different. This year in late October and early November there's been severe flooding, especially in central Thailand. People say that it's been the worst flooding in 100 years; over 600 people have lost their lives. In our region the flooding hasn't been so bad, and the rice fields are still in good condition.

"Rainy season" lasts from late May and early June through until November. But early rainy season and late rainy season aren't the same. Here the early rains come from the southwest monsoon, similar to the major rainy season that predominates in the Indian subcontinent. Every morning the sky is crystal blue, and around mid- to late afternoon big cumulus clouds start to build.

If all goes as it should (which isn't always the case with the fickle monsoon), by late afternoon the rain comes, life returns to the parched earth and everyone is happy. June, July, August and even into September, the southwest monsoon is in control and life is good.

But late September, October and November are not the same. As the southwest monsoon starts to taper off, in its place comes typhoon season, cyclone season. Northeastern Thailand is too far from the coast to get hit directly, but as with hurricanes in Florida that hit eastern Canada several days later, the tail end of a tropical storm can bring a rainfall of 5 or 6 in (12.5 to 15 cm) to northeastern Thailand in one day. When there's flooding here, it's generally at this time of year,

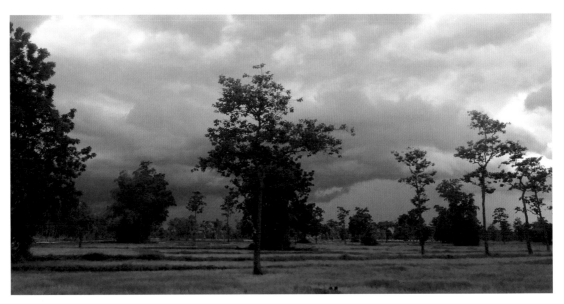

When the big storms of late rainy season roll in, a day can suddenly become almost black.

even though the overall level of rainfall is lessening. The flooding is not because of the rain, but because the level of the groundwater has reached a saturation point.

A few days ago we got hit with the tail end of a tropical storm. We have a drain in the culvert at the front of our house, but instead of the water going down the drain, the drain was like a fountain with water blasting up a foot and a half into the air! The road (which, like almost all roads here, is built up to prevent flooding), was flooded, but not badly. The situation wasn't dangerous, but just the opposite. In the fountain of water there were fish—fish everywhere. There were freshwater eels, small snakes, frogs and serpent-head fish. Up from the other side of the road came *pla mo*, small perch famous for their ability to climb up steep inclines of earth.

Pea was in heaven, catching fish by hand from early morning until well after dark. So too were all the neighborhood kids and eventually their parents. Everyone was soaked from head to foot, but nothing could deter anyone from chasing the fish, shrieking every time a fish was caught. Pea was particularly thrilled because we have a fishpond, and everyone was happy to throw fish they caught into *our* pond.

On the second day I finally got up my courage and joined in. I'd never caught a fish by hand, and that was immediately apparent. I was big entertainment, with everyone watching and laughing. Every time I'd reach down to try to catch a fish, the fish would jump away. I couldn't understand; it looked so easy for everyone else. Finally Pea came out, barely able to talk through laughing, and explained that I needed to use two hands, to go under the fish and to scoop the fish, not to grab at the fish.

Aha!

Kha

STEAMED FRESH GALANGAL SHOOTS

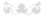

I WILL NEVER FORGET THE VERY FIRST DAY I CAME TO LIVE WITH PEA IN Kravan. We'd traveled 15 hours by bus from Chiang Mai in the far north of Thailand, the city where we'd first met. It was a long trip, and we didn't talk all that much. Looking back, it felt a bit like being 21 years old and moving in with a girlfriend, finding an apartment, scraping together some furniture. We both had little idea of what to expect, but we trusted each other enough to go forward. After many a long conversation, we'd agreed that we wanted to try living in the country, not in a city. Kravan, Pea's home village, made the most sense.

We arrived at Surin bus station, got off the bus and retrieved our baggage. Pea was immediately on the phone, anxiously looking around through the crowd. I knew it was no use for me to participate, or to ask any questions; I knew that somehow we would get to the village. The crowd started to thin out, and Pea kept looking, searching in all directions, no longer on the phone. At last an old red pickup drove up adjacent to the bus stand, an older man looking intently out from behind the wheel. Pea waved so that he could spot us, and then we carried our bags over to the truck. We greeted in Thai style, putting our hands together and saying *sawatdee kap*, then threw our bags in the back and climbed in.

Kravan is about 30 mi (48 km) from Surin, but 30 mi here can seem a lot longer than 30 mi in North America, especially in an old pickup with one door almost falling off. I had no idea where I was, following one bumpy potholed dirt road after another, weary from 15 hours on a bus, yet excited. Again, no one spoke much. The driver was a cousin (who I now know as Tat, a brilliant musician who plays the *khaen*, a large bamboo mouth organ). We drove along looking out at parched earth (it was March), meandering our way through village after village.

Finally we arrived in Kravan, unceremoniously, which I think is the rural Thai-Khmer way. We pulled up to Pea's mother's house and took out our bags. I paid Tat 400 *baht* (roughly 15 American dollars) for coming to pick us up, and he headed off. We walked up beneath the shade of the overhang where there were (as there always are) half a dozen older men and women, most everyone chewing betel. Pea introduced me to Mae ("Mae" is the word for "mother," and it is also the name by which I have come to know her), and we greeted *sawatdee*. Pea then told me that we should carry our bags up the steep wooden stairs,

and so we did. She opened the door to one of the three rooms and in we went.

"I take care here," said Pea. "You want shower?" She didn't wait for a response, already opening a bag and looking for a towel and a sarong. She found them quickly and handed both to me. "You shy?"

"A little bit," I replied, laughing.

"I will show you. Don't be shy."

Thirty minutes later, refreshed from a cold shower, I was sitting with everyone else in the shade, drinking a cold Leo beer. Pea appeared, her arms wrapped around a large bundle of what looked like very thick grass. "You know these?" she asked. "*Kha*—these are *kha*."

Kha is galangal; I knew galangal. But I only knew galangal as a rhizome, a part of the ginger family. These were obviously the stems, the shoots, but they were a good 3 ft (1 m) long, and longer.

"Help me," Pea said, sitting down, putting down the bundle. She took one stem at a time, and starting at the top, peeled off the outside harder leaves, leaving a long tender shoot as if peeling a green onion. I started to help, happy to have a job. It took a long time; there was a lot of *kha*.

When we finished, Pea disappeared with the tender shoots. Thirty minutes later she reappeared, the stems all freshly steamed and wound together into small bundles. There was a bowl of *nam prik*. She showed me how to pull out a stem of *kha* from a bundle, gather it together and dip it into the chile paste. The stems were tender and delicious, and the *nam prik* unbelievably hot.

She disappeared again, this time coming back quickly with another cold beer, and a glass for herself.

After six months of rain with fish swimming in the streets, as you can imagine, things are pretty green! Every rice field is filled with nearly 2 ft (0.6 m) of water. The rice itself has thick heads of grain. When we step outside the house we are in tall rubber boots, not flip-flops. Wherever there isn't water, there's mud, and the mud from this soil is like superglue, clinging to everything. When we walk along the embankments that keep the water contained in the rice fields, we walk ever so carefully, like walking on the moon, one steady step after another. The muddy embankments are sticky yet slippery, and the last thing one wants to do is to fall into the water. At this time of year, leeches abound.

For rice farmers here, there are two critical times of the year. The first is deciding when to plant, and the second is now, at the end of rainy season, deciding when and how to harvest. Unlike with the golden fields of ripening wheat on a Kansas farm, the reason the rice goes so quickly from green to yellow is because a decision is made by every farmer—by every family—to drain the water from the field, and once the water is drained, the rice goes quickly yellow, like a houseplant left out in the hot sun with no water. It's a decision not easily made, because everything happens quickly thereafter. If harvesting by tractor, will a tractor be available and has it been reserved? (There are very few tractors.) If harvesting by hand, have people

been lined up to help? (Usually this will include aunties and uncles, neighbors, cousins, children and grandparents.) And is there money set aside to pay for the harvest, or is there access to credit? (Credit is generally offered by private moneylenders at interest rates around 8 percent per month.)

And there's one more, perhaps even bigger, issue to consider in deciding when to drain the field: Are you ready? Do you have "power" (as people here like to say)? Harvest is by far the most labor-intensive time of the year, and there's no such thing as a day off. Once you start, you only stop when the harvest is complete.

It all begins when you open the concrete pipes that are buried beneath the embankments, letting

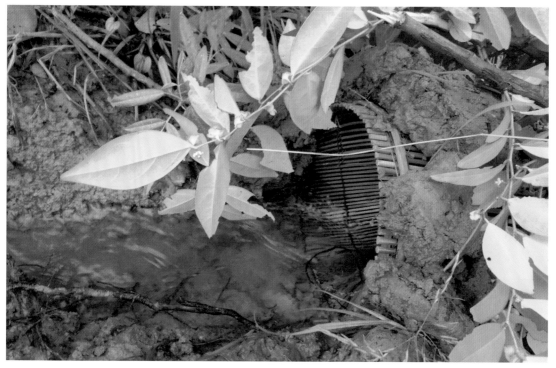

Pea buries bamboo traps in the mud walls between rice fields. When the water is drained the traps catch a daily supply of food which includes fish, snakes and crabs.

the water flow from one small field to another and eventually into a nearby canal. But before you open the pipes, you set bamboo traps and fishnets (some as long as 20 ft/6 m), harvesting all the life that has been living in the water.

Pea barely sleeps. At four-thirty every morning, she leaves the house in the dark and heads to the fields. She doesn't want anyone to steal from her traps, and she's also motivated, I think, by sheer excitement, or adrenalin, or a combination of the two. In the nets and traps she will harvest fish (*pla mo, pla chorn, pla duk*), frogs, crabs, shrimp, eels and snakes. "Four snakes," she announced the other morning, beaming. "But I kill one, small one. Small, but if it bite me, I die." She gave the

three other snakes—alive—to her third brother, who this year has a tractor and is helping all seven siblings with their fields.

Snakes are very much a part of life in Kravan, especially now in late rainy season. A few weeks back Pea came home from the farm in the afternoon and asked if I would share a beer. I could see that something was wrong, that something had happened. I took a beer from the fridge and I grabbed two glasses, and then we sat out in the thatch hut.

"There's a cobra in the barn," she said. "I was taking grass for the cows, you know, and just there," she said pointing to a spot a few feet away, "the cobra raised up, like this." She raised her

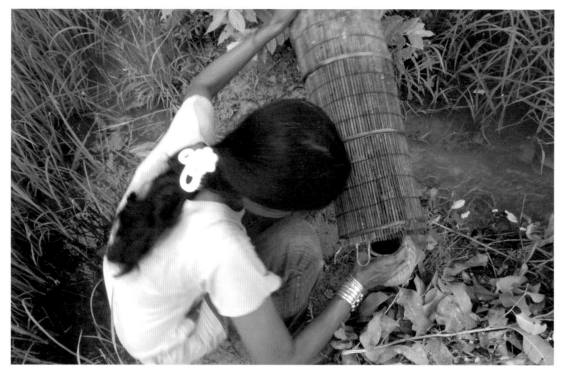
The bamboo traps must be checked every morning for anything caught during the night.

forearm at the elbow, fingers pointed out. Pea was telling me the story, but almost telling it more to herself, thinking back through the moment. "I should have killed it, but today I have no power, no power in my hands." For the next little while there was silence, both of us taking a gulp of cold beer.

"What now?" I finally asked.

"I have to kill it. Many people use the barn, and they don't know there's a cobra living there. If a cobra bite, you know, you die."

It was strange to see Pea deep in thought about the cobra. I knew that there were things I didn't understand, but I couldn't even formulate a question. We just sat there quietly and drank our beer. But later the same evening, just before bed, she came back to it, the cobra still weighing on her mind.

"You know," she told me, "in the cold season some people take the snake and hold it to their chest, because the snake is cold and happy to get warm. The people want to make friends with the snake. But sometimes it doesn't work."

Every day thereafter Pea went to the barn prepared to kill the cobra. I went with her to feed the cows, and also just to be there. But I was too afraid to go into where the hay is kept. She would walk right in with her rake and start taking grass for the cows, exactly where she'd met the cobra. Two days, three days, four days.

The cobra hasn't returned.

Som Tam

GREEN PAPAYA SALAD

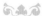

THERE'S NO DISH IN NORTHEASTERN THAILAND AS IMPORTANT AS *som tam.* I have theories about why the dish is so important: Green papayas are virtually free and they symbolize rural life; the dish is almost universally extremely *phet* (spicy hot) and has the strong back taste of *pla ra* (fish paste), two essential elements in northeastern food; and the dish is very communal, almost never eaten alone.

But these theories don't remotely begin to explain the role the dish has as "comfort food"—comfort food beyond comfort food. Five o'clock in the morning in the city, young people returning from dancing their brains out in a bar: *som tam.* Two in the afternoon in the village on a horrible, hot April day, everyone almost motionless in the heat: *som tam.* Construction workers slogging through a 14-hour shift on a Bangkok high-rise: a 20-minute break for *som tam.* A comfort food for me was my grandmother's chicken noodle soup on a cold January night; *som tam* is the exact opposite. *Som tam* is strong; *som tam* is powerful!

If Pea or Gung (Pea's daughter) asks me if I would like to eat *som tam,* I often say no because I know they will tone it way back, and I know that for them that's not *som tam!* I eat hot food, and from a Western point of view, I eat extremely hot food. But can I eat as hot as Pea, or even as hot as 12-year-old Gung? No. Not even close. Most of the food we eat every day comes with *nam prik.* Pea eats *nam prik* by the tablespoon; I eat it by the half teaspoon, barely.

Som tam is meant to be hot (in Khmer language the word for hot is *hrrrr,* a wonderful word). The following recipe is for *som tam* at its simplest: no peanuts, no dried shrimp...village *som tam.*

1 large clove garlic

3–5 bird's eye chiles

Pinch of salt

1½ cup (350 mL) shredded green papaya, skin removed

3 cherry tomatoes, or one plum tomato, sliced

1 Tbsp (15 mL) Thai fish sauce

1 Tbsp (15 mL) fresh lime juice

1 Tbsp (15 mL) *pla ra* (fish paste; optional)

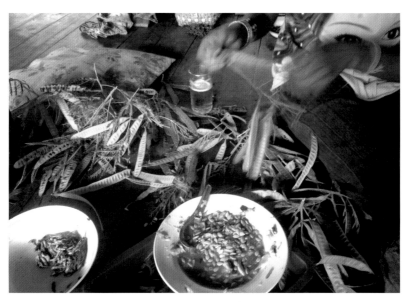

The *krathin* tree is hugely important here, not only for fixing nitrogen in the soil but also for its edible leaves and seeds. The seeds are stripped from the pods and added to *som tam* (green papaya salad).

1. In a Thai-style mortar and pestle (or a blender or food processor), place the garlic, chiles and salt. Pound strongly, breaking down the chiles and the garlic, using the salt to help grind. It's not necessary to grind to a paste, but grind to pulverize.

2. Add the shredded (or julienned) green papaya and continue to pound. The aim is to break down the green papaya and to distribute the flavors, but not to pulverize. Come from different angles with the pestle.

3. When the green papaya is sufficiently broken down, add the tomatoes and continue to pound. Mix in the fish sauce, lime juice and *pla ra*, if using. Pound briefly, then stir with a spoon to mix all the flavors together. Taste and adjust seasoning as needed. Add a pinch of sugar if too hot and sour.

4. Serve with pieces of raw cabbage, winged beans, yardlong beans, leaf lettuce: anything that you like. Serve on a flat plate with fresh vegetables.

MAKES THREE TO FOUR SERVINGS AS AN APPETIZER

isaan

We live in a region of Thailand called Isaan, or northeastern Thailand (traditionally Thais see their country as having four regions: the south, the north, the northeast and central). More precisely, we live in southern Isaan; Cambodia's a 30-minute drive away. Southern Isaan is intensely tropical, in many ways—both physically and culturally—much more like Cambodia than Thailand.

When I first came here I assumed that there would be two crops of rice per year, but there's just one (and unlike Isaan generally, where sticky rice is the staple rice, here people grow and eat regular jasmine rice). Rice is planted in late May and early June and harvested from late November to December. I don't know for sure why there's only one crop, but my guess is that it's primarily a matter of irrigation, or in this case, an absence of irrigation. In rainy season there's water, and in dry season there isn't water, simple as that. Irrigation takes money, and Isaan is poor, very poor. Thailand has 75 provinces, and the province of Surin, where we live, has the third lowest household income of all of them.

But there's another important factor affecting rice, and that's the soil. Here the soil is lateritic. Lateritic soils are rich in iron and aluminum, the iron making the soil rusty red. In rainy season it can rain up to 5 in (12.5 cm) a day, an extraordinary amount of water. Water erosion—flooding—puts an enormous stress on the lateritic soil. Over centuries people here have learned how to maintain soil fertility in what is a very fragile environment. They've learned not to overstress the soil by taking two crops a year, and they've learned the importance of leguminous trees.

When I first moved to Isaan, I knew nothing about leguminous trees. But then I didn't know much about a lot of things.

Pak

VEGETABLE PLATTER

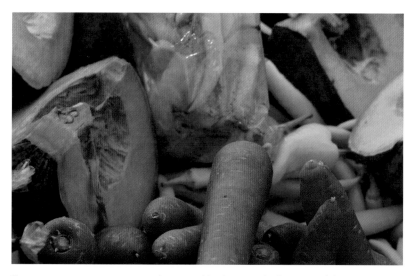

There are so many components to the vegetable platter, and color is one of them.

HOW BEST TO DESCRIBE *PAK*? OR WHERE TO BEGIN? IN OUR HOUSE IN KRAVAN the vegetable platter is a somewhat inglorious large plastic or metal platter, round, about 18 to 20 in (45 to 50 cm) in diameter. We have one that's red, and another that's green. Both are bright in color and have pictures of flowers; for me, they are classic Chinese-manufactured housewares, cheap and tacky. But it doesn't matter; my "taste" or lack thereof is not the issue here. The platters are cheap, durable and lightweight, and they get completely covered in vegetables, so it doesn't really matter. (And "salad bowls" don't work, because the platter must be flat.)

There are, I think, a few rules about what kinds of vegetables should generally get served with a particular *nam prik*, or a particular dish, but 95 percent of composing the vegetable platter is a matter of taste, and of course depends most on what is in season.

Many of the vegetables, tree leaves, flowers and wild and aquatic greens that are available in Kravan may not be available where you live, so I have concentrated here on common foods that are available in more temperate climates (for a detailed listing of other local ingredients, please see the glossary, page 194).

If I were in eastern Canada and putting together a vegetable platter in October, I would lightly steam cauliflower, broccoli and carrots (perhaps with a light drizzle of oyster sauce on the cauliflower and broccoli). I would put out washed and trimmed green onions, cabbage and cucumbers. I might include, as Pea often does, a hard-boiled egg or two. If kale were in the market, I would steam it in the same way as the broccoli and drizzle it lightly with oyster sauce. Small peeled shallots are also good, almost all year round, as is peeled and thinly sliced daikon. Late lettuces, arugula, endive, spinach, radicchio and chard could also be included.

If I were assembling a platter in June, the list would definitely include fresh asparagus, very lightly steamed. Dandelion greens, garlic tops, chives, perennial onion flowers and sorrel would be obvious additions. And in July, fresh baby okras and zucchini (again steamed ever so lightly), squash flowers, cosmos leaves, daylily buds and flowers, nasturtium leaves and flowers, parsley, dill, snap peas, green, yellow and purple beans (perhaps lightly steamed), fennel and pea tendrils. The tendrils from squash and pumpkin are a common sight on Pea's vegetable platters.

If I had access to an Asian grocery with fresh vegetables, the seasonal lists would again be very different, though most likely with a combination of familiar and less familiar produce. Winged beans, yardlong beans and baby cucumbers are some of my favorites.

One way to think about *pak* is as a kind of salad, but it's definitely not a salad. The vegetables are seldom if ever sliced or cut up. Each vegetable is eaten separately, usually after dipping in a *nam prik*. Each taste is a new surprise. There are dishes like *Pla Nin Nung* (Steamed Tilapia with Herbs and Vegetables, page 182), where the vegetables are all steamed together and eaten together, but a vegetable platter is very different.

When Pea steams something for the vegetable platter, she puts a wok filled halfway with water over a gas burner. (When not working with charcoal, Pea uses gas. The gas cookstoves we use here in Kravan are totally illegal in North America; ours is a simple cooktop connected to a large tank of gas, whether indoors or out, and our BTUS are extremely high.)

As with so much of how Pea cooks, she makes it look so easy, almost instinctual. I've never seen her overcook anything. When we first arrived here in Kravan, in the market I found asparagus, okra, zucchini and brussels sprouts in a local market. She'd never before cooked with any of them, but she took to them immediately, cooking them perfectly.

Maybe it's instinct, but then again maybe it has something to do with first learning to cook when she was six or seven years old (and now the same is happening with her daughter, Gung).

There are eight children in Pea's family. Numbers three, four and five (Pea is number five) look as if they could be triplets. They all have big, deep, glowing eyes and long skinny limbs (Pea is nearly the same height as I am—five foot ten). Isaan is a place where people are famous for having high cheekbones and "no nose" (meaning no bridge), where even a woman working in a factory at a terrible wage will save and save in order to "make nose" (get a nose job) to make her nose bigger. Pea happily jokes that her nose, a big nose, was free. "It was a present from my father." She looks much more like someone of Indian descent than she does a person from Thailand. I joke that if she put a red *tikka* on her forehead… She doesn't laugh.

Brother number two, Tat, is the one whom everyone seems to respect the most. Pea's father died when she was just a kid, getting hit by a car when he was coming home on his motorcycle. My sense is that Tat took his father's place. He works the farm but he also works construction in Bangkok, working way too hard. But he "looks after" in the classic Thai sense of the expression. He has three great kids, and his spouse, Doi, is just like him: steady and reliable.

The other night we were at a wedding in the village and there was *kantrum* music, the Khmer version of Lao *morlam*, great indigenous music. I ended up dancing with Bpoo, number one son of Tat and Doi. We got to dancing more and more (dancing, like the music, has a very specific character here, somewhat resembling south Indian classical dance, though with a very strong beat), and while he was in a whole different league than I, it was really fun. Boy, could he dance! I don't know exactly how old Bpoo is, maybe 15 or 16. At some point I had to bow out, totally spent, and for sure he could've gone for hours more. He's a remarkable dancer, long limbs dancing in four different directions, body always in control but so limber and loose.

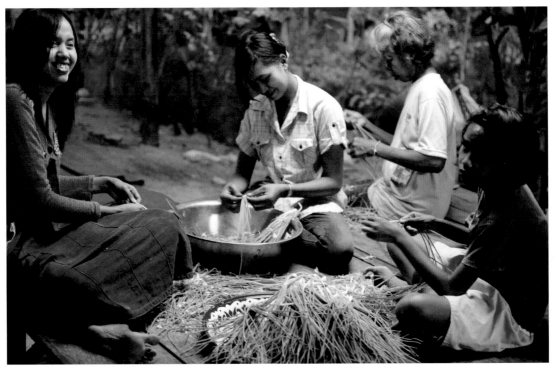

Sister number eight, Ang, and her two cousins, Kwahn and Ngaa, are cleaning green onions picked from Mae's garden. Big family meals require a lot of food.

A few days later we were all together in the evening. After dinner someone put a video on TV of Bpoo in a dance competition sometime last year. He was the only young dancer, and it was all traditional Khmer dancing, and no question, he was again by far the best, and this time among really good dancers. Pea made a comment about Bpoo being the only *katuey* (transgender) in the competition, and people just smiled, acknowledging that she was right.

Later that evening when I brought the subject of dancing up again with Pea, she told me that his father, Tat, had also been a great dancer, but that Bpoo is even better. "You know," she said, "it's very good for body, and he can make a lot of money with it sometime if he wants."

I finally, at this stage of being in Thailand, resisted the urge to ask the idiotic North American question (for which I am so adept) about how his parents feel about him being *katuey*, and living at a young age in a small village as a *katuey*. They're immensely proud of their son, and so is everyone else in the family.

Nam Jeem

FIERY FRESH CHILE SAUCE

NAM JEEM IS NOT MADE FOLLOWING A SINGLE FIXED RECIPE, WHICH IS TRUE for most recipes I learn from Pea. Even the word "recipe" (*dtam rap* in Thai) is a concept that doesn't sit that well with her. "I put peanuts in *nam jeem* if I'm making *nam jeem* to eat with chicken, but if I don't have peanuts, I don't put them in."

I love *nam jeem*. Of all the chile sauces, salsas, chile pastes I've eaten that Pea has prepared—and we're talking a lot—it's my number one favorite. I like its thin consistency, as opposed to many *nam priks*, which are more like chile pastes. I also like it because it tastes clean and sharp, not complicated.

"What you do?" she asked when I suddenly appeared with my laptop as she was cooking dinner on the concrete slab in front of the house.

"*Tham ai?*" I asked back in Thai ("What you do?"). I've slowly learned that my best defense is a good offense. But of course Pea didn't reply. "You make *nam jeem*?" I asked.

Again, silence. Then she finally gave in: "We eat *pla nin* [tilapia]. When we eat *pla nin*, I make *nam jeem*."

More silence.

Pea *always* cooks on the ground, either sitting cross-legged or squatting, most often squatting. I recently made a wooden table that stands outside, thinking that it might ease the burden on everyone's knees. Pea and Mae both said, "Thank you, thank you," but immediately it became piled high with pounds of shallots and garlic, containers of fermented fish paste, cockle shells soaking to become lime, etc. I knew better, but at least I'd tried. Cooking happens on the ground, and so does eating.

Pea was squatting, pounding fresh garlic and bird's eye chiles in a Thai-style mortar, a clay mortar about 10 in (25 cm) tall. She added a bit of salt to give grit, to help break down the garlic and chiles. Often, at this stage, Pea will turn this job over to me (I get the jobs that take no skill), but on this occasion she continued on her own.

Pounding with a mortar and pestle takes time, a little bit like sharpening a knife. It takes the time it takes.

"*Hew mai?*" Pea asked ("Are you hungry?").

"*Hew.*"

This is the wonderful *nam jeem*—enough for a wedding celebration. It's my favorite of Pea's chile preparations, but it would take me a year to get through this much of the fiery-hot condiment. And then I would probably no longer be alive!

"*Hew hoi*?" Pea asked, suddenly laughing hilariously. *Hoi* is a classifier: oysters are *hoi*, same as cockles, clams, mussels...And in Thai, same as in English, this whole group of foods is loaded with other, cheekier connotations.

Pea jokes a lot, and as far as I can tell there's no difference between a sexual joke, or teasing, or scaring someone, or practical jokes, or a loud fart. And in Kravan, she's definitely not unique in this. When we go to Prasat (our nearest town, 14 mi/23 km away), we drive the motorbike a mile and a half, then park the motorbike and wait for a "taxi." A taxi, *songthao* in Thai, is an old pickup that has been fitted with a canopy in back (in case of rain) and two long benches for people to sit on. *Songthaos*, in one form or another, are the basic rural transport all across Thailand.

One hot afternoon we were packed into the back of a *songthao*, everyone sitting stoically, enduring the heat, the cramped space. Then suddenly someone reached a hand over the side of the pickup and slapped the side, loudly, a

practical joke. Everyone leaped and immediately shrieked, "*Uramballi!*" (This is a word I hear constantly, but Pea steadfastly refuses to translate. In 30 years of learning Thai, I don't know a single "bad" word. In Khmer, I already know many.) After shrieking, everyone laughed and then happily started to talk again.

"You make recipe?" Pea asked, squatting on the concrete slab, smiling, coming back to the *nam jeem*.

"Yes."

"*Nam jeem* very easy, you know. You put chile and *kratiem* [garlic], and a little *kleua* [salt]." She stopped talking, focusing once again on pounding away with the wooden pestle. When she was happy with the consistency of the garlic and chiles, she set the mortar aside, stood up, readjusted her sarong, disappeared and then reappeared with a handful of freshly washed green onions. She found a small tamarind cutting board, a knife and then, once again, squatted down to resume cooking.

On the cutting board, she finely chopped the green onions, both green and white parts, and then she put them into a small bowl. She picked up the mortar and spooned the chile-garlic paste out into the bowl, together with the green onions and then again stood up, disappearing into the house.

"*Tham arrai?*" I asked, still sitting on the concrete slab. But no reply.

When Pea walked back out she had a sauce: *nam jeem*!

"Pea, what you do? You put *nam pla* [fish sauce]?"

"Yes," she replied somewhat impatiently.

"And?"

"A little sugar. And *nam manao* [lime juice]. And a little water."

"And?"

"*Chu rot* [MSG]...I don't know in English. Some people put, some people not put. But no put, not good for eat."

"No peanuts?"

"Not have peanuts today."

See Krong Moo Tort
SHALLOW-FRIED PORK SPARERIBS

PORK IS BY FAR THE NUMBER ONE RED MEAT EATEN HERE IN ISAAN. NEARLY every household in the village raises pigs, and they can be a sizable part of many families' yearly income—or particularly their yearly cash income. A full-size pig (250 to 300 lbs/110 to 135 kg) will sell for about 9,000 *baht* (roughly 300 American dollars). A full-size cow will sell for 7,000, and a water buffalo for about 10,000 (though water buffalo are kept mainly as "wealth," not for slaughter). For a wedding or a funeral, the ceremony almost always includes the slaughter of a pig. Families raise pigs to sell, but they also raise the pigs for events that arise unexpectedly.

I first learned this particular dish at a wedding. The cook saw me looking a little lost and hungry, so she cut off a length of spareribs and fried them—fried them so long that they looked as if they had been grilled, all the fat gone away.

1 lb (455 gr) pork spareribs, cut with a cleaver into 2–3 in (5–7.5 cm) lengths	½ cup (120 mL) vegetable oil Salt and pepper to taste

1. Use a heavy cleaver to separate the ribs, and to cut into smaller lengths, leaving meat on both sides of each rib.

2. Heat the oil in a large heavy wok over medium-high heat. When the oil begins to get hot, gently toss in the ribs. Cook the ribs for 8 to 10 minutes, turning occasionally with a slotted spoon or tongs. If they are cooking too quickly, reduce the heat. The idea is to burn off all the fat on the ribs, leaving a rib that almost looks as if it has been grilled. Be sure to cook long enough so that you are no longer seeing fat.

3. When cooked, drain the ribs of oil and set out on a plate. Sprinkle with salt and pepper to taste and serve.

SERVES TWO TO THREE AS PART OF A LARGER MEAL. EASY TO DOUBLE AND TRIPLE THE RECIPE.

harvest, day one

Today is November 6, our first day of harvest. We helped Mae's brother's family harvest 32 *rai* (approximately 14 acres/5.5 ha). Like many people this year, and a growing number of people every year, we harvested alongside a small tractor, a combine. Our job was to harvest in all the places where the tractor couldn't go, like around trees and close to the edges of the fields. With a sickle, I cut rice that the tractor missed and then threw it back into the line of the combine. It wasn't hard work, but it was tedious, and the day was long. I'm tired tonight.

Mae's brother-in-law Ong is dying from liver cancer, caused by a bout of hepatitis as a child, not by excessive alcohol. He's one of my favorite people in the village, and we're only months apart in age. Most nights Pea, Mae, Gung and I go over to sit with him and his family. He sleeps a lot, but when he's awake he has family around. There are several babies crawling around on the floor; several grannies and grandpas chewing betel nut.

I have access to the internet with a "stick"—like a mobile phone connection—and while it's slow and tedious, it's still a connection. Sometimes late at night I go online to read about Ong's condition and to research his meds. The doctors are trying to make him as comfortable as possible, but for sure he's dying, probably sooner than

later. There's no possibility of a liver transplant or of advanced therapies; there's no money for any of that. When we harvested today—harvest, day one—for everyone, it was with Pea's uncle in mind, who lay resting at home.

Around midday Pea walked over to the barn and put down her sickle, then headed off in her Wellingtons. I knew that she was on the hunt for food, free food, so I too put down my sickle and followed her. We walked along through the fields of newly cut rice, the ground now amazingly hard-packed and dry. When we got to Pea's fields, we climbed back up on the embankments, her fields not yet harvested. Pea has four small fields, 4 *rai* (the equivalent of 2.3 acres/0.9 ha). In the middle of the four fields there's a pond, a place

Pea loves and a place I generally try to avoid (the snake thing...). She walked to the edge of the pond and started to collect an olive-green creeper that lay all around the surface of the water. She collected two large handfuls, gave one to me, and then we walked back.

By the time we reached the barn, everyone else had gathered and started to lay out food for lunch. With sister-in-law Doi's help, Pea first rinsed off the greens and then started to strip off the outside skin of each. As always, she passed me one to taste, and sure enough, it was sweet and delicious.

Food started to assemble. Everyone had brought a lunch, but all the food was put out together to be eaten by everyone. It was a feast, and all of it—or almost all of it—wild and foraged! There were tiny crickets (*jingreet*) that Doi brought that were particularly delicious. There was a soup-like dish made from tamarind leaves, which was also flat-out yummy. There was a frog curry made by Pea that was, of course, super hot (Pea cooks and eats *extremely* hot food, even compared with others in the village). There were tree leaves, raw and steamed, maybe six different varieties altogether. There were at least three different *nam priks*.

If lunch can be a powerful experience, this lunch was a powerful experience. Here we were harvesting a family's fields of rice and eating rice that had been harvested from these same fields. And to eat with the rice: crickets and frogs, tree leaves and fish, everything free, foraged and sustainable.

After lunch everyone went back to work, the day now hot and hard, but everyone stayed happy. I lay down on a pile of rice straw in the barn to take a 30-minute sleep, but I got bitten badly on my neck and arms by who knows what, waking me up in a not so happy way. Three days ago I'd been working at the farm to get ready for harvest, and I'd put out my lower back, something I hadn't done for a long time. But three different people stopped by the house for *nuet*, massage (three people with very strong hands and a lot of experience), so between my new bites and a still creaky back...anyway.

By eight o'clock we were all asleep.

Pad Pak Kanaa

STIR-FRIED GAI LAN ("CHINESE KALE")

PAK KANAA (BRASSICA OLERACEA), GAI LAN (SOMETIMES SOLD AS "CHINESE kale"), is one of my favorite foods. It grows easily in the garden and is almost always available. It's a sturdy, leafy vegetable, dark green in color. It looks like the leaves on a broccoli plant, only it doesn't flower in the same way as broccoli. *Kanaa* is eaten commonly all across Thailand, often used in mixed fried vegetables (*pad pak*) and in *laad na* (rice noodles in a dark gravy sauce).

Pea's version is simple to make and loaded with fresh whole garlic (garlic almost being used as a vegetable). There is no chile heat. Serve it as a side dish in a meal with rice. *Pak kanaa* is easy to find in any Asian grocery with fresh produce. The best substitute would be kale.

1 lb (455 gr) *pak kanaa* (gai lan, or "Chinese kale")

1 Tbsp (15 mL) vegetable oil

¼ cup (60 mL) lightly chopped fresh garlic

1 Tbsp (15 mL) fish sauce

1 Tbsp (15 mL) oyster sauce

1. Wash the *pak kanaa* and then cut into large pieces, about 3 in (7.5 cm) long.

2. Heat a wok over high heat. Pour in the oil and swirl around. Toss in the garlic and fry for about 1 minute, until the garlic starts to soften and begins to brown.

3. Toss in the *pak kanaa* and stir-fry until the leaves cook down and soften. (It is a much hardier green than spinach, for example. It won't go limp.) Stir-fry for about 4 minutes.

4. Add the fish sauce and stir to combine. Then add the oyster sauce and continue to stir-fry for another 30 seconds. Turn out on a plate and serve.

MAKES THREE TO FOUR SERVINGS AS A SIDE DISH

gung

Tonight we ate *morgita*, something not unlike hot pot in Sichuan Province. It seems to have arrived in Thailand the way the hula hoop arrived in Laramie, Wyoming, when I was a kid—it's everywhere, and it's popular! Someone told me that it started here as Korean barbecue and then morphed in its own Thai way. It basically consists of a raised brazier, shaped like an upside-down bowl, and around the circumference is a trough for soup. The brazier is put on top of charcoal, and then the whole thing gets very hot. People sit around the *morgita* putting meat onto the grill and vegetables into the broth. It's good, and Pea *loves* it (which I find interesting, because it is so unlike *her* food, *nam prik* and *pak*).

Serving the home version is a special occasion not unlike a Sunday evening roast around the time of the hula hoop. Pea calls her sister-in-law Doi, and Doi bicycles over with her children Tey and Ip. Our neighbors Ahn, Aht and baby Off are invited, and inevitably even more people turn up. Everyone sits around together, cooking and eating, and of course yak-yakking (a word that somehow, unbelievably, has worked its way into Thai).

Tonight, for the first time, I became aware of Gung (Pea's daughter) addressing Doi, her aunt, her closest of five aunts, as "Mae," or mother. Pea, busy eating and cooking, interrupted and said in Thai, not in Khmer, "I am your mother, too."

Gung shot Pea a quick sharp glance (like mother, like daughter), and again in Thai, said *arrai gor dai* ("what-*ever*").

Gung's skin color is black, black as black (in a Thai context), blacker than her mother who, on a Thai scale of things is very black (in Thailand people tend to be very "color" conscious, as in "black" are people who work outside for a living, and "white" are city folk, educated, wealthy). Gung's father was from Cambodia. He and Pea first met when they were working together on a construction site in Bangkok in their early 20s, they fell in love and after some years had Gung. But he was a citizen of Cambodia, not of

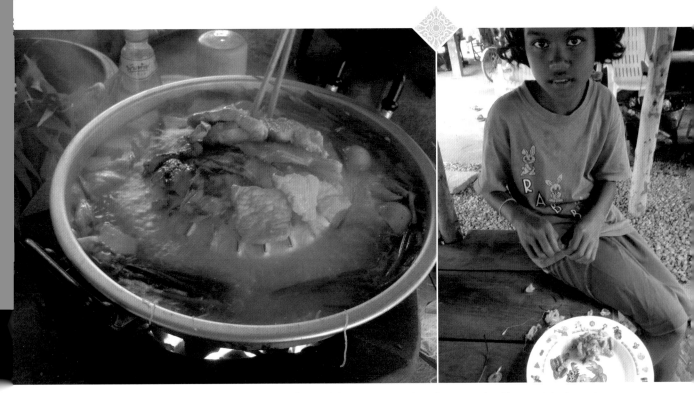

Left: Korean barbecue, Thai-style, is called *morgita*. It's a meal that everyone cooks and eats together. The meat is barbecued on top of the raised brazier, and the trough surrounding it holds a broth used to cook cellophane noodles, mushrooms, green leafy vegetables, or almost anything. Right: Gung is sitting in the bamboo hut with a funny look on her face. Maybe the funny look is on account of the silk larvae she's eating: sometimes the silk gets caught in between your teeth.

Thailand, and Thai immigration would routinely send him back to Cambodia. And then one time he never came back. Gung was two, and Pea was devastated.

Gung never really knew her father. From the first day I arrived in Kravan, for Gung I'm "*Pa*," not unlike Doi, who is sometimes "*Mae*." Gung's whole life has been spent here in Kravan. Pea went away to the city to work as a young teenager (first in construction, and later in a garment factory), to send money back home, just like millions of other rural young people in northeastern Thailand.

Pea's mother, Mae, has been in many ways more a mother to Gung than Pea has. But only in practical terms, not emotional. Their relationship (among the three of them), and the millions of other relationships just like it in northeastern Thailand, is a book, but not one I can write!

Gung, like her mother, has a smile that makes me melt. She laughs, she jokes, she wears pink most every day after school and she's as tough as nails. She's top of her class (her cousin Tey, son of Doi, is running a close second), and she can fell a 25-foot eucalyptus with a machete.

Khao Pad

FRIED RICE

PEA JUST CAME IN CARRYING A SMALL WASP NEST. "YOU KNOW THESE?" she asked. "When they bite they hurt very much." She started to pull the wasps out one by one, all alive and some about to fly away. "You can eat them."

"You eat these?" I asked, not believing.

"No," she responded. "These too old. Eat when baby."

Sometimes, here in Kravan, I stick to eating the things I know, like *khao pad* (fried rice). I've been eating *khao pad* in Thailand for 35 years, and I still love it. But I don't think I have ever seen Pea cook or eat a plate of fried rice, and I doubt that I ever will. Gung will eat fried rice. If I'm cooking a plate for myself I will often ask her if she wants some and cook two plates. And she will do the same. But with Pea, there's no way. It's not that she thinks we're crazy, but she'll no more eat fried rice than she'll eat Camembert cheese. She eats rice when it's freshly cooked, but after that, never, which may be partly the reason she cooks only small amounts of rice at a time (see Rice, page 107).

Making fried rice is the classic Thai way of using leftover rice. Here's my basic recipe.

1½ Tbsp (22 mL) vegetable oil

5 cloves garlic, minced

¼ cup (60 mL) minced or finely chopped pork

2 cups (475 mL) cooked rice, cooled

2 green onions, finely chopped

1 medium tomato, cut into chunks

2 tsp (10 mL) fish sauce

GARNISH:

Cucumber slices

Lime wedge

Fresh coriander leaf

Whole green onion

Nam Prik Pla (Chile Paste with Fish, page 36)

1. Heat a large wok over high heat. When hot, add the oil and swirl around. When the oil is hot, toss in the garlic and stir-fry quickly until it just starts to turn brown.

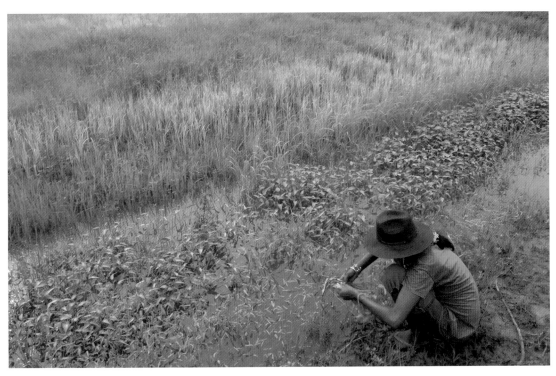

On the edge of the rice field, Pea forages for *pak boong*.

2. Toss in the pork and cook until it changes color (about 1 minute).
 Toss in the rice, and with a spatula, move the rice around constantly,
 bringing all the rice into contact with the hot wok. Cook for 1 to
 2 minutes, until all the rice is hot.

3. Add the green onions, tomato and fish sauce and continue to stir-fry,
 about 1 minute more.

4. Turn out onto a medium-size dinner plate and garnish as desired.
 Serve with *nam prik pla*, a simple, delicious condiment.

MAKES ONE SERVING

Nam Prik Pla

CHILE PASTE WITH FISH

JUST THE OTHER DAY IT HIT ME LIKE A THUNDERBOLT: PEA COOKS SLOWLY! One reason that she cooks on the floor is because what she cooks, and how she cooks, takes a lot of time, and better to do it in a relaxed way on the floor. Two of the largest agricultural products in Thailand, by the tonnage, are shallots and garlic. I have read that Thais eat more garlic than any other nationality in the world (followed by Koreans), and I don't know if that is true or not, but there's never a time in this house when there aren't pounds and pounds of shallots and garlic, all hanging in beautiful braids along the walls or between the rafters. With camera at hand I'm quick to take a picture. To me the braids look so beautiful: quaint, rustic, artisanal. But here they are none of that. They're a sizable ingredient in almost all dishes prepared (especially *nam priks*).

Garlic and shallots (both of which here are very small and especially good) take a long time to peel and then to grind or to slice. Pea sits on the floor patiently peeling 20 shallots, and then she turns to the garlic. In the garden she goes out collecting tiny bird's eye chiles, and maybe holy basil, lemongrass. Pea doesn't move slowly, but she doesn't move quickly, and it's the same for when she's at the farm, or in the market. She works hard, damn hard, but not quickly. And the same is true for Mae.

I first learned kitchen technique as a line cook in the United States, a big chef knife in hand. The point was to learn to cook quickly, and to sauté quickly (I was never very good at it).

Pea cooks slowly.

This *nam prik* is the simplest of what are dozens of different *nam priks* (chile pastes) that Pea makes. It's a kind of core recipe, as all *nam priks* start off with chiles, garlic and shallots.

5–6 fresh bird's eye chiles (or 2–3 for a not-so-hot version)	1 Tbsp (15 mL) salt
7–8 shallots	1 cup (250 mL) grilled or steamed fish
7–8 garlic cloves	

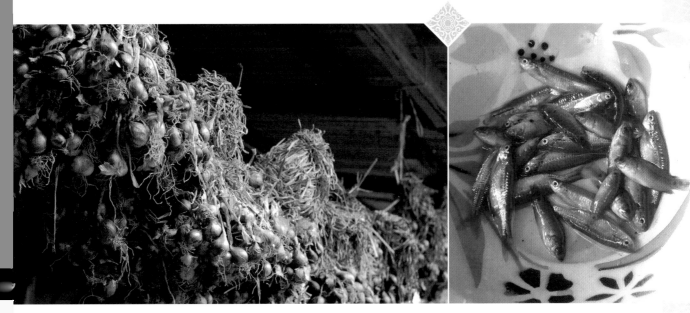

Left: Without shallots, *nam prik* wouldn't be *nam prik*. Shallots are as essential as garlic and chiles, and around here that's very essential! They are usually hung to dry further after purchasing. Right: These tiny fish will be pounded with garlic, shallots and chiles to add the *pla* to *nam prik pla*.

1. Place a heavy wok over medium-low heat. Put in the chiles, shallots and garlic. With a wooden spoon or spatula, move the ingredients around slowly. You want to lightly brown the ingredients, but not burn them. It will take 4 to 5 minutes. Remove from heat and allow to cool.

2. When cool, take off the chile stems and discard. Peel the shallots and garlic and put all together in a large Thai-style mortar and pestle (a food processor or blender can also be used). Add salt and then grind with the mortar. Use the salt to help break down the other ingredients. Pound until a paste starts to form.

3. Add the cooked fish and continue to pound. Mix thoroughly. Turn out into a small bowl and serve with *Pak* (Vegetable Platter, page 21).

MAKES ABOUT 1 CUP (250 ML)

lao khao with herb

Where to begin about *lao khao*? *Lao* means alcohol, booze, whisky, basically anything that isn't beer. *Khao* means "white." White whisky. All across Thailand you can go into a store at any time of the day or night and buy a bottle of *lao khao*. It generally comes in two sizes: one is 21 oz (621 mL), and the smaller, 11 oz (325 mL). The bottles are dark brown with a pale blue label with writing and sheaves of rice printed in red. I'm not an aficionado when it comes to *lao khao*, but I suspect that by the time this book is finished, I will be!

In one form or another, *lao khao* is drunk not just in Thailand and Laos, but in Cambodia, Yunnan Province in China, and probably, I would guess, about anywhere people grow rice as a staple food. In Thailand it is centrally manufactured, but in many places it's made locally, village by village. Even here some people manufacture it locally, basically as moonshine.

In Thailand there is a 30 percent alcohol version, and a 40 percent. When you're listening to a Thai or Lao conversation in a rural area, and you hear the word "percent" (borrowed from English), chances are people are talking about *lao khao*. A small bottle costs about 45 to 50 *baht* (about a dollar fifty), a large one, approximately 90 *baht* (a little less than 3 dollars). The equivalent-size bottle (the larger) of local beer costs 45 to 50 *baht*, about half the price, but is only 5 percent alcohol. The cheapest bang for your *baht* is obviously *lao khao*.

But the popularity of *lao khao* is about much more than its price. It's as central to rural Thai culture—and especially to Isaan culture—as Guinness beer is to the culture of Ireland. Some people refer to it as Thai tequila, and the comparison is in some ways valid. *Lao khao* certainly tastes more like tequila than it does vodka, rum, whisky or gin. And like tequila, it's most often drunk neat and by the shot. One person will have a bottle and a small glass, and will be in charge of pouring shots and offering the glass to others.

A common time to drink in rural areas is right around four-thirty to five in the afternoon, signifying that the workday is coming to an end. During

the long month of harvest, or in the busy season of planting, having *lao khao* on hand is absolutely imperative. Around four-thirty everyone will stop work, sit in the shade, drink a few shots of *lao khao* and then head back to the field for a few minutes' more work.

Another favorite time to drink a few shots of *lao khao* is first thing in the morning, kind of like an early morning coffee. Here in Kravan most everyone, including Pea and Gung, wake at five, five-thirty. By dawn (being this close to the equator, there's not much difference between the longest day of the year and the shortest) the village is very much active and alive. People yell from house to house, courtyard to courtyard, making noise together with the chickens.

It's a busy time of day in this house particularly because Mae and Kaesorn (Pea's eldest sister) operate a small shop from the front of the house. A big part of their business is selling *lao khao* by the glass, 10 *baht* (30 cents) for a shot. They have a dedicated clientele, a little bit like a stand-up bar in Italy. A carpenter on his way to a job site, senior citizens getting together for a chat, a farmer heading to work in the fields—everyone stops in and takes time to chat. It's not like Mae's is the only shop in the village selling *lao khao*; there are many, perhaps one per village block.

I remember when I first came here to the village, and not wanting to miss a thing, I'd wake up early and struggle down the long wooden stairs to where everyone was gathered. I've *never* been an early riser, never, and especially in Thailand. The sight of so many cheerful, energetic people was almost appalling to me, but then up walked Pea.

"You want whisky?"

"Whisky!"

"*Lao khao*, with herb."

"With herb?"

Pea disappeared before I could say another word, and reappeared with a glass filled to the top with a dark brown liquid. She motioned for me to try it, and I did. It was delicious. There was nothing sweet about it, but it tasted a little bit like coffee mixed with liquor, only with a somewhat thicker consistency.

We now drink it nearly every day, sometimes first thing in the morning, sometimes just before bed. The "herb" is a Chinese ginseng extract, and it comes in a bottle that looks a lot like the *lao khao* bottles, only written in Chinese. Pea pours about a shot of *lao khao*, then fills the rest of the glass with herb. The ginseng extract costs about 15 *baht* a bottle, which is cheap, but, to my knowledge, it's only available in this local region. Whenever we go to Bangkok we take three or four bottles to give to friends who come from this region. It's a much-appreciated gift.

My coffee consumption is definitely down, almost to the point of disappearing. Tea is nonexistent here in the village.

Gap Glem
DRINKING FOODS

WE JUST CAME HOME FROM YET ANOTHER CEREMONY, OR MAYBE "PARTY" is a better word. A neighbor, Nee, just finished an addition to her house. It looks like a carport but she doesn't have a car. It cost about the equivalent of 1,000 American dollars, and consists of a steel roof set high on concrete pillars. The structure is about the same square footage as her small cinder-block house, and under the steel roof she built an outdoor shower and toilet, as well as an outdoor kitchen. I think she did a really good job because shade is everything here in Kravan, and she just created lots of it! Eventually she will have a kitchen garden (lemongrass, galangal, chiles, shallots, garlic) right beside the outdoor kitchen, and on three sides of the new structure she'll hang orchids and terrace beans. Within a few months all the newly created shade will be surrounded by green.

But like so many other events here (anything from buying a new bicycle to going on a long trip to finishing a large project), a ceremony had to take place. From what I understand, the ceremony in this case has three main purposes: to protect and bring good luck to the new structure; to show gratitude to the people who helped make the structure; and to have a party. A small pig would be slaughtered early in the afternoon, and many people were already assembled to help with the work of slaughtering the pig. There was beer, Coke and Fanta, and shots of *lao khao* were passed around for anyone who wanted something a little stronger. The noise level inside the new structure immediately went up.

The event was like a wedding, only smaller. And people didn't expect a meal, only *gap glem*. Gap glem—or "drinking foods"—are a tradition all across Thailand, but many of the most famous come from here in Isaan. Many *gap glem* are what Westerners would call very spicy salads. You can make a spicy salad (called a *yam*) with almost anything (such as *Yam Tua Plu*—Winged Bean Salad, page 74; *Yam Hoi Kraeng*—Spicy Salad with Cockles, page 52; *Laab Moo*—Spicy Ground Pork, page 88). The point is that they are spicy and big on flavor. They come served one dish at a time, meant to be eaten with drinks, over the duration of the party.

The slaughtered pig was the source of most of the *gap glem* today. Pea brought around one dish early on, consisting of soupy fresh blood, slivers of fresh raw meat, *Khao Khua* (Roasted Rice Powder, page 159), slivered green onions and a ton of fresh, finely cut bird's eye chiles. One spoonful was all that I could do.

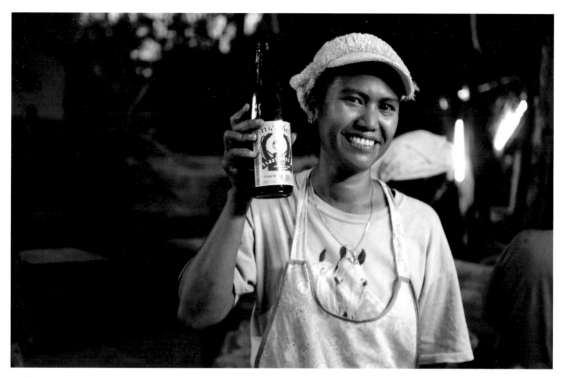

Pea's best friend, Nee, is not at all shy about drinking *lao khao*. This bottle of *lao khao* is the large size.

But the next dish was a *laab moo* (spicy minced pork, see page 88), loaded with fresh green herbs and finely chopped shallots, particularly delicious.

Early afternoon merged into late afternoon, and then into evening—the party gained steam as time passed. There was a ceremony (conducted by my neighbor, who oversees almost every ceremony), with Nee and several of the elders in the village, Mae included. Yellow strings were tied around the wrists of the women for good luck. Most people didn't pay much attention to the ceremony. They were too busy eating and talking. Eventually a few pairs of drums arrived, and by dark the party was in full swing: eating, singing and dancing.

The *gap glem* never stopped, and neither did the *lao khao* and beer. As people were starting to drift home, a *tom yam moo* arrived, bowls of hot soup for anyone who was still hungry. It tasted so great—the lemongrass, the chile heat.

khmer

Pea's family is Khmer, as are almost all the families here in Kravan. They're born in Thailand, all are Thai citizens and everyone (or most everyone) can speak Thai. But when people get together they speak Khmer, a language not at all related to Thai. Thai is part of the Tai-Kadai language family, and Khmer is part of the Mon-Khmer language family. But here in this part of Thailand, Khmer speakers will use a lot of Thai and Lao words when speaking Khmer, a phenomenon unique to here. In Thai, the language from neighboring Cambodia, or Kampuchea, is called *phasa Kamin*, but Khmer people here call themselves Khmer, and their language *phasa Khmer*.

There are 78 households in Kravan, approximately 250 people, almost all of whom are ethnically Khmer (having no relationship whatsoever to the Khmer Rouge, or "Red Khmer," the ruling Communist party in Cambodia during the mid-'70s—as in Pol Pot and *The Killing Field*). It's the same for the neighboring village, and for almost all of the villages in this region. There's one small city, Surin, 30 mi (48 km) from here, that is an urban hub for the region, and Surin is well known in Thailand as a Khmer city.

"Minority populations" are not uncommon in Thailand, even though it is by and large a very homogeneous nation. There are hill tribe people throughout northern Thailand, people who have spilled over into Thailand from neighboring Burma, Laos and southern China. In the northern part of Isaan there are Vietnamese who fled from the Battle of Dien Bien Phu in 1954 during the First Indochina War. In south Thailand there are Burmese in exile.

But in the case of the Khmer living here south of Surin, they are living on soil that has been Khmer for a much longer time than it has been "Thailand." Phanom Rung, one of the two most significant Khmer temples (both from the era of Angkor Wat, AD 1290), is about a 30-mi (48-km) drive west of here (the other major temple complex

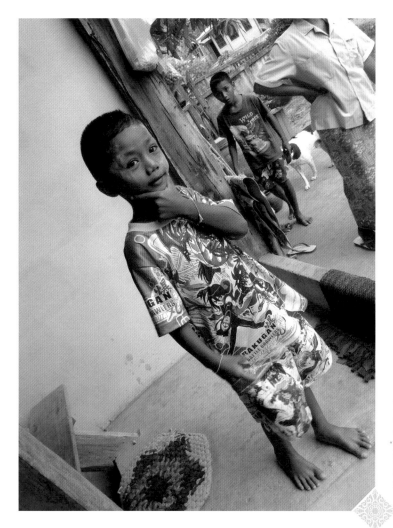

This is Ip, the youngest son of brother number two, Tat. After Pea's father died when she was 15, Tat stepped into the "father" role and works in Bangkok while his family lives in Kravan. His three sons are cousins to Gung, but more like brothers.

is Phimai). Angkor Wat, in neighboring Cambodia, is a two-hour drive away.

Pea speaks with Gung in Khmer and Thai, but Gung will almost never respond in Khmer. Mae, meanwhile, speaks very little Thai. Pea and I speak together in Thai and English. Gung and I speak together in Thai. For me, with language,

I struggle simply to keep my head barely above water. I arrived here with relatively okay central Thai, but with no Khmer. "Mae," Pea said one day, trying to explain to her mother, "when you speak to Jeff, think of him as the same age as Ip." At the time, Ip was three years old. It helped.

Hoi Lai Bai Horapa
CLAMS WITH BASIL AND GARLIC

There are several different kinds of clams that appear in the market, but *hoi lai* is everyone's favorite. Pea cooks *hoi lai* with a ton of garlic and basil (*horapa*), and it is so good.

I'VE GROWN ACCUSTOMED TO THE FOOD I EAT HERE BEING ALMOST TOTALLY unlike food I have ever eaten before, anywhere. Tonight Pea, Gung and I sat under the thatch, a small fan blowing from one corner. For dinner we had a large bowl of *hoi lai* (short neck clams) cooked with garlic and basil (*horapa* in Thai), absolutely delicious. There was another bowl with large steamed crickets that Pea had bought from the Cambodian market on Saturday, and all three of us agreed that they were the best yet. There was also one plate of rice for the three of us, piled high with rice from the bottom of the pot, all of it a lightly crusted brown. We could take a handful of rice, as if it were sticky rice, and dip it into the *nam prik* left over from lunch.

But tonight, for some reason, both Gung and I ate very little rice, perhaps so as not to waste a single mouthful on anything but the crickets and the clams. Both were *so* savory, so full of flavor. The crickets, salty and oily (there's no oil added; it's just the natural oil of the crickets), and the clams, a great balance of big flavors. At one point I smiled to myself, thinking of eating the crickets and

the clams as bar food in a fancy New York City bar, sipping a martini. Such an incredible hit they would be!

Often these last few months, like tonight, I don't eat any rice. And it's not about the rice, because the rice is great. It's somehow about me and my body. My whole life I've eaten primarily bread and rice, sometimes almost *exclusively* bread and rice. In Kravan, bread is nonexistent, but it's not something I crave. In some ways I'm eating exactly the opposite of what I used to eat. I used to fill up on carbohydrates and eat a tiny bit of the proteins. But now, like tonight, I will eat only the proteins. I won't eat a lot; I seldom overeat anymore, especially here with such intense heat in the day.

After dinner Pea and I sat back against two of the four tall eucalyptus poles that support the thatch, not talking, just enjoying the night in silence. Gung did her homework. The village was quiet and dark, as it is almost every night from around eight o'clock. There are no streetlights, no sidewalks, and seldom a motorcycle or a car. People turn in early. In Kravan, quiet can be *very* quiet, and dark, especially without a moon, can be *very* dark!

There are no martinis, no fancy bars. But it's a good place.

1 Tbsp (15 mL) vegetable oil	1 tsp (5 mL) salt
3/4 cup (180 mL) roughly chopped fresh garlic	1 tsp (5 mL) fish sauce
	Handful fresh basil (*horapa*)
2 lbs (910 gr) *hoi lai* (short neck clams)	2 Tbsp (30 mL) oyster sauce

1. Heat a wok over high heat. Pour in the oil, then add the garlic. Stir-fry until the garlic starts to go light brown, about 1 minute.

2. Toss in the clams, and then the salt and fish sauce. Cook 4 to 5 minutes, stirring the clams as needed. The shells will start to turn a yellowish brown (and they open). There will be more moisture in the wok from the clams.

3. Add the basil and stir to mix. Add the oyster sauce and cook for another minute to blend into the other flavors. Discard any unopened clams, transfer to a bowl and serve.

MAKES THREE TO FOUR SERVINGS,
AS PART OF A LARGER MEAL

the rice is in

I'm pooped. Everyone's pooped, but happy. Pea got 22 bags of rice from her four small fields. Each bag weighs 200 lbs (90 kg), which makes about 4,400 lbs (2,000 kg) of rice altogether. If she were to sell the rice right now (which she won't, because the price increases the longer she can wait) she would get approximately 8 *baht* per pound (there are 30 *baht* to an American dollar), which makes her rice worth approximately 36,000 *baht*, or 1,200 dollars. Given the fact that the average household yearly income in our province is approximately twice that amount, it's not bad for six months' work (the daily wage here is 150 *baht*—5 dollars a day for skilled labor). But of course the 1,200 dollars is not factoring in the cost of the seed, the cost of fertilizer (which here is applied only once, and is straight nitrogen) or the cost of the harvest.

We cut Pea's rice by hand (not with a tractor), nearly two and a half weeks after first helping to cut Mae's sister's rice. When harvesting rice by hand, you work your way through the golden-yellow rice (which is about three to four feet high), gather together a bundle of rice straw using your free hand and sickle, then cut it free. Twelve of us worked: mother, sister, sister-in-law, nephew, neighbors—Eit, Dom, Yaa, etc. Anyone that wasn't family Pea had to pay 150 *baht*. She was also responsible for providing lunch, and at four-thirty in the afternoon (as is customary), pouring glasses of *lao khao* and beer, Coke and Fanta. By four-thirty the heat of the day was finally starting to retreat, and everyone knew that the day's work was nearly finished. A glass of beer or a shot of *lao khao* tasted mighty good!

We all sat in the shade of the enormous *mai traat* that towers over the intersection of Pea's four fields. There was, as always, a lot of joking, everyone sitting with their sickle slung over their shoulder or tied at their waist. There was a lot of

joking about how bad I was at harvesting, but I knew that no one really cared; a body is a body. Most of the joking revolved around *jukitan*, the grasshoppers. One of the big treats of harvesting rice by hand is that you can forage for grasshoppers at the same time. Everyone except me had a plastic bag tied at their waist, and every bag was filled with grasshoppers, though some much more than others. Pea, of course, was by far the best, and I, of course, the worst. I'd finally mastered the art of catching fish by hand, but I never managed to snare a single grasshopper!

After the break we all started in again, working in one long line, the end in sight. When you cut one bundle, and then another and another, then you take one length of rice straw and tie it around to gather all the rice tidily together, and then lay it down flat on the stubble of the area where you have just come through. One of the major reasons to cut by hand instead of using a tractor is that the rice dries directly on the fields. If you cut with a tractor—a harvester—then the rice must be dried immediately after, a task that involves several days of extra labor (which Pea steadfastly refuses to do). The customary way to dry rice harvested by a tractor is to lay it out flat on tarps set out on a road, and throughout the day to rake it so that it all gets exposed to the heat of the sun. Rice that is cut by hand simply dries on its own on the field, and when it has sufficiently dried out, a large threshing machine is brought to the site and all the bundles are collected by hand and fed into the thresher, and from the thresher the rice goes straight into bags.

After our break we worked for another hour and then we were finished, everyone making their way by motorbike, by bicycle, by cart back to the village. By the time we got home it was dark. I went for a shower (I have a shower outside…) and Pea immediately set to work cooking the grasshoppers. Then we sat in the thatch and had a cold beer.

Two days later Pea's uncle passed away, and on the same day his daughter, Gai, gave birth to her first child, a son named Boy.

CHAPTER TWO

daily life

the chicken in the mango tree

I've never lived this closely with chickens in my whole life. Sometimes they drive me crazy, but most of the time I find them likable, and definitely intriguing. I read in my agriculture "bible," a book called *Permaculture* by Australian Bill Mollison, that when chickens and dogs are raised side by side, the dogs won't attack the chickens. Here that is definitely the case. They sometimes get in each other's way, and when they do, the dog will usually growl, and the chicken will retreat. But they have enormous tolerance for each other and occasionally actually play with one another.

Another thing I learned about chickens in Mollison's book (I learn *everything* in Mollison's book) is that chickens are ideal redistributors of seeds. They eat and poo, eat and poo, constantly, and if they are let free to roam (as they are here), the seeds are forever on the move, which helps make for greater plant diversity over a larger area.

But there's one thing about chickens that Mollison does not explain. One particular chicken here, every night at dusk (like clockwork), goes to the base of the large old mango tree, ruffles its feathers, and then leaps (I can't call it flying) to the first large branch of the mango, and then with lots of commotion—squawking and more ruffling around—it finds a good position and settles in for the night.

All the other chickens sleep together under the rice barn, protected by chicken wire. Only one chicken sleeps in the mango tree.

Yam Hoi Kraeng
SPICY SALAD WITH COCKLES

I DON'T REMEMBER EVER EATING COCKLES BEFORE COMING TO KRAVAN. I once lived eight months on the Dingle Peninsula in southwest Ireland, and I remember that people there would forage for cockles and periwinkles, but I was nineteen years old and a picky eater from landlocked Laramie, Wyoming. I didn't try them.

Here we often eat *hoi kraeng,* which we buy at the Thursday afternoon market when available. Like the small Thai oysters (see *Hoi Nang Rom,* page 132) and the short neck clams (see *Hoi Lai Bai Horapa,* page 44), the cockles are brought to the village on ice from the sea, where they are farmed. When Pea first bought and cooked them, I found them delicious, but I had no idea what they were.

One trip to Bangkok, I finally sat behind a computer with high-speed internet, determined to find out about *hoi kraeng.* I must have had some notion of cockles, because I typed in "cockle" and bingo, there it was! It has an unmistakable shell: fluted and about an inch wide. But as I read further I was once again confused. The cockles that we eat are red inside, not white. When we buy them at the market they have to be open and the deep-red meat inside very much exposed. If a shell is closed, it's tossed away. When Pea cooks them, they then close their shells tight. The cockles I was reading about, cockles from the United Kingdom, are white in color, and behave in exactly the opposite way. They are closed going into the pot and open coming out!

The cockles we eat here in Kravan, I now know, are called blood cockles (*Anadara granosa*). The deep red color inside is from a form of hemoglobin found inside the cockle. Thanks to the wonder of the internet, I now understand that blood cockles are a food that some people feel very strongly about. A writer from Singapore said that whenever he's having a really bad day, he goes to a street vendor for blood cockles and a beer. But then when he's having a really good day, he also goes to the same vendor for cockles and a beer: to celebrate! It seems that many people won't eat blood cockles because of their obvious "bloody" look. That doesn't bother me, but every once in a while a certain large, strong-tasting mussel appears for sale, and that one I can't eat. And neither can Mae, as she admitted, laughing, one night: "I can't eat that," she said in Khmer. "It looks exactly like you know what."

Of the three foods from the sea that we eat regularly—oysters, clams and cockles—the cockles are by far the cheapest (though they are all relatively cheap). I don't know why. When they are around in abundance, Pea will make a *yam*, a spicy salad, using the cockle meat. It is, like all *yams*, classic *gap glem* ("drinking food").

2 lbs (910 gr) *hoi kraeng* (blood cockles)

4 cups (1 L) water

½ cup (120 mL) chopped shallots

2 Tbsp (30 mL) finely chopped lemongrass

2–3 fresh bird's eye chiles, sliced diagonally

2 Tbsp (30 mL) finely chopped green onion

1 small yellow onion, thinly sliced

2 Tbsp (30 mL) loosely chopped coriander leaf

2 garlic cloves, finely chopped

1 Tbsp (15 mL) fish sauce

1 tsp (5 mL) lime juice

Leaf lettuce to serve

1. To clean, soak the cockles in a large tub of water. If fresh from the market, the cockles will be open, the red cockle inside clearly visible.

2. Bring water to a boil. Drain the cockles, and then pour the hot water over them. Stir. The cockles will close their shells. Drain the water, and when cockles are cool, pick out the meat from the shell and put into a separate bowl.

3. If you haven't opened cockle shells before, insert both thumbnails into the opening of the shell and gently pry it open. It may take a few shells to get the hang of it, but soon it will be easy and fun.

4. Add all remaining ingredients (except lettuce) to the cockle meat and stir to combine. Taste and add more fish sauce or lime juice if desired. Serve over leaves of lettuce, or with *Khao Neeo* (Sticky Rice, page 174).

MAKES THREE TO FOUR SERVINGS AS AN APPETIZER

the gardens

Depending upon how I count them, there are roughly four different gardens here at the house in Kravan. The property is about a half acre in size, if that, but every piece of ground is growing something. I've come to think of the gardens as dividing into the back garden, two side gardens and the front garden. Most of my time is spent in the front garden, which when I first arrived was basically a trash heap. It was a place where I felt like I could be of help and, selfishly, a place where I felt like I could exercise some control. It's the place where our thatch hut is located (and now three thatch structures). It's worked out well so far because I can be social (as opposed to being asocial, which is not a good thing in the village) but still be "working," which I like.

On the two sides of the house, these are the gardens looked after mostly by Mae and Kaesorn. On the east side there's a wooden rice barn (where all the harvested rice is safely stored), a small stable for the four cows (in rainy season), and a pigpen with two pigs (all looked after mostly by Mae). There's a largish kitchen garden that used to drive Pea crazy because a stray cow or water buffalo was always getting in, and I've noticed that she's gradually letting Mae take control, no matter how out of control it gets. It's also on this side of the house where Kaesorn raises her crickets, which takes up a lot of room.

The west side of the house is a bit of a jungle. I've worked all around the house, trying to prune and to look after the trees—the mangoes, jackfruit, pomelo, star fruit, wild lime, lime, banana, guava, kapok, papaya, tamarind, coconut, dragon fruit, custard apple, drumstick, etc.—but it's along the west side that I've had the hardest time. There's massive undergrowth, some of which strangles the trees but also provides a small income for Mae. The most important undergrowth, or creeper, is the *papal* leaf, essential for chewing *maak* (see *Gin Maak*, page 110). Mae not only grows a large amount of the leaves, but she

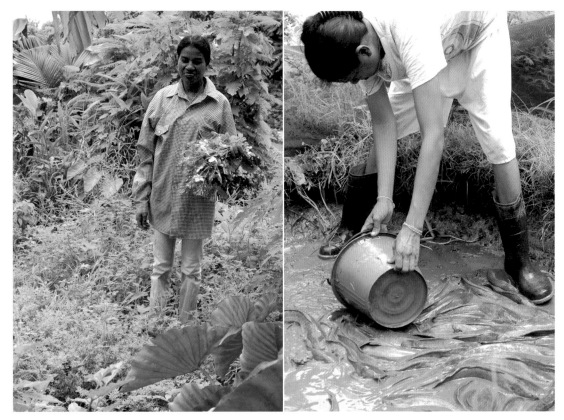

Left: In late May the garden is already a jungle. Pea collects greens to make an overnight pickle. Right: There are several fish-ponds in the backyard loaded with catfish. Pea is cleaning this pond, which must be done regularly, and she will also fetch a fish for supper.

has beautiful areca palms in the back garden for harvesting the betel nut.

On the west side Mae also harvests butterfly pea (*Clitoria ternatea*), a beautiful, deep-blue flower, from vines that entangle their way throughout the garden. Every day she picks the flowers and sun-dries them, but depending upon the weather, it takes at least two to three days for them to dry. When they are dry she packages them and sells them by the pound for the purpose of making homemade soaps and shampoos. There are also bananas, papayas and pineapples in this garden,

but the primary harvest is the undergrowth. The few times I've ventured into the west side garden, I've had to work quickly because of the ants, big and red, small and black, and small and red (the worst).

This morning I've just come in from the back garden, which is the most dynamic garden. The back garden belongs to Pea and Mae, though mostly to Pea. It's at least twice the size of the other gardens, and it enjoys a mix of bright sun and cool shade, making it a lovely place to be. Early on here I imagined building a small wooden "writing hut"

back amidst the towering areca palms, but now I realize that that will probably never happen (and shouldn't happen since this space is better utilized as a garden).

The back garden, together with the farm, I think of as Pea's "bio lab." Pea's not a person who talks that much, or I should say that she's not big on small talk. When I first met her I would often ask *khit arrai* ("what thinking?"), but she would only look at me with a blank stare. Now, through some experience, I realize that 90 percent of the time she's either thinking about the farm, the back garden, cooking or eating.

The back garden is divided into two separate large gardens, both well "walled" with fishnet strapped to bamboo and eucalyptus poles. These two gardens are not unlike a summer garden in Nebraska, only most of the vegetables are different. There are cucumbers and eggplants, both eaten very small, but the primary crops are Asian vegetables: yardlong beans, winged beans and several varieties of gourds and bitter melons. When they were just starting to grow, Pea brought in a large stack of bare tamarind branches, each one about 8 to 10 ft (2.5 to 3 m) tall, and placed them around the garden for the plants to grow up. I remember thinking at the time that she was being a bit optimistic, but all the plants and the vegetables now dangle way up over my head.

But the back garden is only partly about vegetables. There's now a fishpond dug into the ground, home to *pla duk, pla nin, pla mo, pla seu,* and *pla chorn* (but the *pla nin* are having trouble, as Pea suspected that they might). Adjacent to the fishpond is an identical pond for frogs (250 of them). Both ponds are netted off, and both are covered with coconut palm leaves to keep the water from overheating.

And, sorry to digress, but just this morning I was out in "my" garden (the front garden, the one with orchids, jasmine and gardenias) and Dam, one of the three nice dogs who live here, suddenly started to bark at two boys bicycling by. I yelled "tsi tsi" to Dam, like everyone always does, to stop the barking. But then a few minutes later Pea came up to me and told me that Dam always barks at that one boy, and that it's okay. "His family eat dog," said Pea.

Pad Taeng Gwa

STIR-FRIED CUCUMBERS

CUCUMBERS HERE ARE DIFFERENT FROM CUCUMBERS IN NORTH AMERICA. Here, they are small, usually about 4 in (10 cm) in length and 1 in (2.5 cm) in width. They're fabulous! Pea grows them in the back garden, and they grow abundantly. She will almost always put them out on the plate of *Pak* (Vegetable Platter, page 21), there to be munched on as is or dipped into a spicy *nam prik*. She will also, because they're so abundant, cook them as a simple stir-fry.

1 Tbsp (15 mL) vegetable oil

2 cloves garlic, minced

4 oz (110 gr) pork, finely sliced

1 Tbsp (15 mL) finely chopped Anaheim or other medium-hot chiles

1 lb (455 gr) small cucumbers (or substitute English cucumber), cut into ¼-in (0.6-cm) slices

1 Tbsp (15 mL) fish sauce

¼ cup (60 mL) water

1. Heat oil in a wok over medium-high heat. When hot add the garlic and stir-fry 30 seconds. Add the pork and stir-fry until it changes color, approximately 1 minute and 30 seconds.

2. Add the chiles and cucumber slices and cook for approximately 3 minutes, until the cucumbers have cooked through.

3. Add the fish sauce and water and increase the heat to high. Stir-fry until the water starts to reduce and the liquid thickens into a sauce. Transfer to a plate and serve.

MAKES THREE TO FOUR SERVINGS AS A SIDE DISH

Nam Bai Toey

PANDAN WATER

IN THE BACK GARDEN THERE'S A STAND OF PANDAN LEAF, *DOI HOM* (*Pandanus amaryllifolius*). Pandan is a long, straight, dark green leaf. I was excited when I first discovered it growing in the garden, because its fragrance is soothing and so essentially Thai for me. It's not as common now, but when I first lived in Bangkok in 1977, many small neighborhood restaurants had plastic pitchers of *nam bai toey* (pandan water) set out for free on every table. While I would sit waiting for my meal to arrive, I would pour a glass of *nam bai toey* and sit back happily. I had no idea at that time what pandan was or how it grew or what it looked like. But I sure liked the taste and the smell, and like many things here in Thailand, over time, it became something for me that was reassuring and familiar.

"How do you make *nam bai toey*?" I asked Pea one day.

She looked up and glared. *"Nam bai toey?"*

"Uh-huh."

"You boil."

I could tell that this was one I was going to have to do by myself. So later the same day I cut a handful of pandan leaves, rinsed them off and then brought a pot of water to a boil. I threw in the leaves and almost immediately the smell of the pandan began to fill the air.

I boiled them for about five minutes and then put the pot aside, covered, to let the water cool to room temperature. When the water cooled, I poured it into a pitcher and put it into the refrigerator, and an hour later I had a pitcher of *nam bai toey.* Easy as that.

But it made me start to wonder. When I first came to Thailand from India, I was used to being very cautious about drinking water. I would never eat a fresh salad, or drink something with ice. I'd been sick in India a lot and I had good reason to be careful. But Thailand was different. For one thing, there was bottled water everywhere, which wasn't the case on the subcontinent at the time. And almost instinctually I knew that here salads would be okay, and they were. I don't recall being sick once in those first five months in Bangkok.

The *nam bai toey*, I realized while making it here in Kravan, is boiled water, meaning safe water. Free safe water that smells and tastes great.

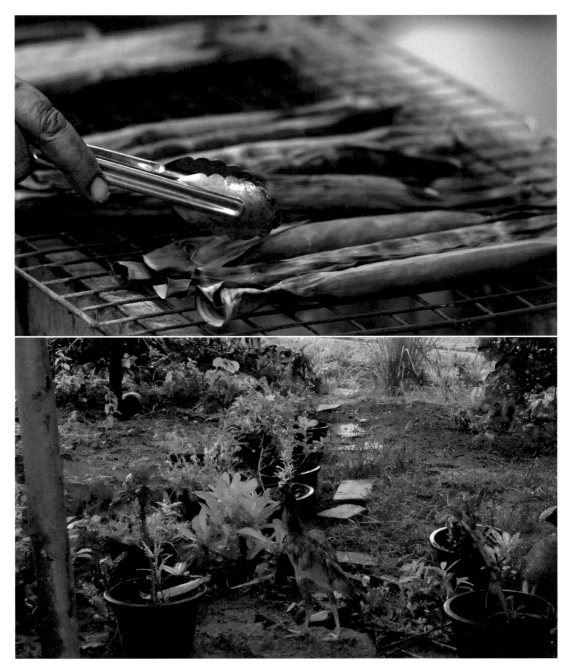

Top: This is but one of many different ways in which pandan leaf is used. Here it is wrapped around sticky rice, grated coconut and palm sugar before being put on the grill. Bottom: There are so many chickens and ducks at Mae's house that there is seldom a moment when they aren't around.

Pla Pao

GRILLED SALTED TILAPIA

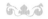

NO MATTER HOW MANY TIMES I EAT *PLA PAO*, I LOVE IT EVERY SINGLE time. There was recently a birthday party for our neighbor's daughter, Nam, who turned nine. Her mother asked Pea if she would grill *pla pao,* knowing that we have a large grill (we have several varieties of grills, but one is large and especially good for parties) and that Pea is a very good "griller." On the afternoon of the party she brought over four large *pla nin* (tilapia), already prepared with lemongrass inside and the outside skin caked in salt. They were large fish, about two pounds each, but the grill was large enough to cook them all at the same time. When they were done, a fish went to every table, where three or four people sat around and shared one fish.

The trick to making perfect *pla pao* is to grill them a long time—30 to 35 minutes—slowly. When I first watched Pea make *pla pao* I was startled at how long she cooked it, thinking that the long cooking time would dry out the fish. But it does just the opposite. The salt covering the skin of the fish works to keep the moisture in, as if the fish was being baked rather than grilled. Perfectly grilled *pla pao* should be tender and moist. The skin is peeled off (I sometimes eat a bit, even as salty as it is), and the succulent meat taken bite by bite, generally wrapped in a lettuce leaf or taken together with a green onion and coriander leaf, and then dipped in *nam jeem.*

1½ lbs (680 gr) fresh tilapia	3–4 Tbsp (45–60 mL) coarse salt
1 stalk lemongrass, cut into 3-in (7.5-cm) lengths	

1.	Start your charcoal or gas grill. Scrape the scales from the fish and cut into the bottom of the fish just enough so that you can clean out the guts, and then clean. Rinse with fresh water.

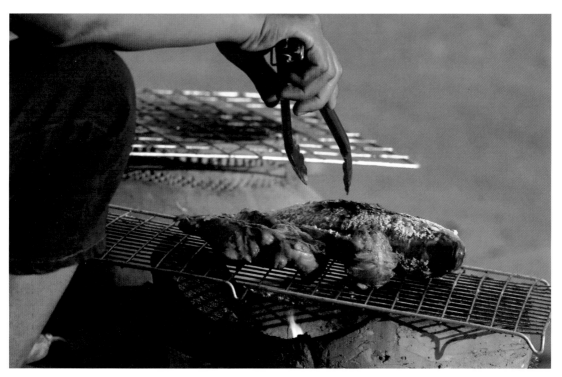

Salt-baked tilapia is a remarkable dish. The fish is grilled slowly for a long time and the salt keeps it tender and moist.

2. Put the 3-in (7.5-cm) lengths of lemongrass into the body cavity, pushing as far in as you can so that the lemongrass is completely inside. Put the fish on a plate and then spread the salt all across both sides of the fish and rub in.

3. Grill over a relatively low heat for 30 to 35 minutes. Serve with *Nam Jeem* (Fiery Fresh Chile Sauce, page 25), fresh coriander, leaf lettuce, green onion and slices of cucumber.

MAKES THREE TO FOUR SERVINGS

chong chom

Our big splurge comes on a Saturday, if possible, when we catch a lift to a market in a town called Chong Chom, which is the major border town in this region of Thailand near Cambodia.

The first time that we went, Pea told me that I had to be up by four-thirty in the morning in order to catch the truck. "Four-thirty," I complained (I hate waking up early), but it did no good. The next morning, dark as dark, I lay in bed thinking, Maybe I'll skip this market... But I got up out of bed, grabbed some money. Just outside the house a truck pulled up and a bunch of us climbed into the back.

Once we were on the road I was fine. Someone gave me a shot of *lao khao*. I sat hanging off from the back. It was almost even cold driving down the road and almost even fun to be up so long before dawn. We drove from Kravan to Kap Cheung, turned south toward Chong Chom and the first light of day began to fill the sky. About 30 minutes after leaving home, we arrived.

For anyone who was in Thailand during the era of the Khmer Rouge, and of the Communist insurgency here in Isaan and in southern Thailand, Chong Chom was famous—dangerously famous. On the other side of the border, the Cambodian side, the terrain gets instantly mountainous and jungled. Even on the Thai side, the area is hilly

and heavily forested, perfect for guerrilla warfare. But now in this relatively peaceful time, it's more famous for orchids, wild mushrooms and herbal medicines, all foraged from the forests.

It was just dawn as we climbed out of the truck. Around me everyone and everything was a photograph, but even more striking was a vein of excitement, of wildness! The market is huge and has many dimensions, but for an hour at dawn every Saturday it's a frenzy of buying and selling, and almost all of it has to do with food. Cambodians come across with red ant eggs, crickets, frogs, fruits, chickens, flowers and so many things that I have no idea what they are.

"What this?" I asked Pea, over and over during this, our first trip to "Cambodia" (as we call it). And Pea of course just glared. She didn't know, and if she knew, chances are she knew the Khmer name, not the Thai name.

At some point I strolled off the main road just a bit and ended up surrounded by scores of small shops with literally thousands of secondhand bicycles. I love old bicycles (almost up there with old patchwork quilts). I started to look, not entirely

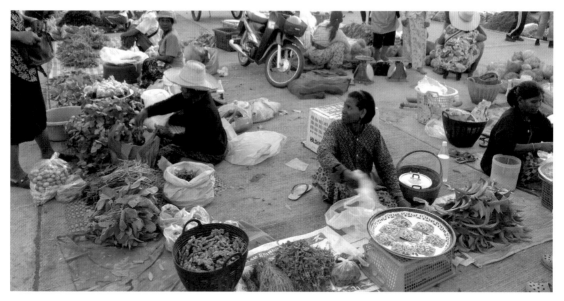

Chong Chom market is a short drive from Kravan and is always a fun place to be. At dawn on a Saturday it's packed with Cambodian vendors from the jungle just across the border selling wild mushrooms, orchids, crickets and grasshoppers and red ant eggs.

believing my eyes. I found a 20-year-old Miyata and a Gary Fisher, bikes that I would have given anything to have, but bikes that were way outside my price range when they were new. "*Gee baht?*" I asked in Thai. (How much?)

"*Sam pun.*" (Three thousand—a little less than 100 American dollars.)

I went to the next shop. My cell phone started to ring. I knew that it was Pea wondering where I was. "Five minutes," I said quickly and then closed the phone.

The next shop had a bright yellow Specialized Hardrock. *A Specialized Hardrock!*

I quickly paid the 3,000 *baht* (which seems to be the going rate at Chong Chom market for any bike that's good but older) and bicycled back through the market, back to the truck where everyone was already packing up to head home. It was exhilarating to be riding through the crowded market, but I also felt a little bit guilty. Three thousand *baht*

is a lot of money for us, and also I worried about how we'd get the bike home. But when I arrived at the truck, everyone beamed with smiles, including Pea. The driver grabbed the bike, jumped on and took off, yelling, "*Gee baht?*" as he rode away (a person *very* experienced on a bicycle). When I yelled back, "*Sam pun,*" he turned with a thumbs-up high in the air.

I don't own a lock. People take it for a spin regularly, especially the kids, and it always ends up back in its place against the wall. Maybe someday it might disappear, but I'd rather play it this way. There are hundreds of bicycles in Kravan, and I have definitely never seen one locked, and I've never heard of a bicycle being stolen. And, anyway, I'd just go back to "Cambodia" and buy another.

By the way, to get the bike home that day, the driver strapped it to the side of the pickup. No big deal.

Nam Sup
CHICKEN BROTH

PEA'S NATURAL WAY OF COOKING REVOLVES MORE AROUND GRILLING, steaming and frying than it does simmering, but every once in a while, especially when she knows that I am a little under the weather or needing a "taste of home," she will cook up a Thai version of chicken broth (*nam sup*). It's very simple, and it really does the trick. It smells great when cooking, and like *Som Tam* (Green Papaya Salad, page 18) or *nam prik* (chile paste, see page 36) for Pea, *nam sup* is comfort food for me. I will usually pour the hot broth over fresh, hot jasmine rice, and maybe garnish with finely chopped green onions and fresh coriander leaf.

½ pot water, approximately 4 cups (1 L)

Chicken bones, about 1 lb (455 gr) or whatever you have

½ cup (120 mL) fresh coriander roots

6–8 garlic cloves, smashed with a cleaver and skinned

1 large daikon radish, cut into 1-in (2.5-cm) slices

2 tsp (10 mL) salt

1. Bring the water to a boil over high heat. Toss in the chicken bones, coriander roots and garlic, and return to boil.

2. Reduce heat to simmer, and toss in the daikon and salt. Simmer for 90 minutes to 2 hours. Strain and serve (reserving the daikon radish for garnish).

MAKES ABOUT 4 CUPS (1 L)

free food

Poor is relative, so to speak. The first time I lived in Asia I left home with 2,200 American dollars, and I lived abroad for 17 months. Most of that nest egg went toward airfares. I had very little money, so I lived on very little. I spent about 70 dollars a month in India and 55 dollars a month in Sri Lanka over nine months in 1978–79. (But in just two months in India I would spend the equivalent of an average Indian's *yearly* income!)

One of the rare times when Mae is actually sitting, and not working.

When I arrived in Thailand people were relatively much better off than the people I had been living with in India and Sri Lanka. In Thailand many people owned motorcycles and refrigerators, not as common in India and Sri Lanka. The average yearly income was perhaps 600 to 700 dollars—five times that of a person on the subcontinent.

Two years later I spent nine months in Taiwan, and there it was again: in general, people seemed to be up another level on the income ladder. In Taiwan in 1980–81, the average yearly income was about 2,300 dollars. Most families in the city had a motorcycle, even a car. People had refrigerators and televisions, and children could continue much further in their education. Taiwan was on the

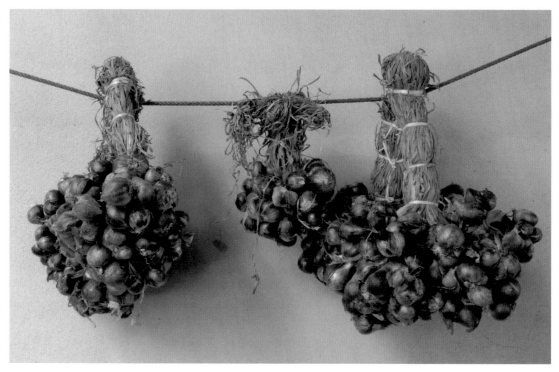

There is never a time when *hom daeng* (shallots) aren't hanging somewhere around the house.

verge of developing a "tiger economy," following in the footsteps of South Korea.

Today I live in rural Thailand, and though money is a big part of everyday life (especially for me, as a person from outside *with* money), I don't often think of people here as poor. Mae has raised eight children as a single parent, and all are alive. She has 10 grandchildren, all of whom are in school, and all of whom wear clean clothes to school each day. She's a landowner and has already transferred land to her children's names. Her second child (son number one) works hard and has a good job in Bangkok. Her third child owns a tractor (or at least together with the bank). Her fifth child (a daughter) has a partner who's a foreigner (me!). Her seventh works in Taiwan and dutifully sends money home every month. Her eighth works hard in Bangkok. (Her sixth, a son, is a black sheep, borrowing lots of money from everyone and never paying back. One out of eight's not bad.)

Mae has raised a good family. Everyone is relatively okay. But is the family relatively poor? *Yes!* And how do I know? I know through food. Tonight at dinner a *pla nin* (tilapia, a high-quality fish) feeds six. People pull back from eating when they're still hungry, leaving more for others.

Why are crabs, crickets, frogs and tree leaves so important? Because they are *free*! *Free food.*

Khai Jiao

OMELET WITH SHALLOTS

IN NORTH AMERICA I SELDOM EAT EGGS. I KNOW THAT NOWADAYS THERE are good eggs to be had from farmers' markets and the like, but I got out of the habit of eating eggs when all I had access to were supermarket eggs, eggs that had no taste. When I'm in Thailand, I eat a lot of eggs. To me, eggs here taste as they should—like eggs! The yolk is a deep yellow, almost orange. One of my favorite dishes is a plate of *Khao Pad* (Fried Rice, page 34) with a fried egg *(khai dao)* on top.

When Pea fries an egg, or cooks an omelet (as in this recipe), she cooks the eggs the same way all Thai cooks do: she deep-fries them. Or, well, it's not exactly "deep-frying," but sort of. She cooks the omelet in a wok, and there will be about half a cup of oil in the bottom of the wok. When the oil is hot, she drops the egg mixture down on the surface of the oil, the omelet starting to cook almost immediately upon hitting the oil. The omelet cooks very quickly (within a minute), turning once. It's not oily.

It is typically eaten on top of a serving of hot, plain jasmine rice. Sriracha is often drizzled over the top. (If you have never had sriracha, it's very easy to find in North American supermarkets.)

2 large eggs

1 tsp (5 mL) fish sauce

1 Tbsp (15 mL) finely chopped shallots

½ cup (120 mL) vegetable oil for frying

Sriracha, for garnish

1. In a bowl mix the eggs and fish sauce. Whisk to make a bit frothy. Mix in the shallots and set mixture aside.

2. Put a wok over high heat, and then pour in the oil. When the oil is hot pour the egg mixture into the oil (and stand back a bit to avoid spatters). The omelet will cook very quickly (depending upon your heat). Cook approximately 30 seconds, then turn and cook another 30 seconds. The egg will be lightly brown and crispy. When done turn out onto a plate of rice. Drizzle lightly with sriracha.

MAKES ONE SERVING

Nam Prik Gorp

CHILE PASTE WITH FROG

FROG IS A VERY IMPORTANT FOOD FOR PEA AND HER FAMILY, AND FOR THE village. Pea basically does three different things with frogs. If the frogs are tiny, about the size of a cricket (and generally these are frogs that she has caught herself, out foraging on rainy nights), she will grind them in a mortar and pestle, grinding them into a paste (*nam prik gorp*) with garlic, shallots, fish sauce, etc. The process is just like making *Nam Prik Pla* (Chile Paste with Fish, page 36), and the chile sauce has a similar consistency. It's put out with any number of foods that are accompaniments, foods that can scoop up or be dipped in the *nam prik*. The most common ones that Pea puts out are raw green onions, tiny sliced cucumbers, tree leaves (*cha-om, krathin, khilek*), red lotus stems (*sai boua* in Thai) foraged from irrigation canals at the farm and steamed purple banana-flower petals.

The second way Pea cooks tiny frogs is to boil them into a thin soup. She does this especially for Mae, because Mae's teeth are so bad that she has trouble eating pork or anything tough. The soup is easy for Mae to eat, and she loves the tiny frogs.

Another way that Pea cooks frog—and this by far is my favorite—is simply grilled. The frogs she grills are about 4 to 5 in (10 to 12 cm) in length. Frogs here get much bigger, but Pea thinks that when they get too big, the bones start to toughen up. She grills the entire frog, not just the legs. At first when I arrived in Kravan, I would only eat the legs, enjoying biting through the crisp baby feet and tender legs. But now I have come to like the entire frog, pulling off the meat from the body.

Frogs have been hard to forage the last few weeks, so yesterday Pea, Gung and I took the motorbike to a neighboring village where rumor had it that a family had a very successful frog farm going (usually, if purchasing large frogs, Pea will buy them on Saturdays at the Cambodian market). We got to the village, asked around, and sure enough ended up on a farm just outside of the village. It was a farm of the sort that I like the most: traditional, a little chaotic, every inch of the farm clearly given over to farming.

A man was sitting in the shade in front of the old wooden house, wearing a sarong but no shirt, carrying a little extra weight. He was sitting cross-legged,

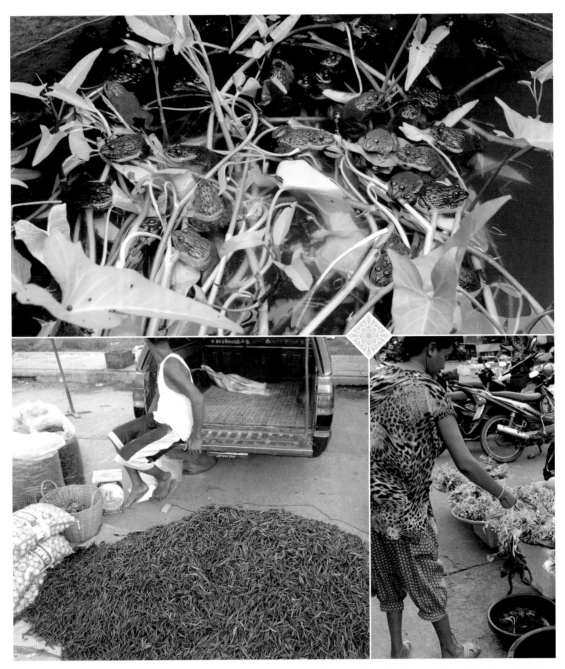

Top: *Pak boong* (water morning glory) grows everywhere: in the fish and frog ponds, and in the water alongside the road. Talk about free nutritious food! Bottom left: There are huge piles of chiles for sale in Chong Chom market. Bottom right: Pea doesn't often buy frogs, but every once in a while she can't resist. She will never, however, buy frogs that are not alive.

eating lunch. "Yes, we have frogs," he replied in Khmer, a big smile on his face. He was surprised, I think, to see a *farang* (the Thai word for "foreigner"). "Does he speak Khmer?" he asked Pea in Khmer.

"No," she replied in Thai. "Speak to him in Thai." Pea and Gung then disappeared back into the farm, leaving me to sit with the man while he finished eating lunch.

He was very nice. At first he spoke with me in very simple Thai, but soon we found a balance where we could speak together well. He had spent a year working in Taiwan (as many Thais do these days, trying to put together a small nest egg), so he also had some words in Mandarin and English.

"Do you like frogs?" he asked in Thai. "Do people in your country eat frogs? What jobs do people have in your country? Is it cold all the time? Can you grow rice?"

He was one of those people who you meet once in a while, anywhere and everywhere, people who are just fundamentally curious about the world. He finished eating, put on a shirt and then walked me back through the farm "yard" (for lack of a better word), past a stand of bananas interplanted with papaya, past a large stand of galangal, past a beautiful old rice barn. It was chaos, but organized chaos: a farm.

At last we got to a series of very large ponds, each pond containing 10 to 20 areas that were divided with fishnet, creating separate ponds within each pond. The small ponds contained frogs, hundreds of frogs, thousands of frogs, all at different stages of growth. I knew that Pea was in frog heaven.

"It takes about three months for the frogs to get big," he explained.

"Where do you sell them?" I asked.

"Only here," he replied, looking a little perplexed by the question.

It was an amazing sight. Like all farms raising fish, or pigs, or frogs or whatever, it wasn't beautiful. But it wasn't ugly. It smelled good. In the ponds there were all sorts of aquatic greens, as well as floating "platforms" for the frogs to climb onto (then immediately leap off from when a human approached).

The man's enthusiasm about his frogs was contagious (doubled by Pea's, who was videoing like crazy with our small digital camera, stealing ideas—a *kamoi*, "thief" in Thai). Pea ended up buying 7 lbs (3 kg), about a dollar a pound.

When we got back home all the neighbors immediately came over, everyone wanting to see the big bag of frogs. People reached into the bag, pulled out a frog, looked it over and then put it back, the whole time exclaiming wildly in Khmer. A few frogs were set aside for possibly laying eggs, but whether they were females about to lay eggs, or potential male fertilizers (I am as useless

with this stuff as I am with automobile engines), I had no idea and I didn't ask. There was also a white frog, an albino. And this frog too was put into a different basket. (There are several different versions of "frog baskets," all of them beautiful objects, all of them made of thick bamboo, designed to keep the frogs alive but confined. With frogs inside, the baskets are—in Pea's house—almost always kept in the shower room so that the frogs can have some moisture, but not too much. I first found out about "frog baskets" the hard way, thinking one day early on that I would clean the shower room. I had no idea at that point what a frog basket was, but I took the basket and turned it on end, making it easier to mop. The next day, most of the frogs were dead!)

As dusk came, and then dark, Pea was still preparing the frogs (and I was secretly hoping she was planning to grill the frogs, not pound them). She killed each one with a whap on the head with the back of a cleaver, and then with a fine cut on the belly, she reached in with both thumbs and stripped off the skin. With another cut, she then cleaned and gutted the frog, much like cleaning a fish. The innards are discarded, but the head, the legs and general shape of the body are left intact. She makes it look easy, but I'm sure it's not.

She took down two grilling baskets and then loaded them up (the grilling baskets are Pea's number one preferred method, by far, of grilling). She set them over the charcoal fires, each basket with its own *dtow* (Thai-style brazier) of charcoal. And then they grilled slowly, Pea very attentive the whole time.

By the time we ate, it was all worthwhile. "This is a very good day," Pea said through her beautiful smile, her eyes radiating. She'd also cooked *nomai* (bamboo shoot) and a *nam jeem*. But the meal was all about the frogs.

the produce truck

Twice a day an old pickup truck drives slowly by our house and everyone looks up. Isaan music can be heard playing in the cab, and the truck drives very slowly, like an ice cream truck, so everyone in the village knows to anticipate its arrival. Nung drives and Gai sits in the back, often accompanied by Sumpoo (aka "Pink," Gai's nine-year-old niece). Gai (now mother to baby Boy) is Pea's first cousin and lives just around the block in the village. But everyone in Kravan knows Nung and Gai. They drive the produce truck.

The back of the truck is fitted with an awning overhead (essential both in rainy season as cover from the rain and in hot season for shade from the heat of the sun) and bars that run horizontal to the back of the truck. Hanging from the bars of the awning, there are small bags filled with food that swing with the movement of the truck. When people want the truck to stop, they simply yell out, and immediately Nung pulls to a halt and shuts off the engine (it takes Nung and Gai between two and three hours to cover the village, something they do every morning and every evening).

People inevitably come from several different households, many coming to look and to chat, regardless of whether or not they buy anything. Nung is a young, animated, friendly guy, who most everyone likes to see coming. He is originally from Nakhon Sawan, near Bangkok, and doesn't speak Khmer, only Thai. We've been buddies since I first arrived, in part because of language. He's slowly learning to get by in Khmer, but he's happy to speak with me in Thai, and vice versa.

The produce truck—its sheer arrival—makes me hungry. Some of the foodstuffs are dried, like little bags of peanuts, but most of it is fresh. There are small bundles of fresh coriander wrapped together with green onions, lemongrass and bird's eye chiles. There are bundles of whatever is fresh and in-season: yardlong beans, winged beans, bitter melon. Nung's mother-in-law is Mae's closest sister (whose husband just died), so Mae often has bundles of food from the garden to put on the truck for sale. She will have a big bundle of fresh dill for Nung to sell for 5 *baht* (15 cents), or

Gung has fun with her precocious cousin Sumpoo (which means "Pink" in English) on the back of the produce truck. Since her father disappeared, Sumpoo lives with her grandmother (Mae's sister) and she rides the produce truck with her auntie Gai, who is baby Boy's mother.

from her giant pomelo trees Mae will contribute half a dozen large ripe fruits. Part of the produce truck is about family, and extended family, and part of it is simply about how food moves around the village, from household to household, never going through a market.

Nung's days are horribly long. Four mornings out of the week, he drives before dawn to Chong Chom, and three days a week he drives into Prasat (see page 127), again, well before dawn. His profit margins, as they have to be, are horribly small. Some nights, before heading off to bed, he will stop by for a late evening whisky (*lao khao*). Some people inevitably gossip about Nung, not being from the village (that makes two of us). But I feel sorry for him; it's a tough job.

The produce truck also carries fresh pork, bottles of fish sauce, dried noodles: basically anything and everything needed to cook. He will also bring treats for the kids, "Five *baht*, Five *baht*."

Yam Tua Plu

WINGED BEAN SALAD

IF VEGETABLES COULD HAVE AGENTS, THEN I WOULD HAPPILY BE AN AGENT for *tua plu* (in English sometimes referred to as "winged bean" or "fly bean"— *Psophocarpus tetragonolobus*). The bean pods are 5 to 7 in (12.5 to 18 cm) in length and have four "wings" that run from one end to the other. The "wings" have delicate, frilly edges. The whole bean can be eaten fresh, or it can be cooked (as in this spicy salad). If picked before it gets too old (Pea grows *tua plu* in the back garden), winged bean is one of the most tender beans I've ever eaten. While it grows best in tropical climates, I've seen it available in Asian groceries in North America and even in the produce sections of well-stocked supermarkets.

8 oz (225 gr) winged beans	1/4 cup (60 mL) coconut milk
1 Tbsp (15 mL) vegetable oil	1 Tbsp (15 mL) fish sauce
2 Tbsp (30 mL) chopped shallots	1 Tbsp (15 mL) lime juice
2 Tbsp (30 mL) chopped garlic	2–3 bird's eye chiles, finely sliced
1/4 cup (60 mL) ground pork	

1. Boil whole winged beans for 2 to 4 minutes (depending on freshness) until tender. Remove from water and let cool. Cut into 1-in (2.5-cm) lengths and set aside in a bowl.

2. In a skillet, heat the oil over medium-high heat. When hot add the shallots, garlic and ground pork. Cook until garlic starts to brown and the ground pork is cooked through (about 2 minutes). Add coconut milk and stir. Cook 1 minute, remove from heat and add to the winged beans. In a small bowl, mix together fish sauce, lime juice and chiles. Toss with the winged beans and serve.

MAKES THREE TO FOUR SERVINGS

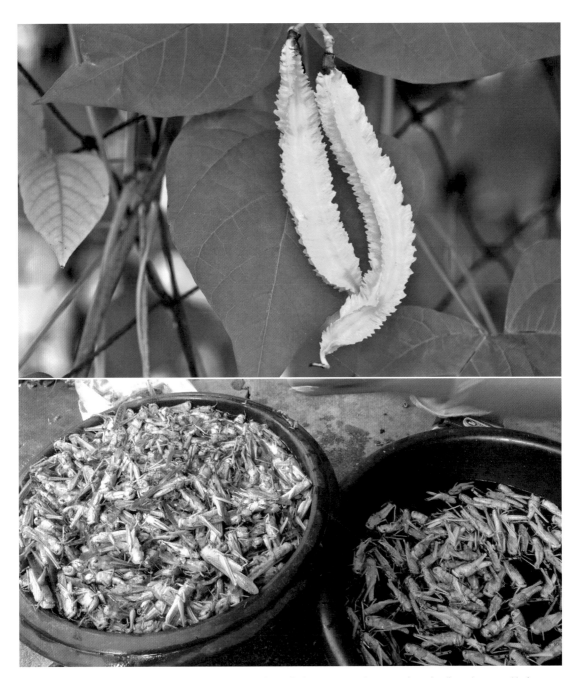

Top: Once *tua plu* (winged bean) is established in the garden it climbs over everything in sight and will produce steadily for at least six months. Bottom: Bought live from Chong Chom market, the grasshoppers are submerged in water in order to kill them and clean them at the same time.

Jukitan

HOW TO COOK CRICKETS
(I MEAN GRASSHOPPERS)

I ASKED PEA IF SHE WOULD SHOW ME HOW TO COOK CRICKETS, WHICH IN Thai are called *jingreet*, and she said okay. I know that people reading here are not necessarily going to have ready access to two pounds of live crickets, but as a coincidence, my friend Richard has a farm in Grey County, Ontario, and he raises crickets as part of his farming operation. He's had the crickets for about two years and boy did we laugh when we realized that we share this intimate cricket connection! His crickets are bought by people who feed them to their exotic pets. There seems to be a large market for live crickets and for live "feed" in general. We've had many a conversation about how he might increase his market if only people realized how good crickets are. But realistically, we realize that the problem is not getting people to like eating crickets; it's a problem of getting the approval of government food inspectors.

One morning Pea set out to buy crickets so that we could test a recipe. She first asked her sister Kaesorn, but her current crop was still too young. Pea went to ask a neighbor, but the neighbor had sold out. She got on the motorbike and went across the village to ask someone else, but she too had sold out. There seemed to have been a run on *jingreet*.

"Tomorrow, when we go to Cambodia market," Pea said assuredly, "we can buy *jingreet*." We knew that we had to make the trip anyway because every two months my Thai visa expires. We go to the Cambodia border where I exit Thailand, purchase a one-month visa for Cambodia and then turn around and come right back into Thailand. As far as "visa runs" (as they are called here) go, this one is relatively painless. But it's still something that must be done, something I can't lose track of. Overstay a day and I pay a fine; overstay a week and I could end up in jail.

So the next day at the market we looked everywhere, but even in Cambodia there seemed to have been a run on *jingreet*. But there were millions, literally millions, of grasshoppers (*jukitan* in Thai). And, well, crickets and grasshoppers are obviously not the same, but I thought why not write about grasshoppers now and crickets when they come back "in season."

We bought 2 lbs (900 gr) for 60 *baht* (approximately 2 dollars). Grasshoppers are slightly less expensive than crickets. Crickets are usually 80 to 100 *baht* for 2 lbs. When you purchase the grasshoppers, the trick is for the vendor to transfer the grasshoppers from a huge bag into a small bag without having any jump away. The vendors pretty much have it down pat, but inevitably a few escape and then we all jump around trying to catch the escapees. The grasshoppers, by the way, are big grasshoppers (about 3 in/7.5 cm long), much bigger than the grasshoppers I grew up with in southern Wyoming. And these are much easier to catch.

When we got them home Pea set immediately to work. She tossed them all into a large tub of water, which kills them. Then one by one she took the wings off each grasshopper, discarding the wings but keeping the body, the legs and the head. When she was finished, she carefully put about one-quarter of the grasshoppers into a wok with hot oil. They cooked very quickly, in about two to three minutes. She took them out, and put in another batch. She sprinkled finely ground dried red chile onto the cooked grasshoppers, a little salt and a little MSG.

We started to eat as Pea continued to cook. Two pounds is a lot of grasshoppers! Mae came to eat. Ahn and Aht came, as did several other neighbors. We poured a glass of beer. The grasshoppers were a midday snack, like putting out potato chips for guests. Unlike the oily rich taste of crickets, the grasshoppers were drier, crisper. Some people, when they cook grasshoppers, mix in deep-fried wild lime leaves (*bai magroot*) together with the grasshoppers. I like the taste of wild lime leaves, but Pea does not. She says that for women, or particularly for her, if she eats wild lime leaves (especially together with beef), then "I take care toilet all night long."

the office

The place where I write most every day is on the second floor of Mae's house, where there are three plain but beautiful wooden rooms. Kaesorn has a room, Pea and I have a room, and the third room is empty (at one point I hinted that I could make it into an office, but maybe the hint was a bit too subtle, or for some reason it was considered a bad idea). Mae and Gung sleep downstairs in an adjacent building that is made of cement and has a tiled floor. This is where the toilet room is, and the shower room.

My "office," which is also our bedroom, is tiny. It's basically the size of our sleeping pad, with a little extra room around the sides where I've built wooden shelves for my clothes, Pea's clothes and books. It's all pretty spare, but, in its way, very comfy and warm (and I don't mean hot, because it's also that!). The ceiling, which is the corrugated metal roof of the house, is very high above, at least 14 ft (4 m) or more. The walls, floor, windows and the door are all made of wood, and all of the wood is very well worn. The house, I don't know for sure, is perhaps about 30 years old. Pea, who is 37, remembers as a child living on the same property but in a different house. Her father and relatives built this house.

This room is my private space, and our private space (otherwise, life is not at all private!). Here I can sit with my laptop, sitting on the floor cross-legged with the fan blasting in my face. If I want to check for an email, I use my internet stick (and most often it works, which still dazzles me given the remoteness of Kravan).

Here I also have my treasured possessions. I have four turn-of-the-century American patchwork quilts. (As hot as it is here in the day, light cotton quilts at night are perfect.) I have two large beautiful bedsheets, handwoven cotton ikat, that I bought in in the Indian province of Odisha, then known as Orissa, several years ago. I have a silk sarong hand woven by Mae, which was a present. I have a picture of my kids, Dom and Tash, and I have books.

When I first came to live here with Pea, she looked at my big bag of belongings and said: "What

One day Pea appeared at the top of the stairs carrying an overgrown vegetable called *buap*, which is preferably eaten when it's young and sweet. She started laughing, finding these things funny. I have to agree.

are you going to do? Are you going to take it all with you when you die?" When I helped Pea pack for her move from the city, Chiang Mai, back to the village, she had five pairs of blue jeans, seven or eight T-shirts, a small bag of toiletries, a fold-up mattress and that was it (all her worldly possessions). One pair of shoes: flip-flops. She had no lipstick, no high heels, no baby powder (all popular items among women in Thailand)—and she still doesn't.

Recently when I'm in "the office," I've started to listen to the music I long ago put into my computer: Celtic fiddlers, world music compilations from Buddha-Bar and Putumayo. I listen to all the music I love. It's a wonderful giant world—the music—and it sometimes makes me cry, sitting on this wooden floor, surrounded by textiles, wooden shutters open wide with tropical green areca palms and mango leaves filling the space. In the last few years of my life there has been a great deal of turmoil, self-inflicted. Since moving to Thailand, for all this time I have listened to almost nothing but Laotian and Khmer music. Traveling between worlds felt too hard.

cold season

I grew up in a drafty house on top of a treeless hill in Laramie, Wyoming, where the water pipes would freeze routinely every other winter and in a bad winter snowstorm the snowdrifts reached nearly up to the eaves of our house. And then I moved to eastern Canada for 24 years, where the winters weren't quite as bad as in Wyoming, but close.

This is "cold season" in Isaan, and for some reason cold season here always catches me by surprise. Daytime highs of 85F (29C) and evening lows of 60F (16C) are not what I would classify as cold, but as I write mid-morning I am wearing socks (one of the two pairs that I own), and this morning I wore a long-sleeve shirt (one of three). In the sun today it's a normal late-December day—dry, bright and warm—but in the shade even I can feel a tiny chill: cold season!

Cold season is no joke to Pea, or to anyone else but me. Jackets come out, stocking caps, blue jeans, woolen scarves and, granted, when riding the motorbike on the highway at 50 mph (80 kmph), a nice warm jacket feels pretty good. But the mysterious thing to me is that everyone catches a cold! Kids have runny noses. People come down with the flu. I've come to think that it's all just what we get used to, and here right now people are cold. And like everywhere else in the world, weather is a constant topic of conversation. *Now mai?* ("Are you cold?"), I am asked at least once a day, wearing shorts and flip-flops. When I look surprised and say no, people shudder in disbelief.

Cold season is for most people, I think, the best time of the year (not for me, because I like rainy season). The rice has been cut, threshed and is safely stored or sold. There's money from harvest, unlike most of the rest of the year, when rural people are living off credit.

Cold season is a time when people can look after chores they've been too busy to do, or simply take it easy for a while. Some farmers will put in a cash crop of *awy* (sugarcane) or *mansaparong* (manioc, or cassava). For Pea, cold season and hot season are the best times of the year to grow vegetables. In the rainy season, trees and rice grow beautifully, but for vegetables there are few that thrive. Many times the rain is just too powerful, either flooding the vegetables or just smashing them. Strong

It's a wee bit cool these days, especially in the morning on the motorbike. Pea bundles up to make her rounds, setting up fish traps and checking others.

plants like *takhrai* (lemongrass), the gingers (*kha* and *khing*) and *gaproa* (holy basil) do well, and need little attention. But 90 percent of the work in the rainy season is in the rice fields (interesting, though, that along the embankments of soil that keep the water inside the rice paddies, Pea plants pumpkins that do very well).

The first thing Pea does after harvest is to remake her gardens, starting them all again from scratch, digging in *buie* (manure) from the pigs, cows and buffalo. In goes *hom daeng* (shallots), *pak chee* (coriander), *kanaa* (Chinese kale), *pak chee lao* (dill), *prik kee noo* (bird's eye chiles)...Cold season is vegetable season.

Pak Boong Moo

STIR-FRIED WATER MORNING GLORY WITH PORK

TOGETHER WITH *PAK KANAA* (GAI LAN OR "CHINESE KALE," SEE PAGE 31), *pak boong* (water morning glory, *Ipomoea aquatica*) is at the top of my list of favorite stir-fry vegetables here in Kravan. Like *pak kanaa*, it's a hardy leafy green that's very versatile for cooking. It makes its way into many soupy noodle dishes and simple stir-fries (as in this dish). But equal to its versatility in cooking, it literally grows everywhere. You can find *pak boong* in almost every watery ditch alongside the road, free for the picking. As an aquatic green, it's happy growing as the top cover on Pea's fish and frog ponds (though the larger fish will eat it), growing beautifully together with water lilies and tender *pak wen* (water clover). But it grows equally well in dry earth, as long as it is well watered. Pea brought a bunch home from the market, cut off the roots and cooked the leaves and stems. She then planted the roots in the garden and now we have a little patch of *pak boong*.

2 Tbsp (30 mL) vegetable oil	8 oz (225 gr) *pak boong*
2 Tbsp (30 mL) finely cut garlic	1 Tbsp (15 mL) fish sauce
4 oz (110 gr) pork, thinly sliced	

1. Heat a large wok over high heat. When hot add the oil. When the oil is hot, add the garlic and fry about 30 seconds.

2. Toss in the pork and continue to stir-fry until the pork is cooked through (about 2 minutes), stirring with a spatula. Add the *pak boong* and fish sauce and continue to stir-fry for 2 more minutes. Transfer to a platter and serve.

SERVES TWO AS A SIDE DISH

the man next door

Kravan, like all the villages around here, is hard to "read," or at least for a *farang* like me. Eit, the woman next door who is horribly afraid of ghosts, lives alone in a tiny cinder-block house, or "room" would be a better description. It's maybe 10 ft (3 m) by 15 ft (4.5 m), with an overhang for cooking outside. I assume she has a shower and toilet inside, but I don't know because I have never been inside her house. The cinder-block exterior is unrendered, and the roof is corrugated metal. It's a dwelling I would expect to see from a train window traveling through a Mumbai slum, not in a village in Thailand. But for her it's a place to sleep, close to neighbors, friends and family.

Just down the street there are several houses that look a bit like they belong in suburban southern California, with red-clay tiled roofs, well-looked-after gardens and yards, big shade trees and tidy car parks. I seldom if ever see a person living in these houses and have come to recognize them as *farang* houses. They've all been built by people a bit like me: people who have come to Thailand, met someone and come to reside in the village. Initially the price of the house sounds very reasonable, especially when converted from foreign currency. The *farang* seldom stays to oversee the construction of the house; the vast majority had

first met their partners in Pattaya (a beach resort) or Bangkok, and they quickly return to one of those two places. Village life looks almost romantic, for about a week.

In a 30-mi radius from Kravan I've met several *farang* who have built houses, learned Khmer or Lao (or both) and have happily resettled in one way or another. And I generally like them very much. But they are a small minority.

In Kravan, apart from *farang* houses and houses that are along the line of Eit's, it's very hard to generalize. One of my favorite pastimes is to stroll around the village late in the afternoon when the

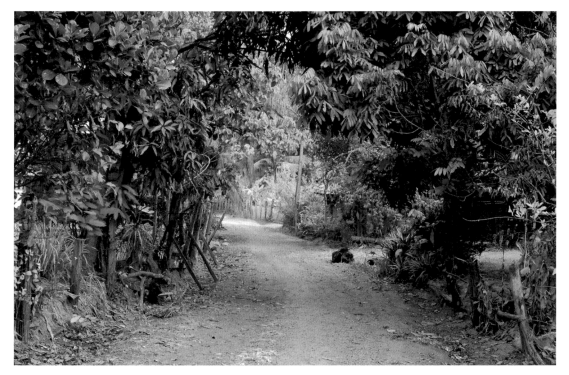

Kravan is a sleepy place (sometimes). This is Tat and Dao's street—a very nice little street.

heat of the sun has subsided and there are long shadows and lots of shade. When I first came to live here, the village looked like a dusty, ill-kept place, a little back-of-beyond. But the longer I am here, the more I have "eyes" to see. There's a wonderful uniqueness to how, without much cash, people build their homes and grow their gardens. Several houses are "under construction," or I should say, construction has stopped.

"Why no one work that house?" I have asked Pea on several occasions with regard to several different houses.

"No money. When have money, make house finish."

Right next door to Mae's house is a big, beautiful Thai-style house, enclosed by a very intimidating wall (with broken glass cemented into the top of the wall in case anyone should try to scale the wall).

"Who lives in that house?" I asked Pea when we first moved to the village.

"Chinese."

"What his job?" I asked.

"No job. You know, he give money, and other people give back more money."

Laab Moo

SPICY GROUND PORK

LAAB IS A VERY TRADITIONAL DISH FROM ISAAN, UP THERE WITH *SOM TAM* (Green Papaya Salad, page 18) and *gai yang* (grilled chicken). *Laab* is a dish that starts with minced meat or fish. If making with pork or chicken, you usually start with a whole piece of meat, and using one or two large cleavers, pound the meat on a large tamarind cutting board. The "mince" is an irregular grind, which makes it more interesting.

My favorite *laab* that Pea makes is with *pla duk*, a local catfish that she raises in the fishponds in the back garden. *Pla duk* is an oily fish that she first grills. She then separates the meat from the small bones and adds all the fresh herbs, as in the recipe below. I have included the more traditional *laab moo (laab* made from pork), knowing that more people will be able to buy pork than catfish. But if you do have catfish, try it!

1 lb (455 gr) lean pork

4 cups (1 L) water

2 Tbsp (30 mL) finely chopped lemongrass

1 cup (250 mL) finely chopped shallots

Handful of fresh mint

1/2 cup (120 mL) finely chopped green onion

3 Tbsp (45 mL) loosely chopped fresh coriander leaf

1/2 tsp (2.5 mL) salt

2 tsp (10 mL) *Khao Khua* (Roasted Rice Powder), page 159

1 Tbsp (15 mL) fish sauce

1/2–1 tsp (5–7.5 mL) crushed red pepper

Juice of 1 lime

1. With a large sharp cleaver (or two) pound the pork until it resembles hamburger meat, only it will be less uniform (the texture of the cooked meat, resembling ground meat but less uniform, is one of the pleasures of the dish).

2. Boil water and then toss in the pork. Reduce heat to low boil and stir well until the pork cooks. Cook approximately 2 minutes, until all the pork has changed color. Drain the cooked pork and place in a medium-size bowl.

3. Add the lemongrass, shallots, mint and green onion to the pork and stir. Add the coriander leaf and salt and stir. Add the *khao khua,* fish sauce and crushed red pepper and stir. Add the lime juice and stir. Taste for seasoning. Add more fish sauce or lime as you see fit.

4. The *laab* goes particularly well with *Khao Neeo* (Sticky Rice, page 174), cabbage leaves and yardlong beans.

MAKES THREE TO FOUR SERVINGS AS A MAIN COURSE

weaving

There's a wonderful lazy feeling to cold season. In its own way it's a very social time, lying in hammocks (*pley* in Thai), sitting on the floor, everyone chatting, people taking it easy. There's little to do in the fields apart from minding the cows and the buffalo, so everyone has time on their hands. Mae, like many women of her generation, used to weave silk sarongs all through cold season, sitting at a large loom outside underneath the overhang, busy but still able to chat with everyone stopping by. A handwoven silk sarong goes for anywhere from 1,000 to 1,500 *baht* (30 to 45 American dollars), and that's in the village. Outside the village it can go for three times that amount, or exported outside the country, ten times that amount. Though in Kravan, like in every village in this region, silk is "money." You get married in silk, you go to the temple in silk. Silk is dowry in every sense of the word.

Now 64, Mae has stopped weaving because of arthritis. But she has a small chest just outside the room where I sleep full of sarongs that she has woven in the past. When I first arrived in the village she disappeared upstairs and came down with a sarong for me, and another that would eventually be made into a shirt: my uniform. It's what I wear to every ceremony. The weave is distinctively Khmer, almost a plaid. Beautiful.

Men, on the other hand, look after all those chores that there is little time for when rice is growing in the fields. The older men will, ever so deftly, repair the bamboo fish traps, or when one is clearly finished, build another from scratch. With a large, incredibly sharp machete they will cut bamboo into strips so fine that the bamboo is almost like cloth. They will then weave the bamboo in and out, sometimes securing with twine, bending and twisting, building exquisite objects that happen to be functional. Building the traps, like weaving a

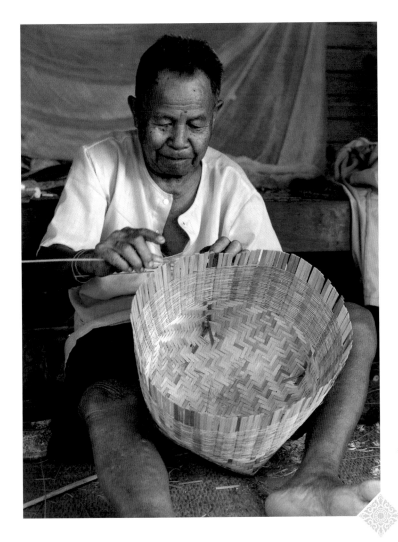

This man lives in a neighboring village, the frog village. Every time we go to buy baby frogs we see him. He is always working, and always very nice.

silk sarong, is not fast. A single trap can take three days, a week. But a good trap can last for years.

Our neighbor Dao weaves hammocks (she wove the hammock I recline in every day, several times each day). From somewhere (I have no idea where) she gets long lengths of shiny rayon/polyester, like strips of discarded women's nightgowns. She gets them for free. And then she starts to weave.

Working steadily, she can finish a single hammock in a day! And they are just about the best hammocks I have ever seen. I've tried to convince Dao that she should make them and I will sell them, but she just laughs. Hammocks here are utilitarian; any given house might have six to eight, strung anywhere there are two trees the right distance apart.

Pad Gaprao Het
MUSHROOMS WITH HOLY BASIL

THIS IS A CLASSIC DISH THROUGHOUT THAILAND, AND A DISH THAT OFTEN appears on menus in Thai restaurants abroad. It's a stir-fry with holy basil (*gaprao* in Thai). It can be made with chicken, pork, frog, fish, beef, squid, shrimp, almost anything. Last night Pea made a version I've never eaten before, with mushrooms. And it was great! We eat a lot of mushrooms, even though we don't grow them (though Pea already has several books on the subject). The variety of mushrooms in the markets is amazing, and generally they are very cheap. But not always. At various times in the rainy season, in those villages close to a forest (not Kravan), people wake up well before dawn and head out to gather wild mushrooms (the villages right on the Cambodian border are famous for mushrooms). They then set up tables alongside a road and sell what they were able to harvest, and these mushrooms are not cheap. I've never seen mushrooms like them in my life. Some are almost scary, so heavily aromatic and in wild colors! And in all different sizes.

Gaprao (*Ocimum tenuiflorum*) grows like a weed in the front yard during the rainy season. Like tree leaves, *gaprao* is "free food," abundant and easily culti-vated. It's a deciduous shrub, native to Southeast Asia. It has a very strong flavor, almost chile-like. When it's used in a stir-fry, there's no mistaking its presence. And in this dish, it's used in large quantities, as are fresh chiles. Pea's version of *pad gaprao het*, like her version of *som tam*, is extremely fiery. In this dish we use oyster mushrooms (which are very common and cheap here), but you can use almost any variety of mushroom.

2 Tbsp (30 mL) vegetable oil

2 Tbsp (30 mL) finely chopped garlic

5 bird's eye chiles, roughly chopped

3 cups (710 mL) washed and roughly chopped oyster mushrooms

1 Tbsp (15 mL) fish sauce

½ cup (120 mL) holy basil

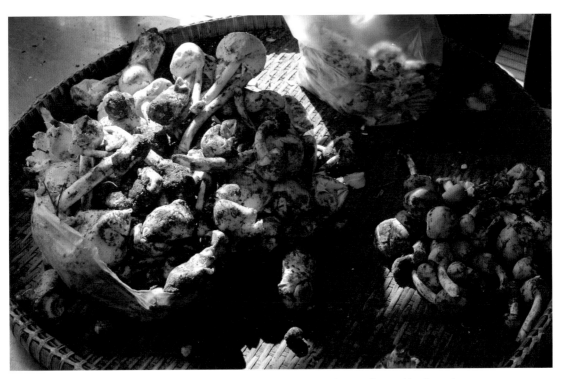

Pea does not forage for mushrooms. Kravan isn't a good mushroom village, unlike places closer to the Cambodian border (more jungly). But we buy forest mushrooms whenever we can.

1. Heat a wok over medium-high heat. When hot, put in the vegetable oil. When the oil is hot, put in the garlic and chiles. Stir-fry until the garlic just begins to turn brown, and then immediately toss in the mushrooms.

2. Stir-fry the mushrooms 2 to 3 minutes, or until they start to cook down, and start to release their moisture. Continue to cook until the mushrooms are cooked through and have reduced in size.

3. Mix in the fish sauce, and then the holy basil. Cook for 30 seconds more and then put out on a plate and serve.

MAKES THREE TO FOUR SERVINGS AS A SIDE DISH

Ngoo

RAT

THE FIRST SIGN OF COLD SEASON, FOR ME, IS THE RATS! NO, NO, NO.… I don't mean rats running around (I've yet to see a single rat, let alone a mouse, running around). I mean the rats for sale in the markets: in town, Chong Chom and in the village market here every Thursday afternoon. This time of year there are many vendors every day, each with half a dozen rats to sell. The rats (often referred to as "rice rats") are cleaned, butchered and laid open (with the tail still attached). They are not cheap, about 70 to 80 *baht* (two and a half American dollars) per rat, depending upon the size. Rats are to some extent a delicacy; the meat is very lean, almost like eating calf liver. The most common way to cook rat is by grilling it, either just on its own or enclosed in a banana leaf. The first few times I ate rat I found it good, but at some point it started to smell bad to me (*men* in Thai is a bad smell; *hom* is a good smell). Finally I stopped eating it altogether, explaining to Pea that it was *men*, which completely made sense to her. I know many people here, women in particular, it seems, who don't eat beef for the same reason: *men*.

The reason why there are so many field rats (they are all field rats; no one here would touch a town rat) at this time of year is because the field rats are easily caught in the rice fields now left bare. After harvest, after all the rice has been cut, threshed, bagged and taken away, there's a bounty of dry straw and grains of rice that got missed. Cows and water buffalo are brought back to the fields to munch away at their leisure (during the rice season they are confined to stables either in the village or communal stables built at the farm, where they're fed straw saved from the previous year).

The rats, like the cows and buffalo, are given time to fatten up, munching away in the dry fields. But then they are caught (at night) and sold. By the beginning of hot season they have disappeared from the markets almost altogether.

thatch

I learn so much every day in Kravan from watching people do things, physical things. And then I get to try. Out of scraps of old wood I made a toolbox, and now in my toolbox I have all my favorite tools, gradually amassing. My number one favorite tool—or tools—are my machetes, for lack of a better word. I probably have at least five, but that number will only grow. A man comes through the village selling "ironwork," pulling a cart going door to door or driving an old Toyota truck loaded not only with ironwork but handmade brooms, hammocks, handwoven baskets and bamboo fish traps.

If you buy a hoe, first you select your piece of ironwork (because each one, made by hand, will be somewhat different). Then you purchase (or not), a handle, choosing between several different tropical hardwoods. For a person who loves tools, old-style tools, it is a dream! From my toolbox, for slivering coconut husks I pick up one machete. For taking down eucalyptus, I grab a different one, and for pruning the areca palms and the bananas, yet another. Each one varies in length, in width, in weight, in feel.

A while back I built my first grass hut, what we now call "the thatch." I copied the grass hut built by Oie and Oat, the one we call "*Ban Off*," or "House of Off," their baby. Mae gave me

permission to cut eucalyptus from her farm, and Aht helped me transport it on the wooden wagon of his three-wheeled tractor. And then for the next two days everyone let me be, watching but not interfering (similar to what occurs between parents and children, here: parents give their children space to learn on their own).

I built "the thatch" in the front yard, between the house and the street in an effort to give more shade from the intense sun, and also wanting to improve the one really trashy part of Mae's property.

On the morning of my third day working, Aht, Oie and Oat walked slowly over from across the street, observing but not saying much at all. They checked out my structure (with no rafters as yet),

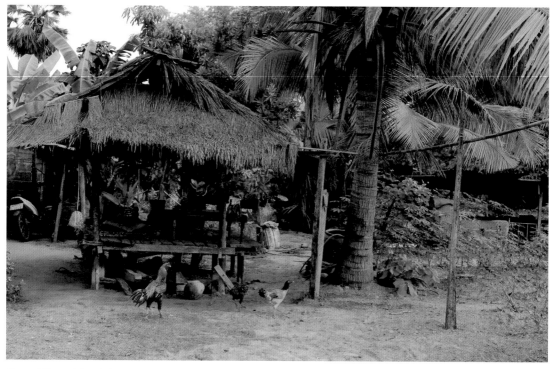

Oie and Oat and their baby, Off, live in this bamboo hut just across the street. At night they have a large mosquito net that comes down to protect them.

pulling here, pushing there. And then they started to work, again not saying anything.

It was wonderful, machetes flying in every direction. Other people came. Food and *lao khao* arrived, mothers and babies, grandmothers and grandfathers. People in Kravan *know* their grass huts, so not only did everyone have an opinion, but no one was going to let me build a bad one.

By late afternoon Rorn arrived in his old maroon Toyota truck and told me to get in. We drove in the direction of Cambodia, about 20 minutes in the truck, and we arrived at a village where several families sold woven-grass "thatch." I bought 150 ready-made lengths, each one about 3 by 5 ft (1 by 1.5 m); each one cost 7 *baht*, or about 20 cents.

By the time we got back home, it was nearly dark, but no one had left. Everyone immediately set back to work, attaching the grass roof one piece at a time, accompanied by laughter and joking. Two long lengths of bamboo were crisscrossed at the peak. We all had one more shot of *lao khao*, proud of ourselves. And then everyone went home.

Gaeng Keow Wan

GREEN CURRY PASTE

CURRIES (OR *GAENG*), ARE NOT REALLY THAT MUCH A PART OF THAI-KHMER cooking. *Gaeng* (especially those of the coconut-milk variety) are an important part of central- and southern-Thai cooking, and are also popular in northern and northeastern cooking. But here in Kravan, I seldom eat curry.

But that doesn't mean that Pea won't try her hand at *gaeng*. One night she sat looking through a locally produced Thai cookbook (one of her favorite things to do) and she announced that tomorrow she was going to make *Gaeng Keow Wan Gai* (Green Curry with Chicken, page 101). I really like curries, and I was surprised. So the next day I followed her every step.

If you live in North America, this might sound odd but I recommend buying a green curry paste instead of making one from scratch. It can be hard to find some of these ingredients fresh, unless you live around a Thai community. And the already-prepared pastes can be very good.

1 tsp (5 mL) peppercorns

1 Tbsp (15 mL) roasted coriander seeds

1 Tbsp (15 mL) roasted cumin seeds

¼ cup (60 mL) finely sliced garlic

1 Tbsp (15 mL) finely sliced coriander root

2 tsp (10 mL) salt

1 Tbsp (15 mL) finely sliced fresh galangal

1 Tbsp (15 mL) wild lime zest

¼ cup (60 mL) finely sliced lemongrass

½ cup (120 mL) finely chopped fresh green chiles (*prik e noo*)

1 Tbsp (15 mL) shrimp paste

1. In a mortar and pestle (or food processor), pound the peppercorns, coriander seeds and cumin seeds until powdered.

2. Add garlic, coriander root and salt. Pound to break down the tough coriander root. Add galangal, wild lime zest and lemongrass and continue to pound.

3. When the ingredients have transformed into a paste, add the green chiles and shrimp paste. Pound until again there is a thick paste. Store in a clean glass jar with a good lid.

MAKES ABOUT 1 CUP (250 ML)

orchids

I first started buying orchids on a trip to Chong Chom, the market town on the Cambodia border. I can't remember what possessed me to buy the first batch, maybe just the price (five for three dollars). In Canada I'd had one or two orchids that someone had brought as a present, but I knew nothing about them. I've always loved houseplants, so I saw them in Chong Chom and thought that I might as well try.

It all seems like a long time ago, buying those first orchids. Now I have hundreds and they are a pleasure every day, a wonder to behold. When I got the first four back to Kravan, Pea's nephew Bpoo came right over. Bpoo is the young man who is such a superb dancer. At 16 years old he's also on his way to becoming a shaman in the village, much respected.

Little did I know but I had bought a variety of orchid called Vanda, which in orchid terms is an epiphyte, meaning it grows high in the jungle canopy, not on the ground (the vast majority of the orchids I buy are epiphytes, coming across the border from Cambodia, which is much more jungled). Bpoo taught me how to mount the orchids on trees in the garden (orchids are not parasitic, but they attach themselves to tree branches for support and light).

With a machete, he cut and then pulverized coconut husks (the thick fibrous outer layer of the coconut when it first falls down from the tree). He found an old discarded cotton sarong and tore it into strips, and then he carefully wrapped the roots of one Vanda with the pulverized coconut husks and then held it to a tree, motioning for me to wrap it tightly to the tree with a strip of cotton. We attached two to the big mango in the front yard, and two others to a jackfruit. The first orchids! I was to water them every day, he instructed me, and so I did.

For a long time not much happened, but the orchids seemed hardy and alive so I just kept watering. On subsequent visits to Chong Chom I bought more and more, attaching them to trees all around the house. At some point I began buying a new variety, a *Dendrobium* (though not

that I knew that then). It too looked fun, and the price was the same, and sometimes even cheaper. But people explained to me that it grows better in baskets lined with coconut husk, not attached to a tree like the *Vanda* but hanging in the shade under a tree.

Over time, more and more of my orchids came to live in the back of the house, in a place where I'd built an outdoor shower. I'd built the shower in rainy season, using old steel roofing to funnel the fresh rainwater into two large *ongs*, round cement or baked-clay water vessels, anywhere from 4 ft (1.2 m) in diameter and 5 ft (1.5 m) tall. I'd wanted to make an outdoor shower so that I wouldn't disturb everyone in the house whenever I needed to shower. Also, after living in Sri Lanka (a place very similar to here), I'd always wanted to have an outdoor shower, and to be able to shower with rainwater.

With my growing number of orchids, I soon realized that the best place for them was right near my shower, because that way I could water them every time I showered, and enjoy watching them grow. They were (and still are) deeply mysterious to me, alive but doing nothing for long periods of time. One or two of the orchids had a short-lived flower, but for some reason it didn't bother me (the not flowering). Gradually they all started to send out roots through the thick mass of the coconut husks and then eventually onto the tree branches. The roots looked like large earthworms, and they attached themselves fiercely to the branches.

Many months passed. I found some books on orchids in a bookstore in Surin and gradually came to learn a little more. At one point we were visiting friends in a nearby village, and one of them had orchids in flower!

"My orchids have never flowered," I told her desperately.

She smiled. "They will. Put small pieces of charcoal into the coconut husks. That will help."

So I did as she instructed, and soon I had some flowers. And I have had flowers ever since, amazing flowers! The charcoal helped, but in retrospect I realize that I'd been buying "baby" orchids. (This was probably the reason she smiled.) They simply had to grow and to mature, like first year perennials. I started "mounting" my *Vandas* on thick, long pieces of tropical hardwood and then hanging the pieces of hardwood vertically, making "orchid walls." They're magic!

But there's one last piece of this story still to tell. I was back in Canada for a visit, and took the opportunity to scour the bookstores. I was in a store out in the country, in tiny Williamsford, Ontario, a seemingly unlikely place to find a beautiful bookstore. More than half their books were secondhand, and suddenly I spotted an old paperback on orchids, three dollars. I grabbed it and added it to my stack, not even looking inside.

Months later I was back in Kravan and noticed the old paperback on my bookshelf. *Orchids as Houseplants* by Rebecca Northen. I picked it up (for the first time since buying it) for a browse through, not expecting much. I immediately found myself engrossed. I had maybe six or eight books on orchids at that time, but none like this. The writer "got it," got the magic! I turned back to the title page and there saw "Laramie, Wyoming, 1955." What? I wondered to myself. Impossible. (Laramie being one of the most "unfriendly" orchid places in the world.)

And then I remembered: A good friend of my mother and father's, just down the street, the

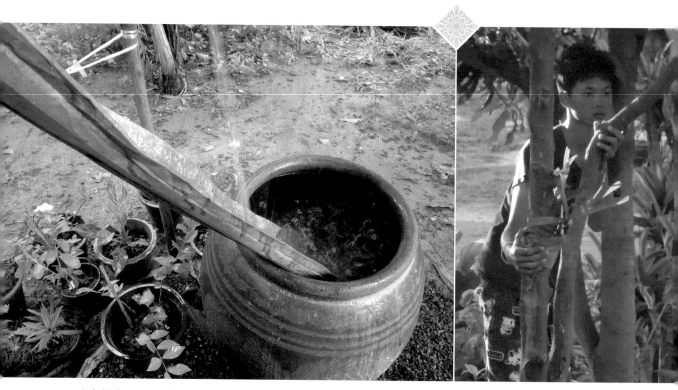

Left: Nothing much to look at, but this is my outdoor shower. The *ong* catches rainwater, and I use a bucket to throw water over myself (wearing swimming trunks). I have orchids all around. It's my little private space. Right: The eldest son of Tat and Doi, Bpoo, first taught me how to tie Vanda orchids to trees. Here he is tying an orchid to a jackfruit tree in the front yard.

woman "into orchids." Rebecca Northen died at age 96, one of the most respected writers about orchids in the world.

(Oh, and incidently, yes, in cold season the outdoor shower is a bit nippy! Around two in the afternoon is okay.)

Gaeng Keow Wan Gai
GREEN CURRY WITH CHICKEN

THIS IS THE GREEN CURRY WITH CHICKEN THAT PEA MADE USING THE GREEN curry paste. She would never in her life make the curry with chicken breasts for herself (preferring all other parts of the chicken over the dry white meat of the breast), but she knows that Gung and I are partial to chicken breasts, so she made it to be nice. And it was fabulous.

Once you have the green curry paste, making the curry is quite simple.

1 Tbsp (15 mL) vegetable oil

2 Tbsp (30 mL) *Gaeng Keow Wan* (Green Curry Paste, page 97)

2½ cups (600 mL) coconut milk, divided

1 lb (455 gr) chicken breasts, cut into ½-in (1.25-cm) cubes

6 oz (170 gr) small Thai eggplants, halved

1½ Tbsp (22 mL) fish sauce

½ cup (120 mL) basil leaves (*horapa*)

1. Heat a heavy saucepan or wok over medium-high heat. Add the oil. When the oil is hot, add the green curry paste and stir. Cook the paste about 1 minute, stirring.

2. Add 1 cup (250 mL) coconut milk and cook for about 5 minutes. Add the chicken, eggplants and fish sauce and continue to cook, stirring occasionally, for about 6 to 7 minutes. The chicken should already have changed color.

3. Add the remainder of the coconut milk, bring to a boil and then reduce heat to simmer. Simmer for another 5 minutes. Stir in the fresh basil, stir, and then turn off the heat. The curry is ready to serve.

MAKES FOUR SERVINGS

ahn

Ahn, who lives directly across the street from us, is a nice enough person who drives me a little bit nuts. She's mother to Oie, and Oie is mother to Off. Off, who is now almost two, brightens all of our days almost by the hour. As a small baby he was so good-tempered, so curious, so willing to be held and cuddled by anyone.

A few months back his mother, Oie, and father, Oat, left for Bangkok in search of work (the classic story of Isaan…). Oie's a big strong woman, like her mother, like her grandmother, like her aunt. She's a very good carpenter, very good laborer, very good farmer. And so is Oat, her husband, but Oat is as small as Oie is big. They both work hard. They love each other. They love their baby. And there's no work. So off they go, and probably for a long time. Oie and Oat took with them Oie's brother, Ung—Ahn's second child, who is only fourteen. He hates school and is ready to work, and we all think that he will be fine.

So back to Ahn. Ahn, as grandmother, has now become Off's full-time mother, a job that she does okay at (a situation, as mentioned before, not at all uncommon in this village and throughout Isaan). Ahn is married to Aht, and when I first met them, I met all four of them: Ahn, Aht, Oie and Oat. Ahn, like her daughter, Oie, is a big strong person

with a big personality, and while her husband is not a tiny, finely put together person like Oat, Aht is also very short, but built like an ox. The picture of the five of them together (and with baby, Off) is a good one: two tall big strong women, and two very short men (I'm reminded of Julia Child and her husband), two like an ox and two like a deer, and baby Off.

Ahn's mother (now deceased), Ahn, Ahn's sister and Oie are, in *Seinfeld* terms, classic "loud talkers." They're almost unbelievable. They talk twice as loudly as anyone else in the village (and are, I think, proud of it). Six o'clock in the morning and from under the boards where my head is resting on a tiny pillow (the three wooden rooms are suspended over the common area, the big overhang, the place where every morning people gather to drink *lao khao* and to talk), I hear Ahn booming, bellowing. And it's not as if she doesn't have a different volume, a softer volume, as an

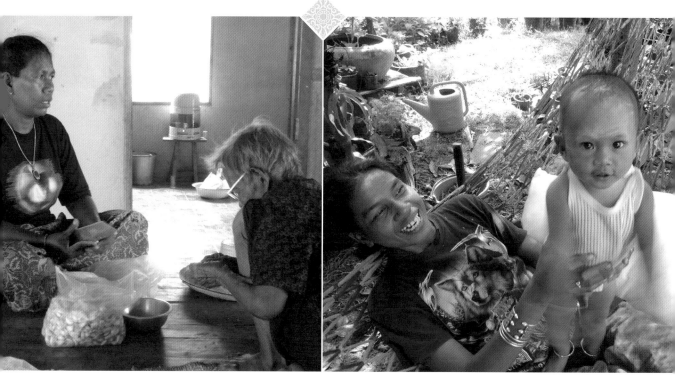

Left: Ahn, in one of her quiet moments, talking with Pea's grandmother. Right: Baby Off is the highlight of almost every day. He is always happy, smiling and laughing.

option. When Ahn wants baby Off to fall asleep for a nap, she's definitely not bellowing.

I once did an experiment, knowing the outcome. Ahn was here with Off, thinking she might rock him to sleep in the hammock at this house (as if they don't have many hammocks across the street). It was midday—for me, right in the middle of building a wooden bookshelf—and so as an experiment, I made a couple of long "rips" with my electric circular saw ("rips" are loud and long). A couple of minutes later Pea came over and asked me quietly if I could take a break, which I did. But my theory had been confirmed: Ahn's own noise is okay, but not others'.

Does Ahn drive me a little bit nuts because she's so loud, or because (apart from caring for Off) she's lazy? Or does she drive me crazy because she's so bossy, or because she treats her husband (who is an incredibly hard and skilled worker) like a slave? I wish she didn't live right across the street, but there is nothing I can do about that.

Goong Dten
SHRIMP DANCING

MY BROTHER, RICH, WHO IS A PROFESSOR OF SOCIOLOGY AND THREE YEARS older than I, came to Thailand a while back for a visit. He had only six days for his visit, so Pea and I went to Bangkok to meet him, because coming all the way to Kravan was out of the question. It was Rich's first time to Thailand, and I worried a little bit about what he would think of the food. He, like me, and like my other brother and sister, grew up as a "picky" eater. I don't know if it was a by-product of living relatively isolated in Laramie, Wyoming, or of my mom being especially indulgent, but we were picky kids when it came to eating. I probably stopped being a picky eater when I started traveling, but Rich, I thought, had remained fairly picky. And so I was worried about him.

On the first night of his visit we took him to our favorite restaurant, an Isaan place on Petchburi Road, Soi 14. It's a great place, always packed and tables spilling out onto the sidewalk. It's not expensive; it's just one of those restaurants that are enormously successful because the food is authentic and really good. We sat down and ordered beer (which in Thailand automatically comes with ice), and Pea picked up the menu (a huge menu) and was soon ordering. In Thai-style, Pea knew that this was a special event, my brother coming all the way from the United States, so she ordered as if we were ten people, not three. And almost immediately food began to appear.

One of the first dishes to arrive was *goong dten*, "shrimp dancing," served in a bowl with a plate over the top. Pea picked up the bowl, holding her thumbs on the top, and shook the bowl as if making a martini, and then put it back down on the table. Then she very carefully lifted the top plate, peering inside, and just as she did, two baby shrimp jumped out and started wiggling across the table. Pea laughed and immediately put the plate back on top, placing the bowl back on the table. "Wait just a minute," she said to Rich, and then she grabbed the two escapees and put them into her mouth. "*Jiangan*," she said, smiling (the Khmer word for "delicious").

I had a moment of panic, worrying about Rich, but then I saw a huge grin on his face. A few minutes later, when it was time to take the plate off the shrimp (many were still alive and jumping, but with a lime juice and fish sauce dressing, they were starting to die), it was Rich who was the first to grab a baby shrimp

Oh boy, an entire plate of shrimp dancing (*goong dten*). Growing up in Laramie, Wyoming, if someone had told me that later in life my mouth would be watering at the sight of uncooked baby shrimp, I'd have said they were crazy.

and eat it. "Good," he said, smiling. "Wait until I tell my students that I ate shrimp jumping across the table!"

For five nights in a row we ate in the same restaurant and, after dinner, went dancing until the wee hours every night at Tawan Daeng ("Red Sunset"), a great place that plays Isaan music. In the afternoon we'd go shopping through Pratunam, an old, giant wholesale clothing market. At the restaurant, every night, Rich ate everything, one dish after another. A few days after he arrived back home, he wrote an email saying that he had had a wonderful time. "The one thing I think I will most remember," he wrote, "is probably that restaurant and the food."

Goong dten is something we eat often in Kravan. We buy them at the Thursday market in the village (they are incredibly cheap). Pea likes to take a handful and put them into her fishponds, where they survive very well. But we haven't figured out how to cultivate them, nor have I seen exactly how they are farmed. It's very common in Isaan to come across *goong dten* "restaurants," a few bamboo huts set up on the shore of a large lake or reservoir. When you order the dish, the proprietor harvests the shrimp fresh from netted baskets in the water.

1 cup (250 mL) baby freshwater shrimp (approximately 3½ oz/100 gr)

1 Tbsp (15 mL) *Khao Khua* (Roasted Rice Powder), page 159

Juice of 1 lime

2 tsp (10 mL) fish sauce

1½ in (3.8 cm) lemongrass, finely chopped

3 shallots, finely chopped

3 Tbsp (45 mL) chopped fresh coriander leaf

3 green onions, finely chopped

2 cloves garlic, finely chopped

2–3 fresh bird's eye chiles, finely chopped

1. Put the shrimp in a bowl and quickly cover with a plate so that they don't jump out. Carefully pick up the plate and pick through the shrimp, discarding any that aren't moving. Some will inevitably jump out, but just catch them and put them back in. Cover again.

2. Carefully removing the plate, add the roasted rice powder and quickly cover. Shake the bowl, holding on to the lid. Add the lime juice, and shake again. Add the fish sauce and shake.

3. At this point some of the shrimp will be starting to die. Add the lemongrass, shallots, coriander leaf, green onions, garlic and bird's eye chiles. Cover and shake vigorously.

4. The shrimp are now ready to serve. Put out the bowl, still covered. At first, when uncovered at the table, some shrimp will jump out, but that is part of the fun. It is best to eat with your fingers, picking up a shrimp and a bit of this and that.

MAKES THREE TO FOUR SERVINGS AS AN APPETIZER WITH DRINKS

I once co-authored a book about rice, called *Seductions of Rice*. I worked on the book (with Naomi Duguid) for three years, and I learned a lot about rice! But the most important thing I learned was that everyone, everywhere, when asked what rice they most prefer, they answer that it's the rice they eat every day, the rice they're most familiar with. The smell is right, the texture is right and the taste is right. It's exactly the same with olive oil. Ask a Greek about the best olive oil in the world: Greek olive oil. Ask an Italian: Italian olive oil.

Thailand is famous for its rice, and there was a time when Cambodia was very famous for its rice, as well. "Fragrant jasmine rice" (*khao mali*) is the rice most often associated with Thailand. It's a low-amylose long-grain indica rice, not unlike basmati rice in India, but softer and with a very different smell. I don't like basmati rice, and never have. My first introduction to eating rice every day, several times a day, was in south India, where there's very little basmati. I liked the south Indian rices, but for some reason, Thailand was where I first came to *love* rice: Thai fragrant jasmine rice.

I lived many years in Toronto. Because of the popularity of Thai food, there were many Thai restaurants in the city, but there were very few that I would ever eat in. If I walked through the door and didn't smell Thai jasmine rice, I would immediately turn around and walk out (Toronto has relatively few people who have come from Thailand, and as a consequence, many of the Thai restaurants are owned by non-Thais who cook with their own preferred rices, not Thai jasmine). When Thai jasmine rice is cooking in a kitchen the smell is very distinctive, a bit like fresh bread in a hot oven, instantly appetizing, and the smell should radiate out from the kitchen and into the restaurant.

In Kravan, we eat the rice that Pea grows, the rice that I help plant and harvest. I've had many a vegetable garden, but this is the first time in my life that I have eaten every day a staple grain that I've helped grow. At harvest, after all the rice has been dried, threshed and then bagged, there's a very satisfying, reassuring feeling knowing that there is

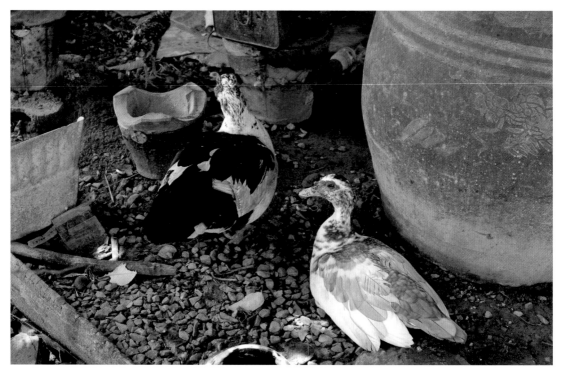

When I first arrived in Kravan, Mae had only chickens. I'm not sure where the ducks came from, but now there are many ducks in addition to the chickens.

food for another year. While Pea does not eat the quantity of rice that people in many other parts of Asia eat, rice is still very much the staple grain.

In Mae's house there is friction sometimes over rice. Pea's sister Kaesorn most often prepares the rice. She has a very badly disabled leg (from carrying a far-too-heavy load when she was a child). Kaesorn works at the farm, but not to nearly the same extent that Pea does. She stays home most days and looks after Mae's small shop, and, as a consequence, she is usually responsible for cooking the rice for evening dinner. Pea and Kaesorn fight a lot, for various reasons, but one of the biggest reasons is that Pea thinks Kaesorn cooks far too much rice. And Pea is right. She does. Most days

Kaesorn will cook twice as much rice as everyone eats, and then she will put the extra rice out for the three dogs, four cats and the many chickens and ducks.

This drives Pea crazy. Pea only ever cooks the amount of rice that the four of us are going to eat. "Animals have plenty of food already," Pea first explained to me, "not need to eat rice every day." If Kaesorn worked every day in the fields, Pea contends, she would not cook so much rice. Mae agrees. Mae and Kaesorn fight even more than Kaesorn and Pea. Kaesorn is very stubborn.

Rice is most often cooked in a large pot over a charcoal fire out in front of the house. First, the rice is rinsed and then put into water. The water is

brought to a low boil, and then boiled for several minutes longer. The pot is then removed from the charcoal and covered with a fresh banana leaf, the rice left to cook slowly and to absorb the water. Before eating, the rice is gently stirred. Everyone fends for him- or herself, at least in Mae's house, because we all eat different quantities.

Most people in Thailand these days eat Thai jasmine rice using a spoon and fork, the fork there to help gather the rice onto the spoon. But in Kravan, and in most rural areas around here, most people at home eat rice by hand. Mae and Pea, in traditional fashion, sit cross-legged on the floor with a plate of rice set out in front of each of them. With one hand (and it doesn't matter which hand; a majority of people in Kravan, from my observations, are left-handed) they reach down with a limp wrist and pick up an amount of rice (not big, not small) and then rather loosely toss it into their mouths.

Gin Maak

CHEW BETEL

MAE, AND ALMOST ALL THE WOMEN OVER 50 IN THE VILLAGE (ALONG WITH Kaesorn, age 42), chew betel from morning until night. In Thai it's called *gin maak*. *Maak* is the betel, and *gin* is "to eat." For whatever the reason, a long time ago I learned the word *maak*, but one time I was in Bangkok, in a convenience store late at night, and three young Thais came up to the cashier wanting to buy *maak farang*, which I suddenly realized was chewing gum (I had never known the word for that), or "foreigner betel." I started laughing waiting for my turn at the cashier, but I couldn't explain to the others why I was laughing. Sometimes words in Thai are just so good. Asparagus is *nomai farang*, or "foreigner bamboo shoot."

Pea doesn't *gin maak*, but perhaps in another 10 or 20 years she might. It's definitely a village thing, and definitely an age, and to some extent a gender thing (women chew more than men). But will it die out with the next generation? I doubt it. There are archaeological findings of areca nut (*Areca catechu*) and betel (*Piper betle*) in Thailand going back several thousand years, and it remains a common practice all throughout the Indian subcontinent and Southeast Asia. Red teeth, red mouth, red spit: it's not dying out.

I first learned to *gin maak* in India, where in Hindi it's called *paan*. There it's a very social thing, where after a nice meal people might sit around and chew betel, almost like an after-dinner glass of cognac. Or if you meet a friend on the street, you might go to a little kiosk where someone will make up two *paan*, and you can stand there together, chewing and spitting. It's all very polite and normal. The taste is mild, and if there is no tobacco added, there is not much effect, if any.

In Kravan it's just the same, but different. Everyone I know in Kravan who chews betel has a beautiful little woven basket, a basket that goes everywhere they go, as if carrying a purse or a wallet. Inside each basket there's a special tool for splitting the areca nut (it's very hard), a tool that looks a little bit like a nutcracker for walnuts or pecans. Also in every basket there's an areca nut or two, a small stack of fresh betel leaves and a small container of lime (the mineral, not the fruit). There might also be a bit of tobacco.

The way *maak* is assembled, same as in India, is that a piece of areca nut is held in a betel leaf, and then a tiny bit of lime is rubbed onto the open leaf. The

leaf is then wrapped up into a nice little bundle and put into the mouth. You put the *maak* toward the back of your mouth and chew it gently, initially, just to get the whole thing activated (when a group is sitting around in the thatch, and they have all made up a *maak* and are starting to chew it, they're all talking in a very familiar, garbled way, most not having many teeth remaining anyway). Soon the *maak* starts to break down and the famous red liquid starts to appear. All of which needs, eventually, to be politely spit out. It's ritual.

When I first arrived in Kravan and started working around Mae's house, I found a somewhat smelly bucket full of cockleshells from a meal that Pea and I had eaten a few days before. It was quite smelly and I wondered if someone had forgotten about them. When I asked Pea, she started to laugh. "Those are for Mae. She will let them dry a few days longer and then grind them to make the lime for *gin maak*."

Tom Yam Het

TOM YAM WITH MUSHROOMS

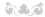

ONE OF MY PARTICULAR PLEASURES IN LIVING IN KRAVAN IS THE BOUNTY of mushrooms, both farmed and, in rainy season, wild. One of my favorite mushrooms is the oyster mushroom (*Pleurotus* spp). It looks like such a fragile mushroom with its fine, large white cap, but in cooking it's anything but fragile. It holds up beautifully in frying, or in soups. Here in Thailand there are many varieties of oyster mushrooms, many of which are farmed in rice straw, making them cheap as can be. You can use oysters in this following recipe, or your ordinary button mushroom.

Tom yam is often found on North American menus offered as a soup, but it's not really a soup. It's generally far too spicy hot to be eaten as a soup. I like to think of it as halfway between a curry and a soup; it definitely should be either eaten with rice, or one spoonful at a time as *gap glem*.

While Pea occasionally cooks *tom yam*, it's not as much a part of her repertoire as it is in the more Lao-speaking areas of Isaan, where *tom yam* has nearly the same importance as *nam prik* has for Pea. In these areas the skill and finesse of a cook is shown in his or her *tom yams*. Notice too in Pea's *tom yam* that there is no *bai magroot* (wild lime leaf), a common ingredient in *tom yam*. She doesn't like it. In this recipe you can cut the mushroom quantity in half and add approximately ½ lb (225 gr) of chicken, cut into strips.

4 cups (1 L) *Nam Sup* (Chicken Broth, page 64)

4 long shoots fresh galangal, trimmed and cut into 3-in (7.5-cm) lengths

1 lb (455 gr) oyster or button mushrooms, washed and cut into quarters

4 medium tomatoes, quartered

5–8 fresh bird's eye chiles, smashed and halved lengthwise

1 bunch (about ¾ cup/180 mL) chopped fresh coriander leaf with roots, separated

¾ cup (180 mL) saw tooth herb, cut into 1-in (2.5-cm) lengths (a herb increasingly available in Asian groceries in North America)

4 green onions, trimmed and cut into 1-in (2.5-cm) lengths

1 tsp (5 mL) salt

These are the essential ingredients for making *tom yam*: lemongrass, chile, coriander, lime leaf and galangal.

1. Heat the *nam sup* in a large pot over high heat. When boiling, add the galangal and continue to boil for 4 minutes.

2. Add the mushrooms, tomatoes, chiles and coriander roots (not the leaves), reduce heat to medium-high, and cook for 5 minutes. Add saw tooth herb, fresh coriander leaf, green onions and salt. Turn off heat, stir and let stand 4 minutes. Serve over rice, or one spoonful at a time with drinks.

MAKES ABOUT 4 CUPS (1 L), OR THREE TO FOUR SERVINGS
AS A MAIN COURSE

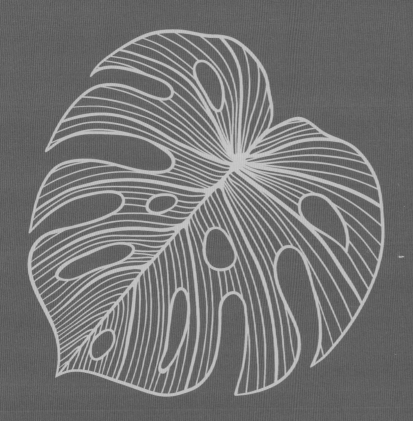

gamore

It's mid-February as I write (Valentine's Day, a big deal in Thailand, was just yesterday). It's been hot for about a week now. The newspaper says that it's 93F (34C), but our thermometer shows 100F (38C). It doesn't really matter—it's hot, and it's early to be this hot. I'm not a big fan of hot season (generally, March, April and May). It's the only time of the year in Thailand that I don't much like.

But Pea and everyone else in Kravan is happy, because now is the season for *gamore*. *Gamore*, with a long rolling "r," is a Khmer word. The Thai word is *monkeysan*. For the longest time I couldn't find the English name, but then found it: a "mole cricket." It's about 1 in (2.5 cm) in length with a small head and a long torso. It has four legs—all toward the front of its body—and the legs have amazing gripping power. If a *gamore* is attached to my leg, it will easily stay there as I walk around. It doesn't bite, but it grips.

Gamores live just under the ground (like a lot of creatures this time of year). At night they come up to the surface of the earth through a small tunnel, which means that in the daytime Pea (and everyone else) can go hunting for *gamores*, searching for the small tunnels in the hard-packed earth. Like hunting for frogs—a season which is also now just getting started—tracking *gamores* reaches borderline hysteria. Although, unlike with finding frogs, which happens at night, *gamores* are found during the day. Pea takes a tool, something that resembles a trowel (only with a yard-long handle), and scours the earth looking for the small tunnels. When she finds one, she digs, uncovering the tiny *gamore* just beneath the earth. As far as I can tell, the *gamores* tend to live in clusters, so when she finds one she is apt to find many, and by the time she's finished the patch of earth will look newly plowed.

I'm not crazy about the taste of *gamores* (they are fried, same as grasshoppers). I like grasshoppers and crickets very much (crickets are also coming into season), but not *gamores*. I don't dislike them, but everyone else *loves* them, so I leave my share for everyone else.

Nam Prik Pao
DARK-ROASTED CHILE SAUCE

NAM PRIK PAO IS MADE ALL OVER THAILAND, NOT JUST IN ISAAN. ALSO, it's a sauce that you can easily buy already prepared from almost any Asian grocery in North America. On the grocery shelf, you will most likely see several different brands; simply buy one and try it. It stores well in a tightly sealed jar.

Nam prik pao is not a *nam prik* like the usual ones that Pea makes almost every day. *Nam prik pao* is more of a condiment, an ingredient, something used by the tablespoonful to enhance the flavor of other dishes (like a *tom yam*). It's very versatile, and the more you use it, the more ways you will discover to use it. You can even take a spoonful and add a little water, perhaps a squeeze of lime, and use it as a dipping sauce.

Pea makes *nam prik pao* over a charcoal fire, but probably the easiest way to roast the ingredients is in a good heavy skillet. Many versions of *nam prik pao* add dried shrimp, shrimp paste and/or tamarind paste, but this is a more basic version.

½ cup (120 mL) whole dried red chiles	½ cup (120 mL) whole garlic cloves, skin on
½ cup (120 mL) whole shallots, skin on	¼ cup (60 mL) vegetable oil
	1 tsp (5 mL) fish sauce

1. Over a low to medium heat, put the dried red chiles into a heavy skillet and slowly cook them, turning them frequently so that they do not burn, for about 5 minutes. They will start to change color, and you will have a big smell of chiles in the kitchen (probably making you cough).

2. Put the shallots and the garlic into the skillet and cook like the chiles. They will take longer to roast than the chiles, about 6 to 8 minutes, and they will start to soften. When roasted, remove from the skillet.

3. When the chiles, shallots and garlic have cooled, remove the skins of the shallots and garlic, and the stems of the chiles. To make the *nam prik,* you can use a blender, food processor or a mortar and pestle. Grind the chiles, shallots and garlic together until you have a thick paste.

4. Put the skillet over a low to medium heat, and when hot add ¼ cup (60 mL) oil. When the oil is hot, add the chile/garlic/shallot paste. Stir to mix the paste with the oil and cook slowly for about 5 minutes.

5. Remove from the skillet and mix in the fish sauce. When cool, transfer to a clean jar with a good lid.

MAKES ABOUT 1 CUP (250 ML)

sister's wedding

I'm not a big fan of funerals here in the village (or anywhere for that matter), but weddings I like. And there seems to be an inordinately large number of both for a place with less than 300 people, or maybe it just seems like that because—with the very loud music that's played at the ceremonies—one is aware of every single one. Sister number eight, Ang, who lives in Bangkok, announced a few months ago that she was going to be married in the village on March 1, so these last couple of months have been filled with planning and anticipation, just like there would be anywhere else in the world. Her fiancé, Bpuh, had agreed to put up a *sin sod* (dowry) of 100,000 *baht* (about 3,000 American dollars) plus 2 *baht* worth of gold (approximately half an ounce). Everyone was happy.

But also, just like anywhere else in the world, with planning and anticipation there was also disagreement and frustration. Mae was adamant about not wanting the wedding to get too big, about the costs spiraling. Sixty guests, eighty guests, okay, a hundred guests. One pig, no, two pigs. Beer and whisky, *lao khao* (sixty bottles, eighty bottles). Ang also announced that she was planning to arrive from Bangkok only the day before the wedding, but everyone (including Pea) quickly straightened her out on that one.

A wedding begins with the butchering of a pig, and this is usually done the afternoon before the ceremony. In this case, however, the pig (or pigs)

had to be butchered two days before, because the day before the wedding turned out to be a "Buddha day," a sacred day, and pigs can't be butchered on a Buddha day. Butchering a 200 to 300 pound pig is not an easy thing to do, let alone two in the same afternoon. A group of 10 to 15 men assembled at the back of the property—in the back garden—and set to work. Meanwhile, the cooks, who in this case were four women, began to get things ready (the cooks are paid, as is the man in charge of butchering). Tables were brought in, gas stoves, tamarind cutting boards. Tents were put up (all owned collectively by the village and kept at the village temple). Before long

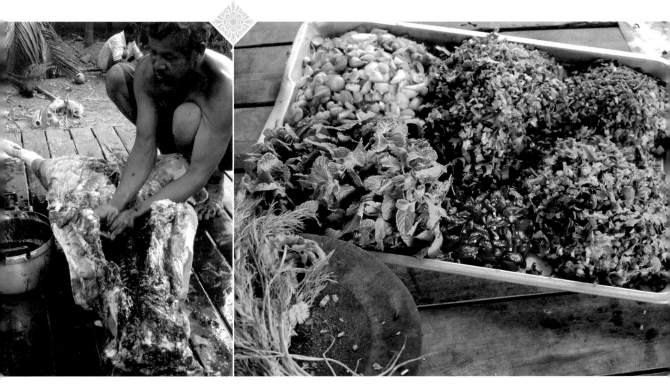

Left: Ohn is a man of many talents, and taking charge of slaughtering a pig for Ang's wedding is just one of them. Soon another ten men will join him to help. It is a lot of work, and must be done quickly and efficiently. Right: A lot of food must be chopped in preparation for Ang's wedding.

40 to 50 people had arrived—immediate family and relatives—and everyone was working.

As far as I can tell, and I have now been to many weddings, Khmer weddings are all about cooking and eating. The cooks are in charge of orchestrating all of it; they are the ones with the grand plan. As the pigs were butchered, separate parts of the pig were hustled into large ice chests. The pigs' skin got deep-fried. A portion of the ribs went into a *gaeng keow wan* (a popular curry, though not really a Thai-Khmer dish; see page 97), and early on they made a large *laab moo* (see page 88). In the cooking area there was a constant sound of dozens of cleavers—and machetes—pounding on cutting boards. Everyone was laughing, working, drinking. Loud speakers were assembled on

the street in front of the house, and *kantrum* music started to blare. Someone brought me a plate of sliced raw pork (*moo dip*) sprinkled with roasted rice powder. I dipped the pieces into a fiery hot chile sauce. Someone else brought me a shot of *lao khao*. Raw pork and rice whisky. Saying no was not an option, nor did I want to.

I have two jobs at weddings in the village, something I figured out from the beginning. I take pictures (and later put them on a CD for anyone who wants one), and I sharpen knives. I have a belt sander that I turn upside down, and it sharpens beautifully. I like to find a fun place to sit (a good people-watching vantage point), and then I settle in. People come back and forth with their cleavers and machetes, which are taking a beating. Pea

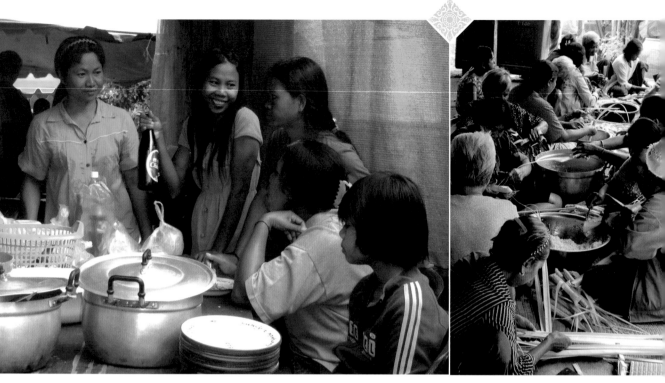

Left: Everyone has a job when it comes to making a wedding happen. Doi, Tian and Bap are in charge of serving. Right: On the day before Ang's wedding, everyone gathered to weave banana and coconut leaves into intricate sculptures for the altar.

comes constantly with food and drink, but before long I inevitably reach a point where I cannot eat another thing. Food, food, food! It's overwhelming!

Tables were set up for guests, and by the second day the guests started to arrive. These are people who are invited (as opposed to immediate family). Father's brothers' families, coming from other villages. Everyone is basically "family." That's what weddings are all about: food and family.

Guests arrive with a donation, money in an envelope. Someone is in charge of recording every donation in a large ledger. They record who made the donation and how much, and in the future, when someone from that other family gets married, you make a donation of the same amount (or more).

On the second day, everyone was dressed up, most commonly in silk sarongs, or the men in silk shirts, all usually handwoven by someone in the family. As each guest arrived they were greeted and shown to a table, and then food and drink was immediately brought in (in this case, as Ang has seven brothers and sisters, most of this work was done by them). After they eat, they were given more food to take home.

After one day of controlled chaos I was pooped, and after two days, totally spent. And the wedding hadn't even happened yet. By ten o'clock at night on day two—the music still blaring, the cooking and eating still constant—I saw a large white van pull up in front of the house, and slowly people

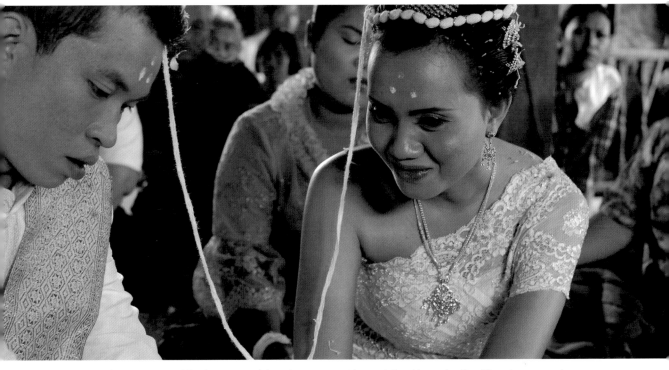

Upstairs in Mae's house. Ang and Bpuh get married. It is a happy time with people laughing and yelling. There is never a solemn moment.

began to get out, all looking a little bewildered. Someone yelled for Ang to come running, and she did. Her fiancé, and her future in-laws, had arrived (all from a village about 10 hours away). I felt my eyes get teary.

At dawn the next morning the actual wedding took place: a casual, happy, relatively low-key event. There were no Buddhist monks, as there might be in some other weddings. The groom, his family and most men (me included) were taken to a house a few blocks away. At that house there was a local band, mostly drummers, ready to escort us dancing our way back through the village streets.

There was *lao khao*, but not a lot, just enough to get rid of a morning's hangover (or to calm the nerves of the groom). When the band started up, the groom and the groom's family went first and we all followed, everyone dancing. We went slowly down one street and then up another, some people joining in as we passed.

When we reached Mae's house, the groom walked to the threshold of the property, hidden under an umbrella, and so too did Ang. They both went down on their knees and then the umbrellas were lifted.

Khai Mot Daeng

RED ANT EGG SALAD

RED ANT EGG SALAD WAS ONE OF THE FIRST DISHES I EVER TASTED THAT Pea cooked. We'd just moved to the village and we were out at the farm, Pea foraging and me just watching. It was just this time of year, early hot season, when everything looks and feels very bleak, the soil hard as concrete. Pea was showing me how to pick tree leaves and how to look for crabs that live underground. It was all very new to me, and interesting. But being out in the sun was really hot. At one point she spotted a nest of red ants (*Oecophylla* spp., commonly called "weaver ants") in a tall mango tree (the red ants particularly like mango trees), so we walked over to the barn and she found a long piece of thin bamboo with a basket attached at one end. We went back to the mango tree and used the long bamboo (and basket) to shake underneath the nest. It was not an easy task, working way up high. But she managed to separate a handful of ant eggs from the nest, and to bring the bamboo down. Pea was thrilled and I was amazed.

When we got back home, Pea, as she always does, disappeared to take care of what she had managed to forage. A few minutes later she re-emerged with *khai mot daeng*. She was so excited, as was everyone else, but for me, I thought, no, I'll pass. I write cookbooks—it's my line of work. But I'm also not the world's most adventurous eater. I grew up in Wyoming eating hamburgers, potatoes and chicken breasts, and after that I was a longtime vegetarian eating garbanzo beans and salad. I've always been immensely interested in what other people eat, and especially rural people, because rural people know so much about their food. But it doesn't mean that I always eat it!

"No, no," I replied, "thank you." But I immediately realized "no" was not an acceptable answer. I took the spoon and picked up a very small amount, putting it into my mouth. And smiled. It was fabulous. For one thing, it had all those pleasures of Thai salads in general: lime juice, fish sauce, chile. The ant eggs are white, and a little bit smaller than a peppercorn, and in the salad they absorb all the other flavors like tiny sponges. I've never eaten that much caviar in my life, but I think of *khai mot daeng* as a kind of Thai caviar. It's one of my favorite local dishes, soft in my mouth and even a bit tangy. The mature ants themselves are sometimes put into soups to add pungency.

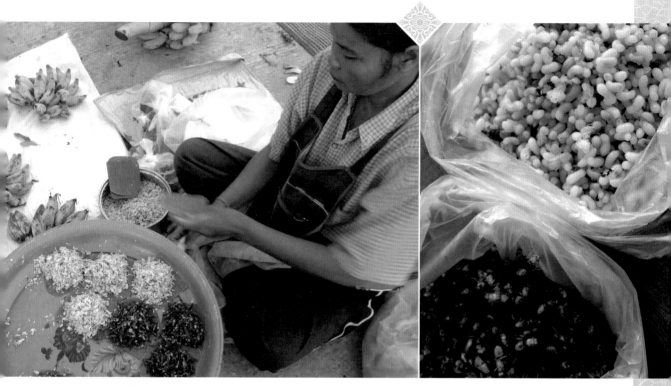

Left. As precious as they are, red ant eggs for sale in Chong Chom are relatively cheap. Right. You can buy red ants at many different stages, from egg to larvae to ant.

And there's another pleasure in eating red ant eggs that has nothing to do with taste. Call it "payback." Red ants terrorize me on a daily basis, and when they bite they really bite! Whenever I'm working around a mango tree they are a constant problem. Here in Kravan when I was cleaning under the large mango tree in the front yard for the first time, I found myself suddenly covered head to toe with hundreds of big red ants, all biting. The only thing that I could think to do was to rush into the shower and throw buckets of water over my body, clothes and all, as fast as I could. There were a bunch of people sitting around, and everyone was shrieking with laughter. But the good thing about the red ant bites is that the sting doesn't linger (there are several varieties of smaller ants here that are truly vicious). Interesting, too, that the ants themselves are often cooked into soups and curries (not particularly Pea's style of cooking). They are included to give a souring effect.

But back to the salad: We recently bought red ant eggs at the Cambodian border. Upon closer observation, what we bought was a combination of eggs

at different stages, some already ants with wings, which made no difference in the salad. When you first see the eggs in the market they look like a jumble of white and black.

To make a simple salad, put approximately 1 cup (250 mL) of red ant eggs into a bowl (I'm told that they are found in the southern United States). Add ¼ cup (60 mL) of slightly chopped fresh coriander leaves. Finely chop 3 green onions, both the white and green parts, and toss in. Add ¼ cup (60 mL) of shallots, also thinly sliced. Finely chop 2 or 3 bird's eye chiles (or more depending on how hot you want the salad to be). Mix in. Finely cut 1 stalk of lemongrass and mix in.

In a measuring cup mix 1 tablespoon (15 mL) of Thai fish sauce and 1 tablespoon (15 mL) of fresh lime juice. Mix and then pour over the salad.

Fourteen mi (22.5 km) from Kravan is a town called Prasat. I have read on the internet that Prasat has 17,000 people. I don't know if that is true or not, but Prasat is definitely bigger than Kravan. It's town!

Prasat is the hub for hundreds of small villages just like Kravan. There's a big bus station in the center of town where one can catch a bus to faraway Bangkok. There's a hospital, an *ampuh* (district) office building, there are banks, a farmers' collective. Prasat is where one goes to buy a motorbike, or fertilizer, or rice seed. It's where a young student can continue on in school after age 14, when the village school has finished.

To me, Prasat feels a little bit like the town where I grew up, Laramie, Wyoming. It's almost identical in size, and to some extent in function. Laramie was the hub for surrounding ranches, and people would come to town for supplies, for the hospital, for the banks and government offices. In Laramie I grew up as a "townie," and now I'm a bumpkin from the village.

Here, I love trips to town, same as I love trips to Chong Chom. There are street-food vendors and noodle shops, even restaurants. There are music stores with local music on CDs and VCDs, and farm supply stores with wonderful collections of herb and vegetable seeds. No matter how long we have in town, it's never enough time to look at everything. Eit, the older woman who lives next door to us in the village, told a funny story about coming to Prasat and seeing a new 7-Eleven convenience store. As she approached the store to look in, the glass door automatically slid open, and it frightened her almost to death. She'd never seen an automatic door, and this is a woman who is horribly afraid of ghosts.

The main reason we come to town is for the markets, especially the big markets. And we are not alone; everyone knows those dates: the 5th, the 15th, and the 25th. It feels like the population of Prasat doubles on those days, the six streets that make up the central market area crammed with vendors and shoppers. Teenage boys and girls hover in small groups, looking to catch eyes with a sweetheart. Children feast on Popsicles and candy. Parents dutifully shop for those things they can't buy in the village: secondhand clothes, school supplies, underwear and shoes.

The markets have exotic items as well. Just like in Chong Chom, there will be several vendors selling orchids from the jungle, the vendors I look forward to the most. Pea loves to buy tropical

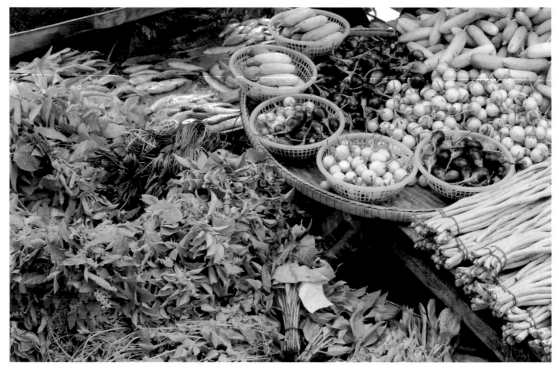

Compared to what is available in Kravan, the produce for sale in Prasat market is unimaginable.

fish—blue, red, orange, black. She has four large earthenware containers that she keeps them in, together with water lilies, lotus and other floating plants. Whenever we are headed to the market she will say "no more orchids," and I will respond "no more fish." But we both know that there will always be orchids and fish to carry home.

One long stretch of the market is made up entirely of older women selling silk they have woven by hand. They have bamboo mats laid out on the street, and they sit on the ground with all their wares around them. It's beautiful to see, but shopping here can be a little complicated. On several occasions we've bought silk, but buying from the right person and for the right price is a bit delicate. Pea will only buy from "family," because

to buy from outside of the family could be seen as an insult. Each time we've bought a piece, we've walked casually past the vendors, Pea whispers to me about who is family, about what our choices are. She asks me if I see something special (it's *all* incredibly special to me), and then I'm told to disappear while she makes the transaction. The going price right now is between 1,000 and 1,500 *baht* (35 to 50 American dollars) per piece.

We always buy food too. We buy fresh clams, small Thai oysters and cockles. There will be squid and sometimes fresh shrimp from the ocean five hours away, put out on ice. At certain times in the year we will find fresh asparagus, brussels sprouts and delicious okra. If Gung is with us, she buys fruit, any fruit, all fruit. Pea and I seldom eat fruit

Pea's true love is her tropical fish which she keeps in six beautiful pots, each with a different lily or aquatic green growing out the top.

(which feels strange, surrounded by tropical fruits all the time).

Every market day we run into friends from the village, or relatives from other villages. If it is someone I have never met before, we put our hands together and say, "*Sawatdee kap*," but at this stage I mostly see people I've already met, and in that case we both immediately look down at whatever the other person is carrying and ask: "*Seu arrai kap?*" ("What have you bought?") There will be a brief inspection, and then everyone carries on. Lingering too long is borderline impolite, as there are usually far too many people who want to move along.

Perhaps my favorite part of the market comes late in the afternoon. Under a large roof at the center of the market there are about 10 women who sell pork and beef. These are important stalls, and they are about the only ones with enough money to afford permanent stalls inside (almost everyone else sells on the streets outside). Surrounded by large chunks of freshly butchered meat, the women sit for long hours serving a steady flow of customers. The customer picks out the cut and the vendor cuts it, puts it on the scale and then wraps it up. But around five in the evening, loud disco music comes blaring from a nearby stereo, and all the women stand up on their cement platforms and start to dance. Customers still come through, and the vendors still cut the meat, disco-dancing as they work.

Ladna Thalay

RICE NOODLES IN BROWN GRAVY
WITH SEAFOOD

IN PRASAT, THERE'S A LARGE CHINESE-THAI RESTAURANT ON A CORNER ACROSS from the bus station, right in the middle of all the action. If we have time, I like to stop in and eat *ladna thalay*. The restaurant makes a great version—rice noodles with brown gravy and bits of seafood—plus it's just about the best people-watching place in town. Pea is never as enthusiastic about sitting and eating there as I am, but I think secretly she likes it the same as me. I always order the same dish, and Pea orders something different every time. Last time we were there she ordered the Thai version of steak tartare, which is unbelievably hot.

2 Tbsp (30 mL) vegetable oil, divided	½ cup (120 mL) mixed fresh seafood (shrimp, fish balls, squid)
1 cup (250 mL) fresh rice noodles	1 tsp (5 mL) fish sauce
1 tsp (5 mL) *dao jiao* (fermented soybean paste)	½ cup (120 mL) broth or water
1 Tbsp (15 mL) chopped garlic	Pepper to taste
1 cup (250 mL) mixed vegetables (cauliflower, carrot, kale), lightly steamed	

1. Heat a wok over medium-high heat. When hot, put in 1 tablespoon (15 mL) of the oil, add the rice noodles and stir-fry until hot, about 45 seconds. Take out and put on a plate.

2. Wash out your wok and dry it. Over medium-high heat, add the remaining tablespoon (15 mL) of oil. Toss in the *dao jiao* and stir-fry briefly (not more than 30 seconds). When hot, add the garlic and stir-fry briefly until it begins to brown. Add the lightly steamed vegetables and the seafood. Stir-fry to mix all the ingredients and cook 2 to 3 minutes until the seafood begins to cook (shrimp should start to turn pink).

3. Add the fish sauce and broth. Bring to a boil and cook 1 to 2 more minutes, cooking the seafood but keeping the vegetables tender but still firm. Toss in the rice noodles and cook 1 minute more. Sprinkle pepper on top. (A traditional condiment served with ladna is a chile-vinegar sauce. Make your own using rice vinegar as a base, and then mix in a chopped mild chile.)

MAKES TWO SERVINGS

Hoi Nang Rom
FRESH OYSTERS WITH FRIED SHALLOTS
AND TREE LEAVES

THREE OF THE FOODS WE EAT COMMONLY—OYSTERS, COCKLES AND CLAMS— are not at all local, but it almost feels as if they are because they are so easily available. All three (and also horse mussels and green mussels) are farmed in the Gulf of Thailand and magically arrive fresh in Kravan's small Thursday afternoon farmers' market. They aren't for sale every week, and sometimes there are cockles but no oysters, or clams but no cockles. All three are also really cheap; 8 oz (225 gr) of oysters costs roughly 29 *baht* (1 American dollar).

There are three different oysters that are both farmed and found in the wild in Thailand. *Crassostrea lugubris* and *Crassostrea belcheri* are larger and elongated, but the variety we get—*Crassostrea commercialis*—is smaller and rounder. All three have been farmed here for well over 50 years, and there are also two varieties of pearl oysters grown for the production of pearls.

When we buy oysters they have already been taken out of the shell. They come in small plastic tubs and are sold on ice. A very common dish in Thailand, as in other parts of Southeast Asia, is to cook the oysters as part of an omelet, but we always eat the oysters raw and on the same day that we buy them. Pea immediately soaks them in soda water for at least 30 minutes, which makes the surface of the oyster, which is tinged with black, go entirely white. She then puts them in a bowl and covers them with ice.

The hard work then begins. If we have ½ pound (225 gr) of oysters, Pea will begin peeling approximately 2 lbs (910 gr) of shallots. Thai shallots are quite small, so peeling 2 lbs takes time. After they are peeled, they must all be sliced, relatively thinly. Pea then heats a wok over medium-high heat, puts 1 cup (250 mL) of oil into the wok, and when the oil is hot she deep-fries the shallots until they are golden brown. And then they are drained.

Nam Jeem (Fiery Fresh Chile Sauce, page 25) is prepared, and finally, if *krathin* leaves are fresh on the tree, someone is dispatched to gather the leaves, about two large handfuls. The leaves are then washed and put out neatly on a platter, together with the deep-fried shallots. A bowl of *nam jeem* is put out alongside, and finally the oysters, still under ice.

At this point we usually sit down in front of the TV. We each have a bowl and a large spoon. Then, we first put a single oyster onto the spoon, then a small bunch of shallots that we gather with our fingers. The *krathin* we fold into 1-in (2.5-cm) lengths, and pile on top of the oyster. Finally, with a small spoon, we take a helping of *nam jeem* (Pea takes much more than I) and drizzle it on top.

The whole spoonful is eaten all at once, and immediately we start making another. The oyster is slippery and cold, the *nam jeem* fiercely hot, the shallots savory and the tree leaves fresh.

It's absolutely one of the best meals I have ever had.

kids

Today's been a delightfully quiet day. Maybe it's because Ahn across the road isn't here, since she's visiting in another village. Ahn's absence in and of itself makes for a quiet day. But it's something more than that. Part of it's the heat, and the fierceness of the sun. And part of it's the absence of kids—all are off at school. When the village is quiet, it's really quiet!

Everything will change when four o'clock rolls around, when the kids come home from school. As much as I appreciate the quiet, I do love four o'clock. The sun is lower in the sky. The heat gives way a little bit. I like to sit out in the thatch and watch as the bicycles suddenly appear: big ones, little ones, old ones, new ones. All the kids are happy; the school day is over, after all. They cycle into their front yards, quickly jump off their bikes, *sawatdee* their elders (me included) and then disappear into the house. Schoolchildren in Thailand all wear uniforms, and the first thing they do when they get home is change clothes. The uniform goes into the wash, and the kids immediately reappear in casual clothes and speed off on their bikes. The quiet village comes instantly to life.

There are a lot of things that are less than perfect about village life, but kids on their bicycles in the late afternoon sun, laughing and smiling, isn't one of them. Three kids ride on one bicycle, or an older sister pedals her younger brother. Kids here are good on their bikes. Tey, Gung's cousin, contorts his little BMX-style bicycle into a different shape with each passing week. He turns the handlebars 180 degrees, as if the bicycle should be going in reverse. He paints it red, then green. His little brother, Ip, stands erect on the back of the bike, feet barely supported on the back axle, his hands holding on to the shoulders of his older brother. Up and down the dirt streets of the village, kids ride with abandon. It doesn't get much better.

By dark it all comes to a close. There's dinner, a bit of TV ("to watch" in Thai is *do*, and "TV" is TV, so to watch TV is to *do* TV), a bit of homework and then a shower and bed. On Saturday and Sunday there's no school; it's never quiet on the weekend.

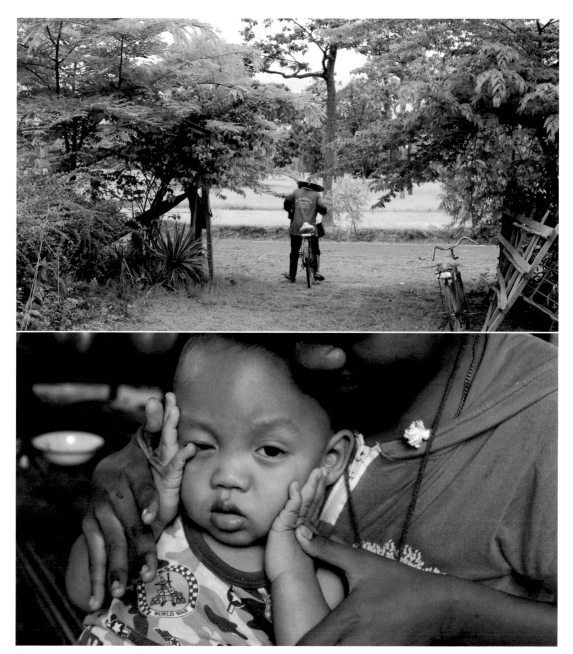

Top: There are motorbikes and the odd car or old truck in Kravan, but bicycles far outnumber any other mode of transportation. Bottom: Everyone loves babies in Kravan, and what's not to love? Gung holds Boy, who we call "Busy Boy" because he never sits still. Boy is a Thai name, having nothing to do with his gender.

Pla Nin Tort

CRISPY FRIED TILAPIA

PEA MAKES SO MANY DISHES LOOK SO EASY TO PREPARE, AND THEN WHEN I try to make them on my own, of course, they're not easy at all. And this is a perfect example. Crispy fried tilapia has become a kind of comfort food for me, something I'm happy to eat almost any time. It's crispy (which I love), yet tender and fresh. I can eat it just as is, or with *Nam Jeem* (Fiery Fresh Chile Sauce, page 25) and slices of cucumber, fresh coriander and green onion. Here in the middle of hot season, eating can be problematic because the heat just zaps my appetite. My "office" is hot, the house is hot and outside it's even hotter. The only time I'm really hungry is after dark. But at least then I can eat *pla nin tort*.

The other night I tried making it on my own, Pea looking over my shoulder, laughing. I'd watched her make it a dozen times, and it seemed easy enough. But cutting the fish in the same way that Pea does (which includes basically slicing the fish in half lengthwise) was not at all straightforward, and when it came time to fry the fish, mine turned out not nearly as beautiful as hers always do.

I guess it's called practice.

1½ lbs (680 gr) tilapia	1 cup (250 mL) vegetable oil
2 Tbsp (30 mL) soy sauce	

1. Using a very sharp cleaver or kitchen knife, take the scales off the fish. It's easiest to hold the fish behind the gills as you take the scales off. When the scales are off, cut the fish down the center, along the line of the dorsal fin, cutting from head to tail. Make a small cut and then continue to work your way down, trying to stay as close to the surface of the ribs as possible. Don't be in a hurry; it takes some time.

2. When you get near the base of the rib cage, stop cutting and with your hands work the two sides apart, leaving the bottom skin still in place. Open up the fish so that the two sides lie flat. At the base of the fish there will be the guts, which you take out. Toss the fish into a large pan or sink of water, and clean thoroughly. Drain. Put the fish into a bowl and sprinkle on the soy sauce. On the surface

of both sides of the fish, cut several parallel slices into the flesh, which will allow for even cooking. The fish is now ready to be fried.

3. Heat a large heavy wok over medium-high heat. Put in the vegetable oil and wait until the oil is hot (but not smoking). Very carefully lift the fish with a metal spatula, cut side down, and slide it into the hot oil. At first the fish will stick, but nudge it loose with the spatula. Parts of the fish will start to curl up, but just nudge them down into the oil with the spatula. Cook approximately 4 to 5 minutes and then turn. Cook on the other side for another 4 to 5 minutes, and then turn one more time and continue to cook for about 2 minutes. The fish should have a nice brown color and be crispy in texture. When finished cooking, remove from the wok and drain briefly on a strainer set out over the wok. The fish is now ready to serve. Serve either unseasoned or with *Nam Jeem* (Fiery Fresh Chile Sauce, page 25) and slices of cucumber, fresh coriander and green onion.

MAKES THREE TO FOUR SERVINGS

buddha day

Yesterday morning, like almost every morning, I got out of bed, went downstairs and started to look around the garden. From across the road I heard a loud voice (you know who) yelling: "Jiep, *pai dten, deeo nee. Plian seu, seu soowai. Reho reho. Kantrum.*" ("Jiep [my nickname in Thai] go dancing, right now. Change clothes. Good-looking clothes. Quickly quickly. *Kantrum* music.")

I had no idea what Ahn was talking about, but I knew enough to go upstairs and quickly change my clothes. Ahn may be loud and bossy, but she's a dancer, and she knows that I like to dance. Pea didn't want to go. She's shy about dancing (I don't as yet know why, because she dances beautifully).

Ahn and I walked down the street, made a turn, walked a bit more, and sure enough, there was already a crowd of maybe 30 people dancing. There were two trucks: one had the sound system and a dj, and the other I assumed was a wedding party, four young women in fancy clothes and all made up, wedding-style, traveling in the second truck. Ahn and I joined in. It was early, everyone just finding their dancing feet. There was of course a quick shot or two of *lao khao*.

The night before we'd had rain all night long, an early season rain, and so the roads were mostly mud. Dancing in flip-flops was tricky, mud splashing back up on everyone's legs; but soon we were all covered waist-down in splatters of mud, so it

made no difference. The day was overcast and not so hot, a great day for dancing.

Within an hour we had several hundred people. We danced from Kravan to Ban Sai, from Ban Sai to Ban Talot Pho (the neighboring villages). We danced from farm to farm, and almost everywhere people came out to greet us. People would join in, or they'd bring water, Coke, Sprite, *lao khao*. After a while the sun came out and the day became hotter. Like spectators watching a marathon, people on the side would splash all the dancers with water, a relief to everyone dancing.

At first people were surprised that I, as a foreigner, could dance to *kantrum* music, but soon I just became one more person in the crowd. People would occasionally dance up and urge me to use my hands more, in traditional style, bending my fingers way back and sort of sculpting the air. And to make them happy, I would for a bit, and then I would go back to dancing the way I am used to.

Here in Isaan, and in Thailand in general, I

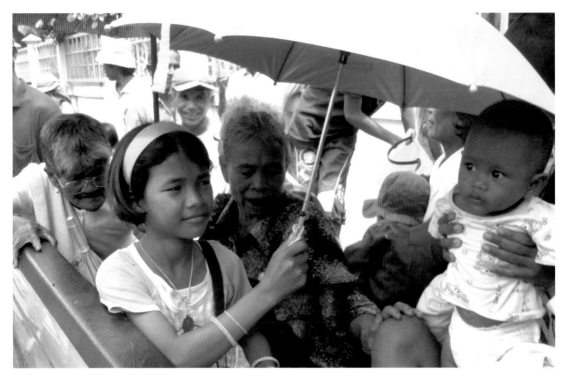

Ning and baby Off have the best seat in the village for dancing day.

have danced a lot. If I go to Bangkok, my favorite thing to do is to go dancing in Isaan clubs. The dancing and the music are a lot like Isaan food: they're important ways for Isaan people to hold on to Isaan culture.

The best dancers, in my opinion, are rural people, people who've been dancing since they could walk (by far my favorite dancer yesterday—which is saying a lot—was a woman who is, I am sure, over 70 years old). Rural people dance from their hips and thighs, which also partly explains why rural people are so good, because from farm work they are incredibly strong in their hips and thighs! Everyone focuses on the hands (as in classical Indian dancing—the main influence, I am sure, on dancing here, via the Khmer Empire). At a very young age, girls, and some boys (such as Bpoo), train their fingers to fold back at the joints, so that they can be beautiful when they dance. But it doesn't make them good dancers, at least for me. When you dance to traditional Khmer music (*kantrum*) or to Lao music (*morlam*), you never touch another person, but you can dance *around* someone, almost like making love without touching. Men dance with men, women dance with women, men dance with women, and many dance alone too. It's beautiful always, but when two people are really good, it's *really* beautiful.

We danced four hours, five hours. Today I can barely make it up and down the steep wooden stairs: a small price to pay. Oh, and it wasn't a wedding after all. It was to raise money to help build the new temple that is under construction at the end of the street.

how to kill a chicken

Last night Pea, Mae and Gung all headed off on the motorbike, three to the bike, to find the new young white calf that somehow got loose at the farm. I don't quite understand, but right now there's lots of commotion around the cows, and it's not just Pea's cow. I think it has to do with it being time to plant the fields, and so it's time for the cows to come back. A few days ago Tat, back from Bangkok, worked all morning building a small stable for the new young cow (who is a recent addition, along with two small pigs).

But Pea, Mae and Gung were gone for a long time, and by the time they came back home they were exhausted. They hadn't succeeded in catching the cow. Pea was particularly frustrated and tired. "We should sell the small cow," she said, falling back into a hammock. Gung brought Pea a beer. Mae put some rice on to cook, then turned on the TV. No one was happy about not catching the cow.

Seeing Pea in the hammock, I knew that she was thinking about the chickens that she'd bought earlier in the day from a neighbor, about needing to cook at least one and about being tired. Sure enough, soon she got up and walked over to the chickens (who were cluck-clucking under a woven bamboo basket), her long arms flowing and long legs striding even more than usual, as if to gather a tiny bit more energy.

"Why you not kill chicken?" she asked me as she grabbed one chicken by the legs, the chicken now screaming, and then put the basket down quickly over the other chicken.

"I don't know how."

"You never kill chicken?" Pea asked incredulously. She looked at me, a quick sharp glance, still not believing. "I teach you." She walked around with the chicken screaming, Pea oblivious. She found a cleaver, set the chicken down and quickly sliced the chicken's throat. She then tossed it aside, having other things to look after. Already, both charcoal burners were beginning to get hot, and on one there was a large pot of water for rice. Pea walked over to inspect the fires, then walked back, picked up the dead chicken and plunged it into the boiling water. She made sure that every part of the

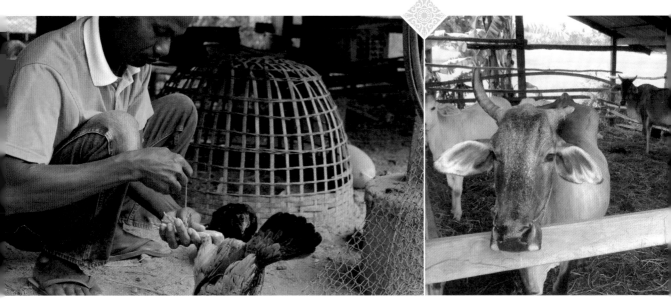

Left: Brother number three, Tee, ties the feet of one of Mae's chickens that he is taking home. Right: The white cows in the barn look so peaceful, but they are mischievous.

chicken stayed submerged, but not for long. Maybe 30 seconds altogether, holding on to the feet the whole time. Then out came the chicken.

Immediately Pea set to work, plucking off the feathers. They came off easily, but it still took a while, a good five to ten minutes. The big feathers were easy, but all the smaller feathers took time. When she was almost finished, she held the chicken over the fire to singe any last feathers, always rubbing, stroking the chicken, cleaning with her hands. When she was satisfied that the chicken was ready, she set it down on a tamarind cutting board and deftly, swiftly cut open the chicken's underside, and then spread the chicken out to expose the innards.

"Mae and Kaesorn, when I not here, I don't know what they eat. Maybe they don't eat," Pea said, almost to herself, with a tiny laugh as she worked on the chicken. "They don't know to cook.

Father teach me everything about cooking. He teach me to catch frogs, to find crabs. When I seven, I could cook. That's why he loved me so much."

Pea loved her father. She loves her mother immensely, but her biggest bond was maybe with her father. "Father teach me everything," she continued, picking up a piece of bamboo and then slicing off a long thin reed with a cleaver. She then threaded the long reed up the inside of the chicken's intestine, which she had already removed, cleaning out the inside of the intestine, a process that took several minutes. "Inside, not clean," she explained, finally finishing the task, rinsing the intestine in water, and then moving on, butchering the chicken.

Last night we ate steamed chicken (*gai nueng*), rice and *nam jeem*. We sat outside in the thatch, sitting cross-legged. We ate and barely said a word, everything tasting so good.

Yam Het

SPICY MUSHROOM SALAD

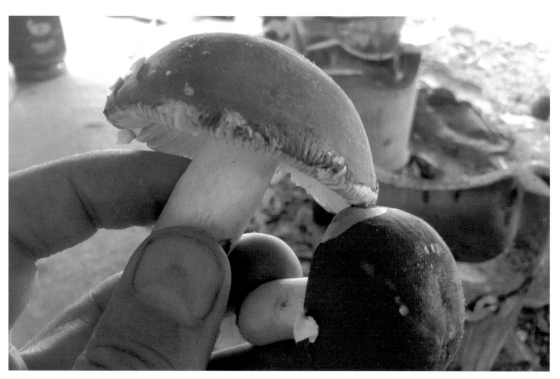

There is a seemingly endless variety of forest mushrooms.

THERE ARE UNWRITTEN RULES ABOUT HOW FOOD MOVES FROM HOUSE TO house in the village, and I probably only know a few of them. When I first came to Kravan I was constantly amazed by how communal food preparation and eating was within the village. Sister-in-law Doi would make a large *gaeng* and then bring some over to Mae and to Pea. Pea often cooks in large quantities (though never with rice, see Rice, page 107). If she is going to the trouble of making a dish she doesn't often make (like *Hor Mok*—Fish "Mousse," page 158), she will cook a large quantity, knowing that, as something special, it will be eaten in several households, and mostly among family. Food is shared.

But the rules get more complicated. Ahn and Aht across the street often eat with us, though they're not family. Sometimes this is okay, and sometimes not (it can irritate Pea at times). This is also true with Eit, the single woman who lives next door in the tiny little shack. Eit will often gracefully disappear when she knows that a meal is coming, but not always (which is generally fine because everyone knows that Eit doesn't have much money). However, sometimes Eit secretly "harvests" a large bamboo shoot from Mae's giant bamboo in the back garden, and this, again, irritates Pea. "Don't steal from my mother," she will sometimes say beneath her breath.

Children always get fed. Also, if a family has sat down to begin eating and someone appears at the door, they will always be asked to join in. More often than not the person will decline, but the invitation has to be made.

Doi brought over this spicy mushroom salad made with wild mushrooms that her husband, Tat, brought back from his drive home from Bangkok. Oyster mushrooms work almost as well.

2 cups (475 mL) water

1 lb (455 gr) oyster mushrooms

1 Tbsp (15 mL) vegetable oil

3 Tbsp (45 mL) finely chopped garlic

3 Tbsp (45 mL) finely sliced shallots

1 tsp (5 mL) dried crushed red pepper

3 Tbsp (45 mL) fish sauce

3 Tbsp (45 mL) lime juice

1 cup (250 mL) fresh herbs (mint, coriander, basil)

1. Bring water to a boil in a medium-size pot. When boiling, add the mushrooms and cook until just tender, about 3 to 4 minutes. Remove the mushrooms and put into a salad bowl.

2. Heat a small skillet over medium heat. When hot, add the oil. When the oil is hot, add the garlic and shallots. Fry 2 to 3 minutes until lightly browned and then add to the mushrooms.

3. Mix the crushed red pepper, fish sauce and lime juice and toss together with the mushrooms. Finally, mix in the fresh herbs and serve.

MAKES THREE TO FOUR SERVINGS AS A SIDE DISH

madrid, nebraska

These days I have been thinking a lot about the concept of "here." Laramie, Wyoming, where I grew up, is a high desert (7,300 ft/2,225 m above sea level and less than 7 in/18 cm of rain a year—an amount of rain that we can get in two days in Kravan). As my groundwater hydrologist friend used to say, people probably weren't meant to live in Laramie. The place was surrounded by ranches and sagebrush, definitely not by farms.

My mother's aunt, Aunt Georgia, lived in western Nebraska, about a three-hour drive away. She lived in a small village named Madrid, a place we visited several times when I was growing up. When we drove east from Laramie, we'd almost immediately drop down in elevation, leaving the Rocky Mountains for the Great Plains where Madrid is situated.

One visit I particularly remember was in the summer. We drove across I-80, exited, drove a while farther on back roads, and suddenly we were in tiny Madrid. The cottonwoods were in full leaf, and there was not a car to be seen on the four or five village streets. It was peaceful and green. We arrived at Aunt Georgia's and turned into the long, well-kept dirt driveway, a dog running, barking, coming to greet us.

Aunt Georgia moved to Madrid because her daughter, Betty, married Jake, and Jake was a farmer from Madrid. Madrid was, as far as I can remember, the only farm village I had ever known before coming to Asia. Betty and Jake, Aunt Georgia, a garden with tomatoes and cantaloupes (absolutely impossible in Laramie), and fields with corn, in all directions, twice as tall as I was: this was what "farm" meant to me.

Here in Kravan I sometimes think about Madrid. Is Kravan the same, or different? Isaan is a far more inhabited landscape than western Nebraska, that's for sure. Kravan is one of hundreds of villages, more or less side by side; there is little land here that isn't a village or under cultivation. Western Nebraska is sparsely populated, about as unlike the Thai-Cambodian border as North Dakota is unlike Bangladesh. But inside the village? Every morning people leave to work on their farms, and every evening they come back. The farm is a private place, and the village is family, relatives, friends, and a wee bit more. That's the same.

How have I ended up in Kravan? Maybe, the same as Betty: she met Jake.

Jingreet
HOW TO COOK CRICKETS (NOT GRASSHOPPERS)

WHEN I FIRST CAME TO LIVE IN KRAVAN, I KNEW ALMOST NOTHING ABOUT this region of Isaan. On one of my first opportunities to use the internet, I wanted to learn more about the frogs of this region, because here they're so much a part of daily life. The first site I came to—probably after searching "frogs in Cambodia"—explained that frogs are an important part of Cambodian cooking because of the French influence. I remember laughing out loud to myself in the internet café. It still makes me laugh to myself. And I suppose that the reason people here in Kravan love crickets, grasshoppers, snakes, *gamore* and red ant eggs is also because of the colonial French influence.

Jingree (cricket) season is finally here. Pea went out last night with a friend, Nee, a battery pack at both their waists, flashlights around their heads like coal miners. They were giddy with excitement. They both threw back a quick shot of *lao khao* and headed off together on the motorbike (I should have gone, but didn't). A few hours later they returned, each with a two-liter plastic bottle half full with *jingreet*. It was a big score, and they were thrilled.

Today Nee came over and together they cooked the *jingreet*. The method of cooking crickets is much different from cooking grasshoppers, and even more labor intensive (see *Jukitan*—How to Cook Crickets, page 76). Like with the grasshoppers, the crickets (which are still alive) are put into a large pot of water, which kills them. Each cricket is then picked up from the back side, and Pea puts her thumb under the head of the cricket, overlapping onto the abdomen. With her thumb she pushes gently, making the innards of the cricket come out just underneath the legs. She then throws the innards away and tosses the cricket back into another basin of water. She does this with every single cricket.

When all the crickets have been cleaned, she puts a large wok over a hot charcoal fire and waits briefly for the wok to get hot. When it's hot she puts the crickets in (no oil). The crickets "dry fry" for 2 to 3 minutes, and then they're covered with a lid, sealing in the natural moisture of the crickets. They cook 4 to 5 minutes longer, covered. When the top comes off, there's a lot of liquid (and the smell is a little bit bad, a little bit pungent). Pea then continues to cook the crickets with the lid off until all the water has evaporated (and so has the smell). She then sprinkles on a little salt and they are ready to eat.

These crickets are for sale in Chong Chom on the Cambodian border. But Pea will never buy crickets (or frogs) that someone else has cooked—she will only buy them if they are alive.

Crickets must have a lot of body oil, because when I first ate crickets here I assumed that they'd been deep-fried. But they're not, and still they're unctuous. There are several interesting nutritional studies in Thailand done by Thais regarding rural people eating insects, and they all agree that eating insects is a good thing: insects are free (if you catch them yourself) and they are a very good source of protein. One study mentioned looked into the question of whether or not the consumption of insects affects the overall insect population. No, it concluded, it doesn't.

play water

For four days I resisted, staying upstairs, needing to write, to work and also knowing that I just wasn't ready for what I knew was inevitable. But yesterday Pea came into "the office" around noon and said, "Now, come, play water."

"Working," I mumbled, knowing full well that my excuses had run out.

"Take holiday. Come on. Now."

"I will just finish up, and close computer," I conceded, though not entirely. Pea walked out and went downstairs, where I could hear laughter and mayhem, now in its fifth day. This is Songkran, traditional Thai New Year, mid-April, at the height of the hot season. It's a time when everyone throws water on everyone else. It's a time for enormous water pistols and buckets of water by the thousands. Gung and her friends have plastic trash cans set out by the roadside, constantly being refilled with the hose (the old well doing its best to keep up). The kids wait until someone passes—on a bicycle, on a motorbike, in a car—and then they attack with water.

If a family has a truck, everyone piles into the back, also carrying large containers of water (they remind me of a more benign version of armed militias I would see on TV, roaming the streets of Liberia for Iraq). When a truck approaches a group like Gung's, buckets of water fly in all directions, mixed with happy screams. It's beautiful. But this year, five days, I knew I couldn't do.

"Jeff," I heard Pea shout from down below, "*ma ma ma*" (come). I carefully stored my laptop and down I went. I wanted to grab my camera, but I knew that it was out of the question (knowing that it would get wet). Before I reached the last wooden step, I was drenched in water, head to toe. And in case that was not enough, I was drenched again. And again.

Songkran, New Year, Water Festival—no matter what it's called, it's age-old. It's a whole lot older than Thailand. In some form or another it happens all across this strip of Asia, from India (where it's called "Holi") to Burma to Thailand. It's a very simple call for the rain gods! Daytime highs are 100F (38C) and higher. Rice cannot be planted before the arrival of the monsoon rains. Life cannot go on. If we, with joy, soak everyone with water—everyone, babies, grannies, everyone—over and over again, then the rains will come.

It's a party, a big party! I was soaked (and it felt wonderful), and immediately I was handed a

Songkran is five days of throwing water. Children, exhausted by the end, throw water on each other and on anything and anyone that passes by.

glass of soda, ice and "Johnnie Red" (as Johnnie Walker Red Label is called here)—a big splurge. I found a place to sit and to watch, and in minutes someone came to refill my glass. I knew what was in store. At the end of my second glass, I was ready. In my bare feet, in what was now mud, I walked out to join Gung's group, where Pea was already standing. I went to pick up a large water pistol not being used, and, as I bent over, another large bucket of water came directly over my head. I turned quickly around and, with the water pistol, unloaded a strong steady stream of water in a young boy's squinting, giggling face. This was my first 10 minutes, and for the children, their fifth day! The good humor was intoxicating.

I went over to the thatch to see if there was anything to eat, knowing that there was bound to be good food. There was *som tam*, of course, but not a plate of *som tam*—a platter! And there were tiny deep-fried frogs, their tiny heads and arms, their long legs sprawled and crispy. I picked up a frog and crunched down; it tasted like the most perfect food to eat, packed with crunchy flavor in a tiny morsel. Johnnie Red and fried baby frog. I reached into the platter of *som tam* with my fingers, grabbing a small mouthful. And like the baby frog, the taste exploded in my mouth, the pungency of the *pla ra* (fermented fish paste) and the intense chile heat. I grabbed another frog and went back into action.

A "militia truck" pulled up, but seemingly without anyone in the back. It came to a stop, and there was a pause, and then up from the back jumped adults and kids, maybe 10 altogether. Immediately water was flying everywhere. And it's not like the water is merely thrown, it's flung with all of the force that one can muster. And still everyone just smiles, and shrieks.

A large ice truck arrived (doing a very lively business this time of year, and especially during Songkran), and two men stepped out to deliver two large bags of ice. The bags were heavy, and the two men, strong. A bag was lifted on top of a shoulder and then carried to the ice chest. But en route the men were pummeled with water, bucket after bucket. I almost expected the men to be angry, but instead they melted into smiles (over these five days, I never saw a single person angry).

I walked back over to check out the food, and to refresh my Johnnie Red. Someone had brought freshly cut sweet jackfruit and durian, the smells and taste almost overpowering, but in a good way. Perfect. Durian, ripe jack, and fried baby frog—phew!

Six hours later the sky was filled with dark clouds, and there was thunder and lightning. The kids—actually, everyone for that matter—were now shivering, part cold, part tired, part not wanting to stop. A big clap of thunder and then rain started to fall. Then it started to pour.

Songkran had worked. Happy New Year.

the beginning
of the rain

delirium

Yesterday afternoon, early May, the rain didn't just break. It pounded. It pummeled. It drove like a 16-wheeler down I-80 on a hot summer's night. It came just short of scaring the pants off me. An eaves trough collapsed, and we tried frantically to put it back up, everyone instantly drenched. But there was no way we could put it back up, and we started to laugh in the rain. Rain! I looked across the street at *Ban Off* (baby Off's grass hut), the tall coconut palms bent at wild angles with wind and rain. It looked like a hurricane on the television. The rain just poured and poured. Everything was mud, rivers of mud.

At some point, afternoon giving way to evening, the rain still pouring, we all sat down inside the house for dinner, our whole world somehow different. No one turned on a fan; there was no need. The reception on the television was terrible, but with the pounding rain on the metal roof, we couldn't hear anyway.

We finished eating, then got up and washed off our plates, just like every night. Gung and Mae rolled out the tiny mattress where they sleep each night. Everyone brushed their teeth. Time for bed.

We came upstairs and got ready for sleep. We turned out the light and then suddenly there were footsteps on the long wooden stairs. Through slats in the wooden walls I saw flashing lights outside the room. I jumped up, terrified, thinking something bad had happened. I opened the door and there in the dark were Gung and Mae, flashlights fixed to their foreheads, an indescribable eagerness in their faces. They were each carrying a woven basket, and quickly, in Khmer, Mae told Pea to come.

Pea leaped out of bed, almost delirious, angry at the thought that she'd missed even a minute of the action. She strapped a flashlight to her forehead, grabbed a raincoat and was instantly gone.

I looked out the front window and watched daughter, mother and grandmother zigzagging

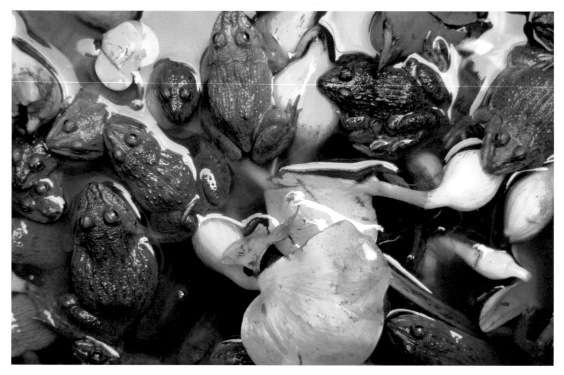

When Pea first began raising frogs we had five hundred. Three months later we had zero. People here like frogs.

their way down the street, the rain still pouring and the lights from their flashlights darting in all directions, facing down. And then suddenly I heard a wild sound, louder even than the pounding rain on the metal roof.

The frogs had returned!

Pak Sien Dom

PICKLED GREENS

PEA AND MAE MAKE PICKLED GREENS FREQUENTLY, BUT ONE BATCH SELDOM tastes like another (though all are good). They have an easy fresh taste, not at all salty. Mae makes a delicious one with tender green onions and another with Chinese mustard greens (*brassica juncea*). My favorite of all is one Pea makes now, in rainy season. The Thai name for the green she uses is *pak sien* (*Cleome gynandra*). People grow it starting from seed in their gardens, and it does well in rainy season (when a host of other vegetables don't thrive particularly). It's picked as a tender shoot, but even still, the taste is bitter (*kom*). Pea seldom cooks with it, almost always pickling it instead.

Almost all of the "pickles" made by Pea and Mae are what I would call "day pickles." There's no intention of canning or preserving for a long period of time, and just setting the greens aside at room temperature overnight generally makes the pickles. They're then eaten over the next day or two.

Pickles in this form are common throughout Thailand. In certain circles they're thought to be a good food for a hangover. I think they are especially good eaten not for a hangover, but with a cold beer!

1 lb (455 gr) greens (such as green onions and kale)

¼ cup (60 mL) salt

2 cups (475 mL) water

1 tsp (5 mL) sugar

1. Rinse the greens thoroughly and strain. Place in a large bowl and sprinkle with salt. Knead the salt into the greens, almost as if kneading a bread dough. Add the water and sugar and leave overnight.

2. The pickle is ready by the next day.

MAKES ABOUT 2 TO 3 CUPS

planted

May 23, a Sunday, and as of tonight the fields are planted. Everyone was up before dawn, making food, gathering supplies. Tee, Pea's third brother, came with a small Kubota tractor. Two cousins came each with a two-wheeled Kubota, each pulling a wooden wagon. We loaded the wagons with 600 lbs (275 kg) of rice seed and all our various supplies and we headed out.

When we arrived at the fields everyone quietly got started, knowing that it was going to be a long day. Like everyone else, I picked up an empty five-gallon (20 L) plastic bucket, made a sling with my cotton sarong (which I felt proud of myself for remembering) and then loaded my bucket with rice seed and lifted it so that the sling went over my shoulder and shared the weight of the seeds. I walked out on the field and then started to toss the seeds. I'd gather a large handful and then with a strong flick of the wrist I'd toss the seeds as I walked. Several people came by to help me improve my method (always), but generally, we all just worked. Pea and Mae, Doi and three cousins: we were seven people tossing the seeds.

After the seeds were spread on one field, which didn't take long (the fields are small, about a quarter acre), Tee came with his tractor fitted with a disc harrow and a rake behind. The tractor took much longer to cover the field than it did for us to spread the seeds, but after the tractor had finished with a field, it looked beautiful.

Around mid-morning Pea left the fields with a bucket and a fishnet. When I first met Pea I might have wondered what she was doing, but now no longer. I knew that she was going foraging, and probably for frogs. So I went along with her, a foraging slave. Wherever there was water (that I would never in my life set foot in, for fear of snakes) she'd walk right in, her blue jeans immediately soaked, and then with the net she'd fish for whatever she could find. She pulled out tiny frogs, about ½ in (1.25 cm) in length and less. She pulled out snails, huge snails, about 3 in (7.5 cm) in length. She pulled out crabs. "Snake" she called out, as if she were simply saying "frog." She pulled the small snake from the net and tossed it at my feet, knowing that it would cause momentary distress (she likes that stuff…). She didn't find a lot, which I think was not a surprise. She just likes doing it, and I get it. But I'm not walking in the water. Maybe next year.

For lunch we gathered in the barn and set out food that had been prepared at home. Tee and

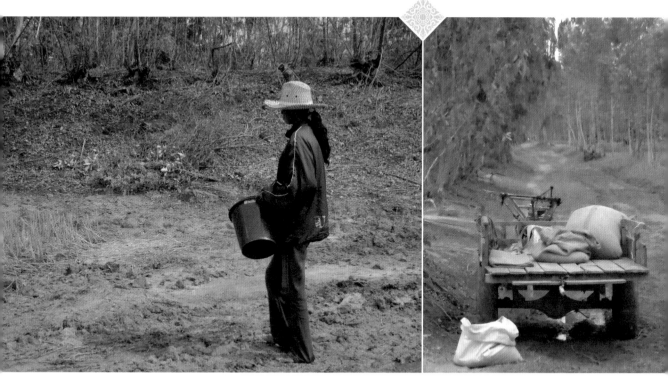

Left: It is hard to get started first thing in the morning knowing that there is a long day to come. But planting is a whole lot easier than harvesting! Right: This is the rice seed to plant 32 *rai* of land, which is approximately 12 acres. Mae divided the 32 *rai* into eight "farms"—one for each child. Pea has 4 *rai*, which grows enough rice for us to eat all year long.

I had a shot of *lao khao*. Everything was pretty low-key, just the seven of us. Planting is nothing compared to harvest. Harvest is dusty, hot and hard work, and lasts for weeks. Planting, for us, is a single long day (covering 32 *rai*, or about 12 acres/5 ha). The day was overcast, not hot. And with planting, there is a wonderful sense of expectation.

I've heard various theories about when to plant. "In Surin Province," one older man told me, "we plant after six big rains. In Sisaket Province, seven." But when I asked Pea, she just shrugged. She didn't have to answer my question because she knew that I already knew. She

plants when Tee has time with the tractor, and other people have time to help. Simple as that. But planting times, from my observation, vary enormously. The rains came early this year, by about three weeks. And while it was nice to have the rain, I certainly wouldn't have planted a field based on a few early rains. But many people did, and they were right.

After lunch we all got back to work, and by dark we were done. We climbed back into the wagons, gathering all our gear, and bounced our way (the dirt road has many big potholes) back to the village, back home.

The fields are planted!

Hor Mok

FISH "MOUSSE"

HOR MOK HAS ALWAYS BEEN FOR ME ONE OF THOSE MYSTERY FOODS IN Thailand, a dish that I'd never learned much about (or eaten very often) because its preparation always appeared overly elaborate, something that only a very good Bangkok street vendor can do well. Also, perhaps because I'm a *farang*, I always gravitate toward easy, straightforward dishes (where my taste in food generally resides anyway). When I've eaten *hor mok* in the city, it has come beautifully presented in a round cup made from a banana leaf. It tastes like a fish custard.

When I heard Pea and her friend Rung talking about making *hor mok*, I was shocked. It seemed like the total opposite from what they normally cook, fussy not simple. But they happily embarked. The reason: the big round *bak-yo* of the *dton yaw* tree (*morinda citrifolia*) in the front yard were looking especially beautiful. It was all about the *yaw*! Instead of steaming the *hor mok* in banana-leaf cups, they steamed it in *yaw*. Their version turned out to be nothing at all resembling what I know as *hor mok*—but it tasted great.

The two of them worked all morning. They finely chopped a ton of shallots, garlic, galangal and lemongrass—one person peeling and chopping, the other pounding the ingredients into a paste in the mortar and pestle. Dried red chiles went in, as did coriander root and peppercorns. It looked much like making a curry paste. They put in salt and shrimp paste, and kept pounding. Then they set the paste aside.

Pea cracked open a coconut, discarded the water inside and then grated the coconut over a sharp-toothed claw. She then squeezed the grated meat, extracting the milk. Rung meanwhile carefully picked the meat from several *pla duk* (walking catfish) that had been grilled earlier in the morning. With an egg and a little more fish sauce, they mixed the coconut milk, the fish meat and the spice mixture. Finally they carefully mixed in a handful of *horapa* (fresh basil).

They put a portion of the mixture in the center of each *yaw* leaf, and then gathered the leaf into a bundle, using toothpicks at the top to secure each. The mixture made about a dozen *hor mok*. They put them carefully into the large steamer and steamed them for about 15 minutes and then let them cool.

By this time Pea and Rung had drunk a few cold beers, and happily asked neighbors to join in. It might not be the same as the *hor mok* you'd find in the city, but it's good. I get it.

Khao Khua

ROASTED RICE POWDER

KHAO KHUA IS ONE OF THE TASTIEST AND EASIEST CONDIMENTS TO make, and it is an essential flavor in a dish like *Laab Moo* (Spicy Ground Pork, page 88). To make it you can use Thai jasmine rice or sticky rice. Most people in Isaan typically use sticky rice, but Pea uses Thai jasmine, since that is what we most commonly have around. The process is much like roasting sesame seeds; the rice roasts slowly at first and then rapidly at the end. You need to keep a close eye on it.

½ cup (120 mL) raw Thai jasmine rice or Thai sticky rice

1. Put a heavy wok (or cast iron skillet) over medium-low heat. Add the raw rice. Continually stir the rice with a spatula to prevent the rice from burning. You want the rice to turn nicely brown, but not to burn. There will be a good aroma as it cooks. Like roasting sesame seeds, the rice starts browning slowly, but then quickly. Just keep stirring it all the time, and when you start to see it nicely brown, take out from the wok and let it cool in a bowl.

2. When cool, transfer to a coffee grinder or a mortar and pestle. Grind until fine. When finished, put in a small jar with a good lid. It can keep for one to two months, depending on your climate.

MAKES ½ CUP (120 ML)

a little bit sick

For two weeks now I've been "a little bit sick." Even though the rains have come, some days have been really hot—over 104F (40C)—and for a while I thought that it was just the heat, some form of dehydration. When it gets this hot I find my appetite disappears. In the evening, after dark, I'm hungry, but not in the day. I have packets of electrolyte powder, and all day long I drink water mixed with the powder. Here people use the expression "I have no power," and that is definitely how I have felt. I have no power.

Like the feeling of catching a cold or the flu in Ontario or Wyoming, this feeling of being "a little bit sick" has become somewhat familiar, and especially toward the end of hot season. I've learned to stay out of the sun and to wear big hats. But still…

And this time it's gone on too long, so yesterday Pea and Mae arranged for a shaman to come. He came to the house and there were many elaborate preparations, all made on site and by hand. Several older women came to help, all seeming to know what to do. A banana tree was cut down and then the man made beautiful long slivers from the bark, as if working with bamboo. There were probably five people altogether, including Mae, and everyone was working on separate projects. Several of the projects involved making little "packages" from banana leaves, all intricately put together. I watched as long as I could, but then went to lie down in a hammock, still feeling punky.

Hours into the preparation, Pea came to get me. We went into the house where all these beautiful offerings were on the floor in the center of the room. They had constructed one offering for me, and another for Pea. I was told to sit with my legs outstretched, the bottoms of my feet set up against the offering. And Pea did the same. The man tied white string around our feet and all around the offering, and then began the ceremony. We had to sit with our hands clasped together out in front of us.

Straightaway I knew this was going to be a problem. I've always been pretty good at sitting cross-legged, ever since my yoga days. But with my

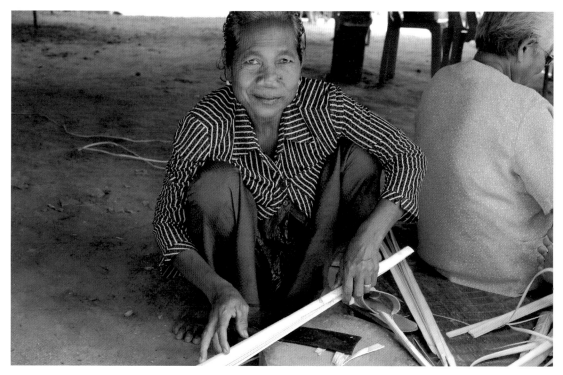

Nom, Mae's cousin, is assembling one of the altar pieces to be used by the shaman in "healing" me

legs stretched straight out in front, my knees were quivering in the first five minutes, sweat pouring off my forehead. And the problem was that there was no other way to sit, because our feet were tied together at the offering, this clearly being the way this particular ceremony happens. Pea could tell I was in pain, and someone brought a towel. But I knew early on that this was just going to be an awful ordeal, and the only question was how long it was going to last.

It lasted forever! He would chant and chant. Then I would have to chant (as if I had any idea what I was chanting), and Pea would chant. Then he would begin again, my knees in total pain, my shirt drenched in sweat. It almost felt like torture. And then finally it was over.

"What was it?" I asked Pea. Pea sort of explained, and a neighbor tried to help. It was something about taking bad things out and putting good things—and good luck—back in. I call it an exorcism. I think they believe that I'm sick because a woman put a curse (a *kae krua*, a malevolent spirit) on me, at least that's what Mae thinks.

Do I believe in curses and shamans? Not really. But I've learned, living here in Kravan, a lot of people know a lot of things that I don't know.

Nomai

BOILED BAMBOO SHOOTS

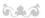

THERE ARE CERTAIN THINGS HERE THAT BLOW ME AWAY ALMOST EVERY single day. Orchids, fish, bananas...and bamboo! I find bamboo absolutely amazing. If I need a new rake handle, I pick up a machete and head to the bamboo. If I need a new railing for the fence: bamboo. It's strong, it's long, it's free and it's very easy to work with and versatile. Here, over the last decade many rural people have planted eucalyptus, so much so that you see it almost everywhere. They plant it around the rice paddies to help prevent erosion, to better secure the fields. They also plant the eucalyptus because it grows quickly, and in a country where almost every tree is a hardwood (which makes wood here very expensive), the eucalyptus is "cheap, usable" wood. But eucalyptus trees can also be very damaging to the soil, preventing other plants from growing up at the base.

Bamboo and eucalyptus, from the wood point of view, perform many of the same functions (and both are, unfortunately, subject to termites, which are a fact of life here). But I much prefer working with bamboo. And while I see many people planting eucalyptus, I seldom see anyone plant bamboo. It is said to be too invasive.

In *Permaculture*, Bill Mollison writes extensively about how to improve lateritic soils (like the soil we have here). Most of it is way over my head, but I'm beginning to understand the basics. To restore humus, he recommends a green crop, especially tree legumes, which we have in great supply. He also recommends basalt, cement powder and bamboo (to increase soil pH). So whenever I cut down a piece of bamboo, I mulch the leaves and any supply of leaves that have recently fallen down. I also began to notice that no one ever discards empty bags of cement, rather they are left to compost on the soil.

There are many kinds of bamboo. I bought one small "tree," or branch is more like it, in town and planted it. And for a long time it didn't grow very much, or do much, but a few months back Pea told me to go look. There was a bamboo shoot coming up from the base, and then another and another. "I cut, we eat," Pea said matter-of-factly.

"No, no!" I replied. "That's my bamboo." She smiled.

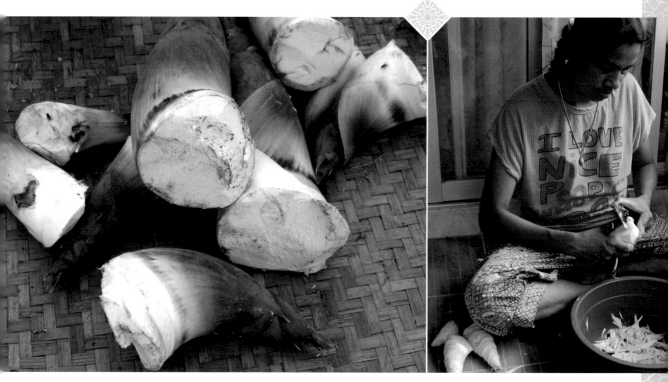

Bamboo shoots yield a lot of free food! They are amazing.

It's now about 15 to 20 ft (4.5 to 6 m) tall, and absolutely beautiful. And when we eat bamboo shoots, we buy them from the market (someone else's bamboo shoots...).

"Pea, can you show me how to cook bamboo shoots?" I asked one day.

"You never cook bamboo shoots?"

"Only from a can."

"A can?" She looked at me as if I were from another planet.

So we bought four large bamboo shoots (also stunningly beautiful) from the market, about 3 lbs (1.4 kg). "Can I plant like this?" I asked, a little bit joking, a little bit not.

"No."

We sat down on the ground and Pea began taking off all the outer leaves, all the brown parts. As she moved her way up to the pointy end, she didn't unravel the outer leaves down to the base (wasting good parts), just taking off enough

to expose the white flesh underneath. By the time she was finished, the shoots were reduced in size by at least 30 percent. She then picked up a cleaver, and just as if she were making green papaya salad, she hit into each shoot many times, and then carved down the length: the Thai version of a julienned vegetable.

When they were all cut she dropped them into a large pot of boiling water and cooked them for 40 minutes, or longer. She drained the water, let them cool, and then put them into the refrigerator. Cooked bamboo shoots, now ready to be incorporated into other dishes, or eaten simply on their own.

[Note: My bamboo tree has matured quickly and now, as with our bananas, there are many tender shoots that Pea often cuts. Unlike the fatter shoots we buy in the market, these cook much more quickly and taste sweeter. They are about 1½ in (4 cm) at the base, as opposed to 4 in (10 cm).]

wrong again

And of course, I was wrong again, as always, about the frogs. There are more than three ways that Pea cooks frog (soup, *nam prik* and grilled); there are probably dozens. Last night, under the thatch, protected from the pouring rain, Pea grilled stuffed frog. She cut off the legs, chopped them finely, and then put them back into the body of the frog together with garlic, galangal, grated coconut, fresh chiles and holy basil. They were great. She also made a dish of julienned bamboo shoots steamed with minced frog (that makes *five* ways of using frogs, and counting).

Oh well. When I am always wrong, at least I'm consistent! July 13. It's raining. It's a good, big rain. Will it be raining on the fields, just one or two miles away? You never know. But it's a good, big rain, and it feels good.

When I woke up this morning—having slept with the reassuring sound of rain hitting the metal roof all night long—life felt glorious. The gardens were soaked and beautiful, the orchids happy as if at home in the jungle. Everything felt a bit different, like a different place, a different country (not Thailand). Pea had the charcoal burners full of fire. The smoke mixed with the damp overcast air and the wet ground smelled like an early morning Nepalese tea shop high up in the Himalayas. From just down the street there was the sound of a large gong, and of chanting, coming from the temple, where villagers were still mourning two recent deaths.

This morning the village felt almost exotic, enchanting, all those adjectives travel writers use trying to lure us into visiting "foreign places." Almost.

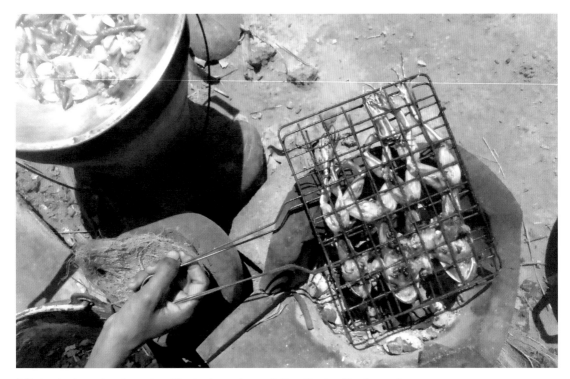

A Thai-style charcoal cooker and a grilling basket work so well. Here, Pea is grilling frogs, of course.

khanom jin—birthday noodles

ea's birthday is July 17, and mine is July 9. Birthdays can be a bit tricky when the people celebrating come from different cultures (they're tricky enough when two people come from the *same* culture). The first time our birthdays rolled around we kept asking each other, long in advance, "What would you like to do for your birthday?" But of course neither one of us really knew what to answer. Mine was the first to roll around, of course, so a few days before Pea suggested, "On your birthday, eat *khanom jin?*"

"Good idea," I responded, any idea being better than no idea. And I like *khanom jin* a lot. I first ate *khanom jin* in the far south of Thailand, and thereafter assumed that it was a southern dish, but it's not. It's eaten all across the country, and much loved. It's a common street vendor food, served morning, afternoon and evening. It's relatively easy to spot because it takes up a lot of space compared to other street foods. You will see a table, or tables, with bowls full of fresh vegetables, especially fresh sprouts and crunchy fresh pickles. When you order *khanom jin*, the vendor puts fresh white rice noodles into a bowl and then ladles a thin, reddish-brown sauce onto the noodles. When you have your bowl of noodles, you "garnish" them with all the fresh herbs and vegetables from the bowls set out on the table.

The whole setup can be relatively simple or very elaborate. Anyone who likes fresh vegetables generally loves *khanom jin*. The sauce (*Nam Ya*, see page 169) is like a fish soup with a coconut-milk base, though if you are eating it for the first time, you might not even know that it's fish-based. It's just spicy and good!

On the day of my birthday Pea was up early and immediately busy, I had no idea with what. Doi came over to help, and Mae's sister, and by the time I'd showered and woken up (which usually happens in that order), the house was full of commotion. Children were running in all directions. There were several large charcoal fires being looked after. There was a large wood fire in the back with a three-foot-wide wok set over the top. It was *khanom jin!*

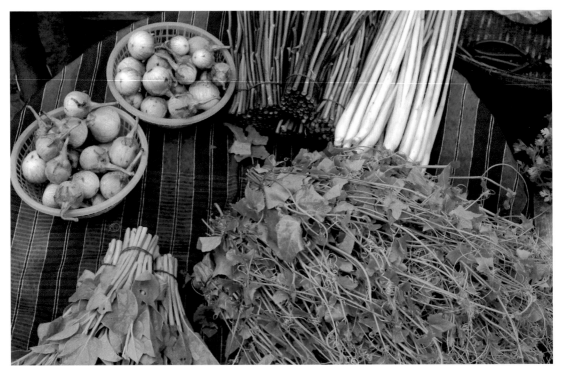

Eggplants and lemongrass are easy to spot here, but the greens are *pak tam lung, pak boong* and *pak kwan tung.*

I'd guess that 40 to 50 people ate *khanom jin* that day, a quiet little birthday. I'm not sure about the meaning behind eating *khanom jin* here, but in Chinese culture people traditionally eat noodles on a birthday, the longer the noodle the longer one's life. And I think this custom has made its way here.

By late afternoon it was over, and I found an empty hammock. On Pea's birthday we went to the Surin, checked into a fancy air-conditioned hotel and went out to eat (and not *khanom jin*).

Nam Ya

SAUCE FOR NOODLES

THE FOLLOWING RECIPE IS FOR *NAM YA*, THE SAUCE THAT GOES OVER THE noodles when preparing *khanom jin*. Almost any long noodle tastes great with *nam ya*, and it all depends upon what noodles you have access to. In an Asian grocery you can easily find long white rice noodles. They usually come dried (and are very inexpensive). Depending upon the noodle, rehydrate them in cold water and then blanch quickly in hot water. They are very easy to work with and you will find that you can make many different dishes using them.

Khanom jin noodles are rice noodles but a bit different, usually made in Thailand as a cottage industry. For my birthday Pea went to a village nearby where a woman makes them every day. They are already cooked and come in fresh little bundles. You order them by weight, and they come packaged in a banana leaf.

The other essential part of *khanom jin* is the fresh vegetables served alongside to eat with the noodles. It's similar to *Pak* (Vegetable Platter, page 21) but more specific. The fresh vegetables and herbs are often put out in individual bowls, not necessarily on a platter. There will always be fresh mung bean sprouts and fresh yardlong beans, cut into 1-in (2.5-cm) lengths, as well as napa cabbage (very thinly sliced) and lemon basil (*maeng lak*). In a more elaborate street stall they will often put out *Pak Sien Dom* (Pickled Greens, page 155). Each person helps himself or herself to the fresh herbs and vegetables, putting them onto the noodles and sauce. They are a fresh crunchy contrast to the spicy noodles.

But now for the sauce: *nam ya*. At a very large *khanom jin* vendor you might have three or four different versions of the sauce to choose from, ranging in shades of red and brown, looking like thin curries. The following version is most typical, using fish as a base in a coconut-milk sauce. In putting together *khanom jin* you will find two ingredients previously unmentioned: *krachai* and *maeng lak* (both available in many North American Asian groceries). *Krachai* is a yellow-brown tuberous root, a rhizome from the ginger family. It is often an ingredient in fish dishes. *Maeng lak*, often referred to as lemon basil, has a lovely taste not unlike regular basil (*horapa*), but lemony. This is a very simplified version of *nam ya* that is easy and delicious.

1 Tbsp (15 mL) vegetable oil	2 Tbsp (30 mL) very finely chopped krachai
2 Tbsp (30 mL) red curry paste (a good bottled version does fine)	Handful of fresh *maeng lak*
1 cup (250 mL) coconut milk	1/2 cup (120 mL) cooked fish
1 cup (250 mL) water	1–2 tsp (5–10 mL) fish sauce (or to taste)

1. Heat a good large pot over medium-high heat. Pour in oil. When hot, add the red curry paste and stir, cooking 1 to 2 minutes until there is a good smell in the kitchen. Pour in coconut milk and mix with the curry paste. Add water and bring to a gentle boil.

2. Put the krachai, *maeng lak,* and the cooked fish together in a mortar and pound into a paste (or blend in a food processor or blender). Transfer into the pot with the other ingredients and gently simmer for about 30 minutes. Taste for saltiness, and add fish sauce according to taste (or even a touch of sugar). Serve over noodles, with assorted vegetables alongside.

MAKES ABOUT 2 1/2 CUPS (475 ML)

swimming

This morning (I am now feeling better, curse or no curse) Pea told me to put on a swimsuit because we're going swimming. I laughed. I love swimming, but I know that Pea is not a big fan. Sometimes I swim in the two small reservoirs that are here in the village, but only because I'm desperate. The first time I went swimming I swam in the larger of the two, but when I got into the water it was anything but refreshing. It reminded me of swimming in the ocean in Miami Beach in the middle of summer on a trip as a kid with my dad. It was like a bath, a warm bath, maybe good in the winter but not in the summer!

Once I was in the reservoir I was determined to go for a swim, refreshing or not. I swam out to the middle and back, but in doing so I noticed a half dozen water buffalo also sharing the reservoir, and a few people, whose homes backed onto the reservoir, rinsing their plates and bowls. Maybe, I realized, it wasn't the best place to swim. But I survived.

Several weeks later, after advice from my neighbor (the money lender), I decided to give the other reservoir a try. He'd told me that it was much cleaner and that animals are not allowed access. I packed my goggles and a towel, and rode over on my bike in my swimsuit. I felt a little silly, but at this stage it's a feeling that I'm accustomed to.

My neighbor was right. The small reservoir was fenced off and the whole area seemed very clean. There wasn't a person in sight. I sat in the shade for a while looking out at the water, trying to get my courage up. It was midday on a hot day, but still there were many large fish feeding off the surface of the water, jumping and making a sizable splash. The fish are alive, I thought to myself. If it's clean enough for fish, it must be clean enough for me. But still I hesitated. What if I bump into one of those fish? Or even worse, a dreaded snake?

Finally I walked down to the water's edge and slowly worked my way in, at last swimming. The water felt good. It was warm, but not hot like the other reservoir. And the water seemed definitely cleaner. I was happy. I swam almost to the other side and back again, and then again. I had my goggles on, but the water was murky and I didn't really care that much about seeing. I was just happy to be swimming.

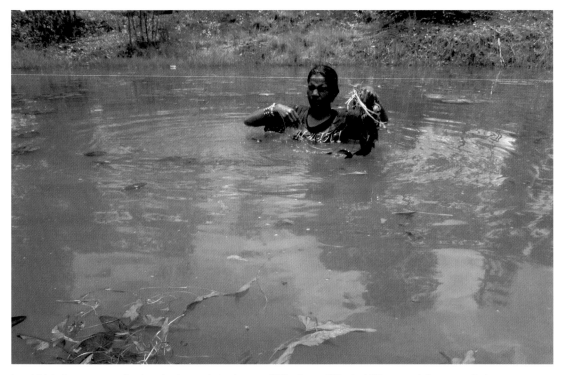

I couldn't believe my eyes: Pea jumping into an irrigation canal! "Can I come?" I asked. "Up to you," she responded.

In the weeks that followed I went over several times for a swim, each time gaining confidence. I never once saw an animal, or even a person. But one time, just as I was finishing my swim, I saw Pea standing at the shore. I got out of the water and we walked over to a bench in the shade. "Good swim?" she asked.

"Yes."

"You're not afraid?"

"Should I be?" I asked, suddenly concerned.

"People in Kravan not swim here."

"Why?"

"Because there are ghosts. Three ghosts. Two children and one old man. They all die here."

Whew, I thought to myself, relieved. I thought I was going to hear about snakes and leeches, the things I'm most afraid of. Ghosts I'm okay with;

it's one of the benefits of being a *farang*. Still, three people drowning, including two children. No wonder there's a fence.

But back to this morning: about Pea telling me to grab a swimsuit. I couldn't imagine what she was talking about, but I did what I was told. We got on the motorcycle and we were immediately met at the road by Ahn, baby Off, and Yoyo, also on a motorcycle, also apparently "going swimming." And then we headed out of the village.

We went past Pea's fields and turned left down a small dirt road. The small road almost immediately turned into a path, and soon thereafter we parked the motorcycles and continued on foot, carrying baby Off under an umbrella. We were following an "irrigation" canal, for lack of a better word. It's more like a big stream, an overflow stream that gets

It is a wonderful and strange sensation swimming in the middle of water lilies. Underneath the water it's like swimming through a jungle of reeds, and on the surface there are beautiful flowers.

fed from the adjoining rice fields regulating their water level by discharging water when the rain is too much. I'd walked along the stream many times, but this day the water level was much higher than I had seen before. We arrived at a particularly deep spot, and then Pea suddenly jumped in, blue jeans, T-shirt and all! And Yoyo quickly followed. The water was deep enough that in places they could no longer stand and had to swim. I had no idea what they were doing, but I was immediately jealous.

"Pea," I yelled out. "Can I swim?"

"Up to you."

"Pea, are there *pling* [leeches]?"

"No."

I took off my shirt and jumped in. The water was beautiful, cool and definitely refreshing. But under the surface of the water there was a massive tangle, like swimming through a maze of fishnets. At first it was a bit scary, but Pea and Yoyo were unconcerned; they were busy somehow "harvesting" the massive tangle, one long root at a time (each one about 3 ft/0.9 m long). They both had large plastic bags, and they were filling the bags at great speed, going underwater, coming up for air, corralling long roots into their bags.

I turned to swim "upriver." It was a sensation I will never forget. My head above water, I was swimming through a vast plain of water lily leaves, and extending up from the leaves, beautiful mauve water lilies. Under the water, my body was in a jungle!

Tonight we ate the roots, rinsed and raw, with *nam prik padoo*. Simple as that: sweet, tender, fragrant and absolutely, unbelievably delicious.

Khao Neeo

STICKY RICE

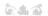

PEA ALMOST NEVER COOKS OR EATS *KHAO NEEO* (STICKY RICE), BUT I DO and a lot of other people here do occasionally (Mae and Gung included), so it seems important to have a recipe. Pea regards sticky rice as Lao (and northern Thai), and Pea is Thai-Khmer. There are a few fields adjacent to Pea's farm where a farmer grows sticky rice, but otherwise it's very unusual to see sticky rice in cultivation. Go one province to the north and the fields will all be sticky rice.

In rice terms, sticky rice is in its own category. The starch in sticky rice (low amylose, high amylopectin) is different from the starch in regular Thai jasmine rice, which makes the rice sticky when cooked. Some people confuse Japanese sushi rice with *khao neeo*, but they are not at all the same. Chinese short-grained sticky rice is a true sticky rice, but again different from long-grained Thai sticky rice, particularly in terms of aroma. *Khao neeo* is easy to spot in a market because the surface of the uncooked rice is a flat opaque white, and jumps out in contrast with all other rices.

There are many ways to cook sticky rice, but traditionally, here in Isaan, the rice is first soaked overnight. The water is then drained, and the soaked rice is steamed—literally steamed, above water, not in the water.

I have always loved *khao neeo*, especially eaten with so many of the foods that Pea prepares (like *som tam* and *nam prik*). I pick up a piece of sticky rice in my hand, make a ball and then dip it into whatever is on the table. You can also use it like a spoon. I recommend it (but don't tell Pea).

Thai sticky rice (*khao neeo*)	Water

1. The night before cooking, place the rice in a large container full of water, giving the rice plenty of room to expand (the water should be at least 3 to 4 in (7.5 to 10 cm) over the surface of the rice). Soak overnight.

2. Drain the rice and place in a conical steamer basket. Set the steamer basket over the sticky-rice pot half full of boiling water (both the basket and sticky rice pot can now be found in many Asian groceries

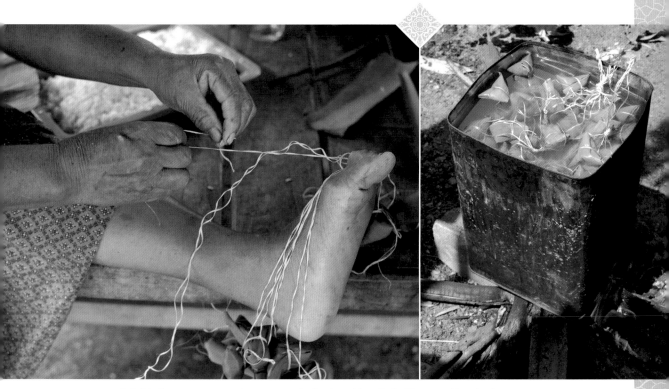

Left: Mae's cousin wraps sticky rice treats for Ang's wedding. Right: This is wedding food: tiny packages of sticky rice, very elaborately wrapped.

in North America). The rice should not touch the water, but sit above it. Cover and steam the rice for about 20 minutes. When you take off the lid, the surface of the sticky rice should be shiny. When you think the rice is done, you can pull off a small bit with a fork and taste that the rice is cooked. Sticky rice is not soft like plain rice, but maintains a bite to it even when done.

3. Turn out the rice onto a countertop and let cool slightly. Put out in a shallow bowl and serve, or, Lao-style, put out in a covered, woven grass basket.

bones

When I was a kid my mother would drive me 47 mi (76 km) to the town of Cheyenne, Wyoming, so that I could go to the dentist. She did the same with my two brothers and my sister. We had dentists in Laramie, but for some reason my parents thought that this particular dentist in Cheyenne was better. I hated him. I dreaded going to see him so much that I would be almost sick with worry for several days before a visit. And he was arrogant. And the fortune he made off my family was enough to pay for his Winnebago.

When I was 26 years old I ended up living in Taipei, Taiwan, teaching English. It was a great experience because all my students were adults and very nice people. But one day I was in a class with three students, all nurses, and I let slip that I had a toothache. One of the nurses said, "Oh, no problem, my husband is a dentist." I politely responded, "Thank you," and that maybe sometime I would make an appointment with her husband (knowing that I never would). But all three nurses adamantly insisted. We would stop the class immediately, and she would drive me down to see her husband. And that is what we did.

I was terrified. I hadn't been to a dentist since the horrible days of Cheyenne, and here I was in another country. We got to his office and went in; there was no such thing as an appointment. He

was, like his wife, extremely nice. He sat me down and started in. No needles, no X-rays. There was a pinch or two of pain, but not bad, and he worked quickly.

"I want to say politely," he said to me in broken English once we were finished and clearing up, "but who your dentist? He very bad. He fill your teeth, your cavities, but he cut your teeth too thin. Very easy for your teeth to break."

Here in Kravan, 30 years later, every so often I remember that dentist in Taipei (and wish that he lived here). I don't know if Pea has ever been to a dentist, but I suspect not. When she smiles her beautiful smile there are big gaps. And she's not unusual in this; many people here have teeth missing. When someone has a problem with a tooth, it's not uncommon to simply take the tooth out. And

down the line, I know—with my limited knowledge of dental science—there are most likely problems with teeth simply extracted. Mae, for example, at age 64, is very limited in the foods that she can eat because of her teeth and gums.

But Pea's teeth are incredibly strong. Take eating frog or snake. Eating a grilled frog leg is no problem for me (it's delicious), but I am only eating the meat, not the bone. When Pea makes a *Nam Prik Gorp* (Chile Paste with Frog, page 68) using the whole body of the frog, grinding the body in a mortar and pestle together with the chiles, shallots and garlic, there are bones. They're small bones, but still they're bones, and when I eat the *nam prik*, hitting a piece of bone is like hitting a small stone. My teeth break (I have two large collapsing molars as I write), but Pea just eats her way through. I can hear her teeth just grinding away, loudly, tiny bone after tiny bone.

baby bananas and scorpions

oday I ate my first scorpion. Scorpions live around the house a lot, especially living under large rocks and boards. Pea eats them often as a snack, and sometimes pounds them into *nam prik*. So today I saw a plate with several large fried scorpions and I thought I might as well give it a try. I picked one up to eat it, and then looked over at Pea. "Do I eat the whole thing?" I asked, knowing immediately as the words came out of my mouth that I was asking yet another stupid question.

"Yes."

I started with a leg, or a claw, or whatever you call it. (The scorpions here almost always look the same: they are shiny black, and 4 to 6 in (10 to 15 cm) in length. I am sure there are baby scorpions, but I've never seen one.) The claw was hard to get into, crunchy and hard. And immediately Pea started to laugh, knowing at this stage that eating through "hard" bits is not something I am very good at. "Eat the body," she advised, "it will be better for you. Leave the other parts for me."

I put down the claw and picked up the body. The body seemed somehow scarier than the claw, and bigger! But like jumping into a cold Canadian lake in May, I took a big bite, and surprisingly, it was good. Or I mean, it wasn't bad. There wasn't a lot

of "meat" to it, mostly shell. And it had been fried, and fried things are almost always edible. The large grasshoppers here, for me, have bigger flavor.

Yesterday Pea had a plate sitting around the kitchen piled high with what I assumed to be sliced cucumbers. I took no particular notice, because there are always stacks of vegetables sitting around. Always.

"You know that one?" Pea stopped me in stride. I looked over at the plate and immediately she picked up a slice and put it into my mouth. I was expecting a cucumber, but it was not at all a cucumber. It was sweet, and with a very distinctive flavor. "Good?" she asked.

"Really good."

"From the banana tree, the baby."

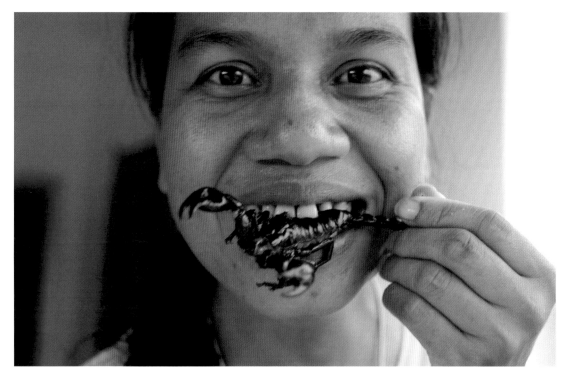

Big black scorpions live all around Mae's house. No one except me seems to be in the least bit afraid of them. They are edible, after all.

"Hmm?" I asked, not really understanding.

"When the banana tree just a baby, just coming up. I cut. Same like *pak* [vegetable]."

Suddenly I understood, remembering all the new baby banana trees we have coming up in the garden. But it seemed incredible to me that Pea would "harvest" a baby banana tree as I might pick a shoot of asparagus.

Rainy season is now officially in full swing, and the growth that's taking place—in all directions—is absolutely phenomenal. The stands of banana trees are growing like grass, or like bamboo. One tree becomes two, two become four. Almost every night I listen to the sound of the rain, and in the morning I see everything taller.

popcorn with chile sauce

The rice fields are spectacularly beautiful right now with a mix of pale yellow and rich green. The pale yellow is from tender shoots, and the rich green comes in just as they start to mature. We've been having many overcast days of late, which make the colors pop even more. In a few weeks everything will be a thick, rich green, though I think not quite as beautiful. The fields also have a lovely sweet smell that permeates everything. Even when going quickly down the road on the motorbike, the aroma is wonderful.

Pea spends most of her time these days at the farm. There are two main jobs, and this is a bad year for both. The first is to redistribute seedlings from where the rice was sown too heavily (like the areas I did) into areas that have come up sparse. It's backbreaking work because you must bend over to pull the seedlings out, and bend over to transplant them. Back-wise I can't do a lot. It amazes me, looking out over all the farms and seeing so many people bent over so beautifully from the waist. A yoga class would be in awe.

The other major task—this one even harder and less rewarding—is pulling out a certain thick heavy crabgrass before it becomes impossible to pull. This year is particularly bad, and not just for Pea's fields, but for everyone's. Each blade of grass must be pulled out, and then the roots washed so that the grass can be fed to the cows.

I'm at home in the village a lot by myself these days, or at least in the company of myself. The house has a constant flow of people, as I've mentioned, because Kaesorn runs her small store downstairs that caters primarily to the 10-*baht lao khao* drinkers. She also has a small gambling business (that Pea and all her siblings want her to abandon). How it works I am not quite sure, but Monday through Friday she has the television (which lives in the big main room where Mae and Gung sleep at night) turned on to a Thai version of something like Bloomberg TV, a ticker-tape of stock numbers running constantly across the bottom of the screen. Kaesorn is the bookie, with a jar of small money that she's always adding to or paying out from. Pea tells me that, in Thai, the game is called *hoon*, and not just played here but all over Thailand. It's like the lottery, but played

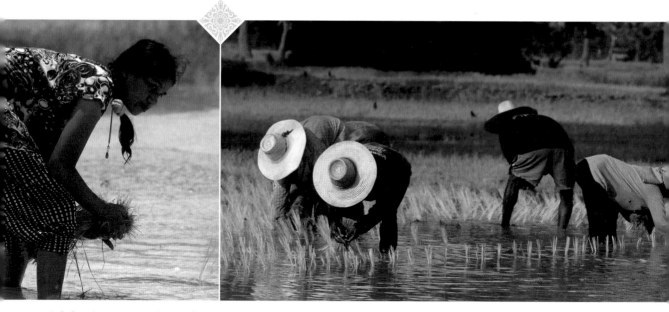

Left: Pea does not transplant seedlings, but her friend Nee does. So we all go out to help. Transplanting makes for a better, more uniform crop—but it is a lot more work. Right: I am sometimes embarrassed by my feet, living here. My toes are close together, without gaps in between them. It seems to me that people who grow up working in rice paddies, working in mud, have spaces between their toes. Or maybe it is just genetic, but I don't think so.

every day. What's most disturbing to Pea and her siblings is that Kaesorn borrowed a lot of money from Mae to get it going, and she's now going deeper into debt. She has her cricket business, but it's not working out very well.

The other gamblers are all, or mostly all (with the exclusion of what I would call "housewives"), elderly people. They sit on the floor looking ever so seriously at the screen, groups of five or six, everyone once in a while jotting down a number. It would all be a comical scene, except that it's not. Rural people here seem to be obsessed with the notion of lucky numbers, bad numbers, bad luck. The 1st and the 16th of every month are the national lottery days in Thailand, and in many ways the country, rural Thailand at least, more or less shuts down on these days.

But anyway, with Pea working in the fields, for

lunch these days I've gotten into the habit of going to the kitchen to cook, and if anything can break the gamblers' attention to the television, it's me cooking! A while back I found popping corn in a supermarket in the city of Surin (I love popcorn!). I put it away in the freezer compartment of the refrigerator and when I thought the time was right, I embarked on cooking popcorn (feeling pretty sure that no one in the room had ever cooked popcorn). It was a great success.

People didn't really like to eat it that much, but they liked the spectacle. Several people pronounced it *kem*, salty. But Mae liked it, eating one piece at a time and then refilling her bowl. Someone then appeared with a bowl of sriracha. People began dipping, again one piece of popcorn at a time, into the hot sauce. And hmm, the verdict: not so bad.

Pla Nin Nung

STEAMED TILAPIA WITH HERBS
AND VEGETABLES

THIS DISH IS A LITTLE BIT LIKE *NAM PRIK* AND *PAK* IN THAT THE QUANTITY of vegetables is large. But this dish is not in any way spicy, nor does anything get pounded! It's simply steamed fish with steamed vegetables. Most often we won't even eat rice alongside, but there might be a bowl of fresh *Nam Jeem* (Fiery Fresh Chile Sauce, page 25). Last night Pea used asparagus, *pak kanaa*, and green onions, but the choice is almost as wide open as when assembling *Pak* (Vegetable Platter, page 21). Also, as with *pak*, don't cut the vegetables, and try to select vegetables that take roughly the same time to cook.

2 tilapia, each about 2 lbs (910 gr)	8 cups (2 L) mixed vegetables
3 Tbsp (45 mL) fish sauce	2 Tbsp (30 mL) oyster sauce
3 Tbsp (45 mL) soy sauce	

1. Scale and then clean the tilapia. On each side of each fish cut three diagonal lines in through the skin all the way down to the bone (this will allow the fish to steam evenly). Place the fish in the steamer, sprinkle on the fish sauce and soy sauce, then steam the fish for approximately 18 to 20 minutes, until cooked through (can taste for doneness by using a fork). When done take the fish carefully out of the steamer and put the fish onto a platter.

2. Immediately put the vegetables into the steamer, drizzle on oyster sauce and steam until tender but still firm. When done, turn out of the platter alongside the steamed fish and serve.

MAKES FIVE TO SIX SERVINGS

ethnography

I recently found a book called *The Thai-Khmer Village: Community, Family, Ritual and Civil Society in Northeast Thailand* by Japanese sociologist Yasuyuki Sato. Most of his research is based on a village called Ban Phluang, which is just down the road from Kravan. The book is amazing, and it's in English. My copy, which I found in our one great bookstore in the city of Surin, is in very large print (which is good for me these days).

For me, reading through the book makes swimming through the water lily roots feel like a swimming pool. First of all, it's in Japanese English, and second, it's sociology. At least a quarter of the book is an academic discussion of "civilized society" that has nothing to do with the village of Ban Phluang. Another quarter of the book is given over to graphs and data: marriage patterns, family structure and so on.

I haven't been able to put it down. And I'm not sure why, but I know that part of it is simply me starving for bits of understanding that I might otherwise never have. He writes that there are 1.3 million Thai-Khmers (the phrase he uses throughout to describe people like Pea and her family: born in Thailand but of Khmer ethnicity) living in these three provinces (Surin, Buriram and Sisaket).

Sato is particularly interested in ritual and ceremony, which obviously involves religion. He meticulously details families in which there has been "intermarriage": A Thai-Khmer woman marries a Lao man, or vice versa. A Kui (yet another ethnic population living in this region, considerably smaller in number than Thai-Khmer) woman marries a Thai-Khmer man, or vice versa. What Sato is interested in is observing which culture becomes dominant, especially in terms of what rituals and ceremonies are followed. In a Lao family the woman will generally move into the house of the man, and in a Khmer family it's the opposite. In the families that Sato interviews, he found that in most situations the two families get together and discuss what to do, and that there are no firm rules (which is what happened in sister Ang's wedding, he from northern Laos, and she Thai-Khmer). But once a decision has been made about where they will live, the person who moves in generally begins to follow the rituals of that household.

Sato's observations about the Thai-Khmer are that the vast majority of the rituals and ceremonies have very little, if anything, to do with Buddhism (Thailand is a predominantly Buddhist country). The customs are basically animist in origin. At the end of our street in Kravan there's an enormous Buddhist temple (a *wat* in Thai), and a huge new renovation being added. But in my time here I have yet to have a single interaction with a monk, and never once has Pea mentioned going to the *wat*. I have attended many a "blessing" for a motorbike or a car, or for someone leaving to work in another country. And I have been to five weddings. I have never seen a monk at any one of these events.

Sato goes into enormous detail in trying to understand the rituals, and their foundation in animism. Every once in a while I'm reading along and suddenly think, Aha, I've seen that one! But most of it I don't understand, and will probably never understand, both the ceremonies and some of Sato's text.

When we bought our motorbike we had to have a ceremony to protect the bike and us, as riders. We had to go down on our knees with our hands put out in that Buddhist way. The ceremony's practitioner (a man who I really like who lives just down the street), chanted in Pali (I think) and would every once in a while sprinkle us with water. It was a bit long (but nothing like my recent exorcism). At one point Pea made a fart (those leguminous tree leaves) and then started to laugh. "Gasoline go out," she whispered to me. The practitioner didn't even blink.

Nam Prik Gai Sai Mamuang

CHILE SAUCE WITH CHICKEN AND
GREEN MANGO

THIS RECIPE MIGHT READ A LITTLE BIT LIKE MY RECIPE FOR *NAM JEEM* (Fiery Fresh Chile Sauce, page 25), in that it doesn't fit that well into cups and tablespoons. This is one of my favorite *nam priks*, the combination of grilled chicken, green mango and tons of lemongrass, garlic, shallots and chiles. When I asked Pea if she could make it one more time—a recipe test—she smiled.

Late that afternoon we went to Thursday market and bought a chicken. At the market you can buy two different kinds of chicken. One is like a chicken I would buy in a supermarket in North America, which here is called a "farm" chicken. Its feathers are white and it has lots of meat. The other chicken, a "village" chicken (what we would call a "free-range" chicken) is completely different. It's yellow, almost brown, and much skinnier, tougher. Village chicken is more expensive, possibly because it is more expensive to raise, and also because it is preferred. Most of the chicken that we eat is from chickens that Mae and Pea raise. If Pea buys a chicken, it will always be a "village" chicken.

We came back from the market and Pea immediately set to work. She built a charcoal fire and cut up the chicken. When the coals were ready she started to grill the chicken, slowly as always.

"How many more days make book?" Pea asked.

"Eighteen days," I replied (eighteen days before my book deadline).

As the meat started to cook, the dogs (Dam, Cookie and Spy) nosed in closer, lying down. The sky was overcast but the late afternoon light was soft and beautiful. Birds were singing up a storm. For sure there would be rain in the evening.

When the first few pieces of chicken were ready, Pea passed a leg to me, and took one for herself. "Village" chicken is not like any other chicken I have ever eaten. We eat a lot of chicken, as do many people here in the village, simply grilled (*gai yang* in Thai). Pea doesn't marinate it, nothing. But the taste is very distinctive. In Thai-English I would call it "strong." The meat is strong, the taste is strong. It's completely different from "farm" chicken. And there is also the taste of the charcoal, which varies widely depending on the wood from which the charcoal was made.

When I finished eating my chicken leg, I threw the bone to Dam (my favorite), who walks on three legs after being hit by a car.

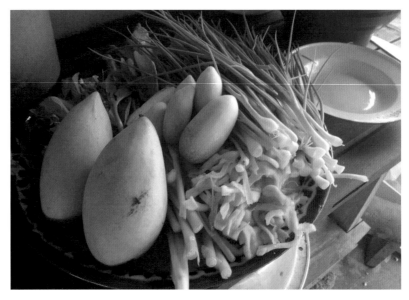

Green mangoes appear in the market almost year-round. The vast majority of mangoes are eaten green.

"After book," Pea asked, tossing her bone to the dogs, "what we do?"

I laughed. "I don't know. What you want to do?"

"I don't know."

"Maybe we go Bangkok. Go Pratunam. Go shopping."

"No cannot. Who take care frog and fish?"

Pea took all the meat from the grill and piled it onto a plate, leaving it to cool. Over the hot coals that were remaining, she put three whole heads of garlic and loads of shallots, all with the skin still on (something that she will almost always do when there is a bit of fire left). She then disappeared and reappeared with a large mortar and pestle (this one is made from wood), and then set about assembling ingredients. Into the mortar she put 12 to 15 bird's eye chiles and a touch of salt, and then passed the mortar and pestle to me.

"You do," she said.

On a small cutting board Pea then finely chopped one stalk of lemongrass and then added it to the chiles, all the while looking after the garlic and shallots on the grill. When they started to soften and cook, she patiently, one by one, took the skin off and threw the morsels into the mortar. Gradually my chile paste was starting to form. Pea again disappeared, coming back with *pla ra* (fermented

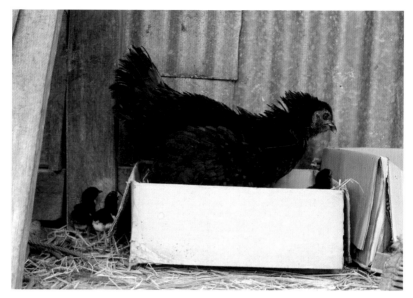

A cardboard box does just fine for this mother looking after her babies.

fish paste), putting about 3 tablespoons (45 mL) into a banana leaf and then wrapping the leaf into a packet and putting it also over the grill.

When the chicken was cool, she took the meat from the bones and chopped it finely on the cutting board. There were probably 2 to 3 cups (475 to 710 mL) of finely chopped chicken, which like everything else, went into the mortar. It was starting to be a very large amount of *nam prik*, and I then realized why we had started with so many chiles.

"You want me to do?" Pea asked.

"I'm okay."

Pea took the banana-leaf packet off the grill and opened it up. *Pla ra* has a very big smell, and an even bigger smell freshly roasted. She spooned it into the mortar, laughing, knowing that the smell was going to be a bit much for me. "Good smell?" she asked.

The last ingredient was the green mango. She took one green mango, peeled it and then grated it into tiny thin slices. And in they went.

And gradually everything became mush. Guacamole. Chicken guacamole. And I tasted: an absolute lightning storm in my mouth!

dreams

There are mornings here when I will wake up from a deep dream—a dream about a midsummer farm auction in Ontario or a winter snowstorm in Wyoming—and I will look around our small wooden room wondering where I am. Dreams can be so disorienting, living in a place different from where one is accustomed. I often dream about my mother and father, who passed away quite a while ago. I will wake up and remember that they are no longer alive, and the life that we lived together feels very far away. I had a good friend in Canada who is 15 years older than I am, and I remember when her mother died. "It's that feeling," she said to me, deep in thought, "the feeling of knowing that you are now on the front line."

I worry about some things, living here in Kravan. I worry about getting sick, getting old, about finding myself poor. I probably think of myself as older than I am (I'm 58), but partly because of how things have happened. I helped my parents move from the house where I grew up. I helped them move again, and then again. Each time they moved their worldly possessions became fewer and fewer, until, when they died, they had very few belongings, intentionally.

Pea and I came here with two backpacks, and we still have very little more. Someday soon we will probably buy a little piece of land, and build a small house, acquire more things. Maybe we will move to town. But our life here will always, I suspect, remain on the simple side, as for most everyone else here.

I was once asked to give a presentation at the Greenbrier Symposium for Professional Food Writers in West Virginia. I was thrilled because the conference is held in a beautiful location, and it's a very interesting conference. But I was even more thrilled because I was asked to talk about travel, not only about food. For months I thought about what I'd say, and where I ended up was thinking about "good travel" and "not-as-good

travel." "Good travel," I concluded for myself, thinking back, was the travel that I most remember, travel that influenced me in a profound way. And many of those "good travel" experiences were not necessarily fun, some quite the opposite. Most occurred when I had in one way or another made myself vulnerable, taking an element of risk, accepting uncertainty.

Where does "good travel" intersect with "finding a home"? I first started traveling as a kid, long before I thought of it as "traveling." Mom and Dad bought Rambler station wagons, put down the backseat to make a bed and headed off with four children (and sometimes others) looking for adventure. They didn't have much money, but from the back of those station wagons, I saw the world, a big world. When I was 19 years old I saved 600 dollars and went to Wales and to Greece, there discovering backpackers and dormitories. And I have continued traveling ever since.

Maybe the home I'm looking for has been here all along, inside myself, a person who travels, a person who was lucky enough to have parents who believed that travel was a good thing.

Khao Tom

RICE SOUP

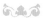

THERE ARE SO MANY VERSIONS OF SIMPLE RICE SOUP, FROM CHINA TO Vietnam, Thailand to Cambodia. This one that Pea makes I especially love, and think of as Thai-Khmer. It's generally eaten for breakfast, or late at night.

6 cups (1.4 L) water	2 Tbsp (30 mL) finely chopped garlic
2 in (5 cm) galangal	4 oz (110 gr) ground pork
2 stalks lemongrass	1 Tbsp (15 mL) fish sauce
3/4 cup (180 mL) Thai jasmine rice	Fresh coriander and chopped green onions to garnish
2 Tbsp (30 mL) vegetable oil	

1. Put the water into a large pot and bring to a boil. Put in the galangal and the lemongrass and continue to boil for 10 to 15 minutes. Add the rice and immediately stir. Reduce heat and simmer the rice for about 20 minutes more. Taste the rice to know when it has finished cooking (al dente); it will not absorb all of the water. Turn off the heat and remove from burner.

2. Heat a small skillet over medium heat. When hot add the oil. When the oil is hot add the garlic and ground pork and stir-fry until the pork has cooked through and the garlic has lightly browned, about 1 minute. Add fish sauce and stir. Add to the rice soup and stir. When ready to serve, garnish with fresh coriander and green onions.

MAKES ABOUT 6 CUPS (1.4 L), ABOUT FOUR TO
FIVE SERVINGS

anticipation

Soon the southwest monsoon will start to taper off, and in its place will come tropical storm systems. I hope there won't be bad flooding like last year, but there's always flooding in certain areas of Thailand (though not so much here in Isaan). Pea's rice is looking good, but it's been the same as last year with too much unwanted crabgrass, meaning lots of work (she doesn't spray, but some people do).

I know that there'll come a time when I'll be looking forward to the end of the rain, but I'm not there yet. Maybe it has to do with having grown up in a high, dry desert in Wyoming (though like Kravan, a unique and wonderful place). Rainy season can get to be a pain in the ass. Riding the motorbike is difficult now because the dirt roads are thick mud with huge potholes. Laundry is a daily conundrum, as you try to get the clothes into the sun whenever possible and back inside whenever a sudden rain starts to pour down. Mildew is also a problem (though less so for us in a wooden room than it is for people living in cinder-block houses).

But the outdoor shower is a dream—any time of the day taking a towel, sarong and swimsuit, dumping bucket after bucket of soft rainwater over my head. The orchids are flourishing, wrapping their beautiful long roots around the towering areca palms, sending out their crazy greenery in all directions.

Cold season will be good when it gets here, but before then I look forward to catching a few more fish in my bare hands.

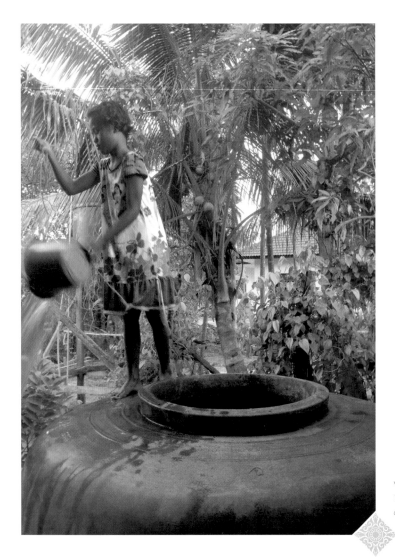

With the rainy season on its way, Gung helps to clean out one of the three large *ongs* at Mae's house.

author's note

I am not remotely knowledgeable in botany or biology, but during these last four years living here, friends who *are* knowledgeable strongly urged me to begin thinking in terms of scientific names: family, species, etc. And they were, of course, right. And it's fun! A Thai name, just like a recipe, can change from region to region, but the scientific name never changes. Also, nowadays, with the wonder of the internet, it's much easier to search and identify something through its scientific name, as opposed to a Thai transliteration. But when you are traveling in Thailand, it's good to have at least a transliteration from the Thai. What is included in this glossary is first the scientific name (species followed by family), followed by a Thai transliteration, followed by English. Beware of Thai transliterations, as they vary widely from one book to another. If you become more and more interested, I suggest working through written Thai, and not looking at transliterations at all. Learning written Thai, like learning scientific names, is fun! But including written Thai here seemed outside the parameters of this book. For more, consult Selected References on page 205.

glossary of ingredients

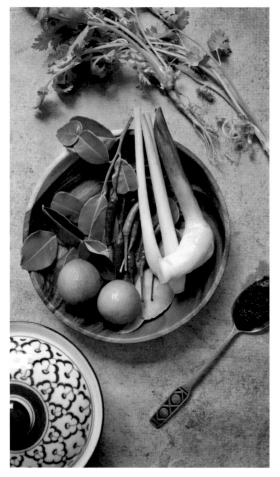

The basic *tom yam* repertoire includes galangal, wild lime leaf, chile, lime and coriander.

BAI GAPROA • *Ocimum tenuiflorum* (Lamiaceae) • holy basil

Wild edible. Small shrubby basil that grows wild all through rainy season and beyond; a very strong almost spicy taste, and used in abundance in stir-fries.

BAI THAWNG LAANG • *Erythrina variegatyta* (Fabaceae) • coral tree

Wild edible. As family Fabaceae, coral trees are nitrogen-fixing; can grow to 70 ft tall; famous as beautiful shade trees; tender leaves eaten as a vegetable and bark used in traditional medicine.

BAI TOEY, DAI HOM • *Pandanus amaryllifolius* (Pandanaceae) • pandan

Wild edible. Long sword-like leaves; much loved because of its aroma in cooking; used in wrapping other foods—both sweet and savory—before cooking to impart taste and aroma. Grows easily in Mae's garden.

BAI TSAI • *Brassica pekinensis* (Brassicaceae) • Chinese cabbage

Cultivated vegetable. Often eaten raw as condiment for grilled sausages and for *laab*, not to mention as a common vegetable in soups and curries.

Top: *Pak sai beua* is one of many aquatic greens enjoyed locally. Bottom: The seeds of *bua laang* (lotus) are a very popular, cheap snack—and good!

BEUA BOK • *Centella asiatica* (Mackinlayaceae) • Asiatic pennywort

Wild edible. Slender aquatic wild greens, slightly bitter; eaten raw with *nam prik* and sometimes as the basis of an herbal drink.

BUA LAANG • *Nelumbo nucifera* (Nelumbonaceae) • lotus

Wild edible. The amazing lotus is an aquatic perennial. To distinguish from water lilies, the leaves of lotus are outside the water and water lily leaves sit on the water; people eat the seeds as a snack (first taking off the outer skin) and also cook the long thick root.

CHA-OM • *Acacia pennata* (Fabaceae) • climbing wattle

Wild edible. One of the major edible tree leaves; large shrub, small tree; a very distinctive odor and taste; eaten fresh or lightly steamed with *nam prik*.

CHAPHLU • *Piper sarmentosum* (Piperaceae) • wild betel

Wild edible. A creeping herb with shiny green leaves; eaten raw, often wrapped around other foods; Pea also cooks it with slivered bamboo, chicken and coconut milk.

DOK ANCHAN • *Clitoria ternatea* (Fabaceae) • butterfly pea

Wild edible. Creeping perennial vine in Mae's garden; beautiful purple flowers she harvests, dries and sells by the pound; fruits are edible when tender, but Mae harvests primarily to be used as a food dye and in making skin lotions.

DOK GUICHAI • *Allium tuberosum* (Amaryllidaceae) • Chinese chive flower

Cultivated herb. Used in soups and stir-fries, but usually only the flowering tops.

DOK KHAE • *Sesbania grandiflora* (Fabaceae) • agati or sesbania

Wild edible. A medium-sized tree; the tender pods and flowers of the white agati (sesbania) are much-liked, as are the tender shoots; easily foraged and cheap to buy; eaten fresh with *nam prik*.

DOK KHAO SAN • *Raphistemma hooperianum* (Asclepiadaceae)

Wild edible. A small creeper that grows on large trees. Flowers, young leaves and shoots are all eaten.

DOK KRA-JEAW • *Curcuma aeruginosa* (Zingiberaceae) • Siam tulip

Wild edible. Underground rhizome ginger (Zingibaracea family); first time I saw them in rainy season all along the rice fields, I thought that they were lilies. Beautiful. Flowers and shoots edible.

DOK PAK GWAN TUNG • *Brassica rapa* (Brassicaceae) • flowering cabbage

Cultivated vegetable. A common vegetable used in making simple pickles. Also commonly used in stir-fries.

DTON YAW • *Morinda citrifolia* (Rubiaceae) • noni or great morinda

Wild edible. A common small tree grown for its fruit (*look yaw*), which are abundant all year long; looks a bit like a small avocado, only very pale green; fruit has a strong smell and a bitter taste,

but most often eaten raw, and usually grated; large leaf also eaten, most often steamed as in the Thai dish *hor mok.*

FUK THAWNG • *Cucurbita moschata* • pumpkin and flower
Cultivated vegetable. Pumpkin a very common ingredient in soups, and also steamed and eaten as part of vegetable plate. Flowers lightly steamed are also used as an attractive part of the vegetable plate.

GORP • *Fejervarya limnocharis* • rice field frog
Common animal. Frogs, as discussed in the text, are hugely important in Kravan, both farmed and foraged.

HAWM HUA YAI • *Allium cepa* (Amaryllidaceae) • common onion and flower
Cultivated vegetable. Shallots are more often used in *nam prik,* but onions in soups. Onion flowers steamed and used for vegetable plate.

HOI KRAENG • *Anadara granosa* (Arcidae) • blood cockles
Common shellfish. Blood cockles have a corrugated shell, and very distinctive red meat inside (which contains hemoglobin, thus the red color).

HOI LAI • *Paphia undulate* (Veneridae) • short neck clam
Common shellfish. Tidal clam, farmed in Thailand. Pale in color, about 2½ to 3 in (6.5 to 7.5 cm) long.

HOI NANG ROM • *Crassostrea commercialis* • oyster
Common shellfish. Like *hoi lai,* this oyster is commonly farmed in Thailand. Relatively small,

when it is out of the shell it is approximately 1 to 1½ in (2.5 to 3.8 cm) long.

HOM DAENG • *Allium ascalonicum* (Amaryllidaceae) • shallot
Cultivated vegetable. Together with fresh chiles and garlic, the most important ingredient in local cooking. Preferred over onion for making *nam prik.* Thought to give "power." Often eaten fresh as part of vegetable platter.

HUA PLII • *Musa sapientum* • banana flower
Cultivated vegetable. This is the large purple flower that emerges high up in the banana plant. Cooked in many different ways.

HUU SUA • *Plectranthus amboinicus* (Lamiaceae) • Indian borage
Wild edible. Eaten mostly raw as part of a vegetable plate; resembles a very large leafed oregano, and tastes similar.

JINGREET • *Gryllidae* • field cricket
Common insect. Usually eaten on its own, cooked. Sometimes eaten with green onion and wild lime leaf chopped very small. Served as a snack, often with beer. Much loved.

JUKITAN • *Orthoptera Caelifera* • grasshopper
Common insect. Can be large—3 to 4 in (7.5 to 10 cm)—or smaller. Large at the beginning of harvest season. Like crickets, typically eaten as a snack.

KACHAI • *Kaempferia panduratum* • Chinese keys
Cultivated herb. Like galangal and ginger, a rhizome that grows underground. Often used in soups and curries that are fish-based.

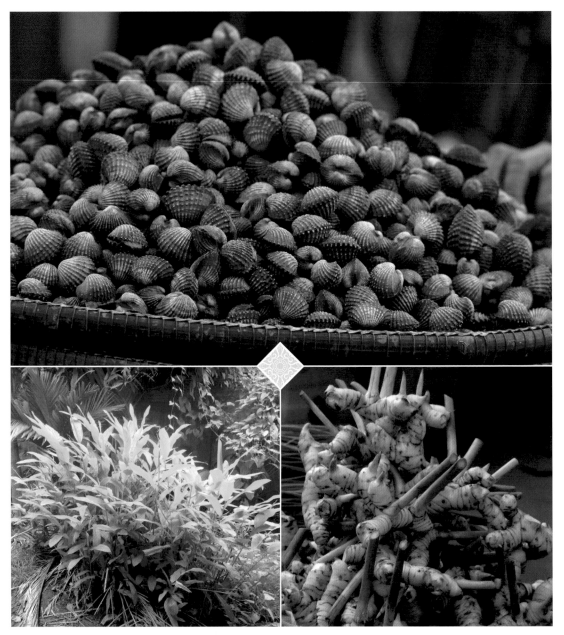

Top: I'm hungry every time I see blood cockles. A fresh *nam jeem*, a beer and blood cockles, and I need nothing more. Bottom: *Kha* (galangal) grows easily and abundantly in the back garden here—even the peeled leaves are steamed and eaten.

KHA • *Alpinia galangal* (Zingiberaceae) • galangal

Cultivated herb. A rhizome; used extensively in a form similar to ginger; the long tender fresh leaves are also popular (peeled and then steamed).

KHILEK • *Cassia siamea* • yellow cassia

Wild edible. Medium-tall tree often used as wind break or for shade; beautiful cascading yellow flowers; tender leaves are cooked in curries.

KHING • *Zingiber officinale* • ginger

Cultivated herb. This is the ginger most commonly found in North America. It can be grown or purchased in the market either as tender and young, or mature.

KRATHIN • *Leucaena leucocephala* (Mimosaceae) • mimosoid or white leadtree

Wild edible (introduced). A very important small tree, tall shrub; nitrogen-fixing and good feed for animals; seed pods and tender leaves eaten raw with *nam prik* and oysters. Native to southern Mexico and northern Central America and now found throughout Asia as well as California, Arizona, Texas, Florida and Hawaii, *Leucaena leucocephala* is considered an invasive species in many parts of the world.

KRATIEM • *Allium sativum* (Amaryllidaceae) • garlic

Cultivated vegetable. Thais and Koreans are the largest consumers of garlic in the world, far above any other nations. Garlic is an essential part of *nam prik*, and used extensively in stir-fries. Also eaten simply raw.

MA KHAM • *Tamarindus indica* (Fabaceae) • tamarind

Wild edible. A hugely important tree from the Fabaceae family, giving shade, food and timber, as well as fixing nitrogen in the soil. Tender leaves are not eaten raw, but cooked in curries. The fruit pods are much loved. When a tamarind tree is cut down, the wood is commonly used in making the famous Thai cutting boards, cutting horizontally across the tree. Tamarind doesn't make for good timber because as a board it tends to split.

MA KHEUA • *Solanum* • eggplant (many varieties)

Cultivated vegetable. At least ten varieties commonly available, and many others that grow here. All sizes, and green, white, purple, green and white. Eaten raw and cooked in curries.

MAI SADAO • *Azadirachta indica* (Meliaceae) • neem tree

Wild edible. Very tall tree; thought to have strong medicinal properties; both fresh tender leaves and flowers eaten; used in toothpastes.

MAI YOM • *Phyllanthus acidus* (Phyllanthaceae) • Malay gooseberry

Wild edible. Small tree; tart fruit used in *som tam* and leaves eaten with *laab*. We have a tree in the front yard and people come by and help themselves. Very abundant.

MAKRUT • *Citrus hystrix* (Rutaceae) • wild lime

Wild edible. Very thorny small tree; the fruit has a bumpy surface, unlike ordinary limes; leaves are famous for their taste and aroma in *tom yam*.

MA-RA • *Momordica charantia* • bitter gourd/ bitter melon

Cultivated vegetable. There are many varieties of bitter gourd, and depending upon when it is eaten (young versus mature), the taste is quite different. Used extensively here, cut thin like a cucumber, and served with spicy salad. Almost always served raw with a plate of raw shrimp (a restaurant dish).

MOT DAENG • *Oecophylla smaragdina* • weaver ant

Common insect. There are many, many kinds of ants here, but *mot daeng* is the most famous because of its edible eggs. The big red ants are also used in cooking soups, adding a sour flavor.

PAK BOONG • *Ipomoea aquatic* • water morning glory (also called swamp cabbage)

Cultivated vegetable. Hugely important vegetable here as it is easily foraged from small canals running alongside the road. Tender eaten fresh or lightly stir-fried.

PAK CHEE • *Coriandrum sativum* • coriander

Cultivated herb. The famous *pak chee* (or cilantro as it is often called in North America). Used extensively here and throughout Thailand. For people who love *pak chee* (like me), it is one of the best herbs in the world, but people who hate it really hate it. I have been wondering as of late whether it might be one of those foods that we are genetically coded for (there are many). Here is it used in almost every spicy salad.

PAK CHEE LAO • *Anethum graveolens* (Apeaceae) • dill

Cultivated vegetable. The only genus of the family Apeaceae; the Thai name translated means "Laotion coriander"; typically eaten here more as a fresh vegetable than as a herb.

PAK DAM LEUNG • *Coccinia grandis* • ivy gourd

Cultivated vegetable. A herbaceous climber, often growing on abandoned land or in a hedge. The very sweet tender shoots are picked and then blanched, to be eaten with *nam prik*. Can also be stir-fried.

PAK DTEU • *Cratoxylum formosum* (Hypericaceae) • mempat

Wild edible. Tree can grow up to 50 ft tall with pink flowers; edible tender leaves harvested in February and March; eaten with *nam prik*.

PAK KAAT HUA • *Raphanus sativus* • daikon or white radish

Cultivated vegetable. Easily grown long white radish. Cooked in mild-tasting soups.

PAK KA-CHET • *Neptunia oleracea* • water mimosa

Wild edible. Here *pak ka-chet* usually grows like an aquatic blanket or a net over still waters, as it does over Pea's pond at the farm. It is a nitrogen-fixing perennial. In free-flowing streams, it can be invasive, but on Pea's pond it is simply there to be harvested. The young tender ends are most desirable for eating, most often eaten raw with *nam prik*.

PAK KANAA • *Brassica oleracea* (Brassicaceae) • Chinese kale

Cultivated vegetable. Used extensively in stir-fries, noodle dishes, etc. A nutritious leafy green vegetable.

PAK KWAANG TOONG • *Brassica campestris* (Brassicaceae) • Chinese mustard green

Cultivated vegetable. Pea has *kwaang toong* in the garden almost all year long. Another of those wonderful—what I think of as—Chinese leafy

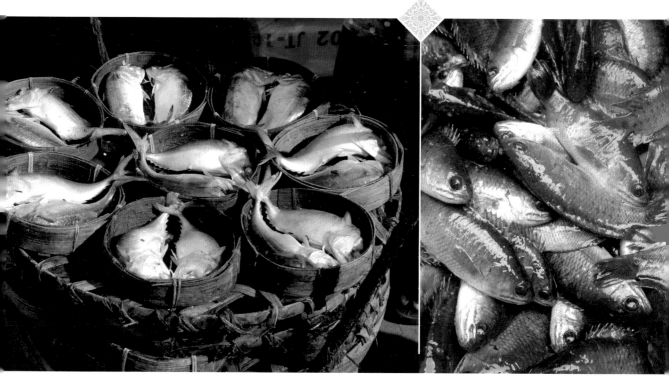

Left: *Pla doo* is often used as an ingredient in *nam prik*. The fish is inexpensive, oily, and the flavor goes a long way. Right: *Pla mo* (climbing perch) don't grow much bigger than three to four inches. Everyone likes them, usually prepared with several fish laced onto a skewer and grilled.

greens, it is versatile to cook with, super nutritious, and easy to grow.

PAK MEK • *Syzygium gratum* (Myrtaceae) • eugenia

Wild edible. Small tree eaten for tender leaves which are a beautiful pale red to white, eaten fresh (or lightly steamed) with *nam prik*.

PAK PAI • *Polygonum odoratum* (Polygonaceae) • Vietnamese coriander

Wild edible. A low-growing perennial herb; used in *laab*. Easily available in Vietnamese groceries

in North America. A good versatile herb to cook with. Slightly sharp in flavor.

PAK WAN • *Marsilea crenata* (Marsileaceae) • water clover

Wild edible. One of Pea's favorites; in the fern family, it looks like a large four-leaf clover; grows in wet areas; eaten raw with *nam prik*.

PAK WAN • *Melientha suavis* (Opiliaceae)

Wild edible. A large tree up to 25 ft (7.6 m); tender shoot, leaves and flowers eaten in soups

or steamed; surprisingly expensive if bought
in a market.

PAK WAN BAN • *Sauropus androgynus* (Phyllanthaceae) • sweet leaf

Wild edible. A tall shrub much liked for its tender
shoots eaten as a vegetable, and for its fruit.

PAK YAI YO • *Clinacanthus nutans* (Achantaceae) •
Sabah snake grass

Wild edible. Medium-high shrub with woody stem;
tender leaves eaten medicinally for dysentery.

PA PLANG • *Basella rubra/alba* (Basellaceae) •
Malabar or Ceylon spinach

Wild edible. Easily grown vine; two varieties
rubra (red) and *alba* (white); eaten as a vegetable
with *nam prik*.

PHAI • *Limnocharis flava* • yellow velvetleaf

Wild edible. Herbaceous plant with rhizome in
the mud. Pea has this growing in her fishponds.
The young plant stems and flowers are all eaten
raw or lightly steamed. One of my favorites, tender
and sweet.

PLA CHORN • *Ophiocephalus striatus* (Channidae) •
snakehead, murrel

Common fish. Together with *pla duk* (and maybe
pla nin), the most important fishes in this region.
Can get very big, 20 in (5 cm) in length and more.
It is a common fish raised in people's large farm
ponds, ponds which are drained once a year or
so, yielding a large supply of fish. *Pla chorn* is also

capable of surviving dry season by burrowing
under the mud, a hibernation for fish called
aestivation.

PLA DOO • *Rastrelliger chrysozonus* (Scombridae) •
long-jawed mackerel

Common fish. A small fish that is farmed, and
then steamed. A very common basis of *nam prik*
(*nam prik pla doo*). It is inexpensive. It is also on the
oily side, so very good for making *nam prik*.

PLA DUK • *Clarias batrachus* (Clariidae) • walking catfish

Common fish. Lives in large ponds, and also in
rivers and irrigation canals. Like *pla chorn*, a very
important fish here, but it does not grow as long.
Pea grows *pla duk* in her fishponds. She likes to use
it simply for grilling, but also for making *laab*. *Pla
duk*, like *pla mo*, can survive outside water for long
periods of time. In rainy season we can sometimes
see *pla duk* wiggling their way across a street to find
different water, hence the name "walking catfish."

PLA LAI • *Monopterus albus* (Synbranchidae)
• paddy eel

Common fish. Usually about 10 in (25 cm) long.
Like *pla chorn*, can survive dry season by hibernation under the mud as the mud starts to dry hard.
Lives, like all the fish here, in ponds, irrigation
canals, etc. Sometimes *pla lai* are deep-fried when
they are very little, under 6 in (15 cm) long, which I
really like.

This looks a little bit like a market shot from Mexico, but these big dried chiles are commonly used for curries here.

PLA MO • *Anabas testudineus* (Anabantidae) • climbing perch

Common fish. A small fish, usually about 3 to 4 in (7.5 to 10 cm) in length. Gets its name from its unique ability to climb. When we have heavy rains toward the end of rainy season, we will see *pla mo* climbing literally climbing—out from irrigation canals, and then wiggling across a road. They are most often eaten grilled, with four or five laced onto a bamboo skewer.

PLA NIN • *Tilapia nilotica* (Cichlidae) • tilapia

Common fish. Tilapia is very popular here, and is raised in farmer's ponds and streams. We have

tried to grow tilapia in the same pond as *pla duk*, but without much luck. It is an ideal cooking fish, as there are not too many bones and it is versatile. A very common dish here and throughout Thailand is to slowly barbecue the fish after it has been caked in salt.

PLA SALIT • *Trichogaster pectoralis* • snake-skin gouramy

Common fish. A small fish, no larger than 6 to 8 in (15 to 20 cm). *Pla salit* are beautiful with fluorescent lines of blue and green running lengthwise along the body. When the rain is heavy and the fish come onto the road, there are often *pla salit*, and they

are always fun to catch. They are very good too, simply grilled.

PLA SIEW • *Rasbora myersi* (Cyprinidae) • minnow

Common fish. Another small fish, *pla siew* is about 3 in (7.5 cm) long. Being a very small fish, though abundant, a handful of *pla siew* are gathered with fresh spices and steamed inside a banana leaf wrap. Mae particularly likes to eat this, as her teeth are not very good and this is easy to eat.

PRIK • *Capsicum frutescens* (Solanaceae) • chile

Cultivated herb. There are a great many varieties of fresh and dried chiles used here, but the dominant chile used in cooking is one called *prik e noo*, or mouse-dropping chile. With the exception of habanero chiles, it is the hottest chile I have ever eaten (even though the level of heat will vary from batch to batch). It is small and thin, about an inch in length. Red and green in color. The heat of a dish all depends on how many *prik e noos* go in!

SATO • *Parkia speciosa* • stink bean

Wild edible. Seeds from young pods that come from the parkia tree and look a little bit like long pods of the tamarind tree. The bean and the seeds inside get the name stink bean because they have a pungent smell (but more so because of the effect they have when you go to the toilet). Hugely important in the cooking of south Thailand, but popular everywhere. The seeds are usually cooked in curries.

TAKHRAI • *Cymbopogon citrates* • lemongrass

Cultivated herb. Grows easily in the garden in large tall clusters. Almost as important in cooking here as garlic, shallots and chile. Can pick fresh from the garden, wash off the bottom and chop very thinly. Used in *nam priks*.

TOM HAWM • *Allium fistulosum* (Amaryllidaceae) • green onion, scallion

Cultivated vegetable. Eaten raw, stir-fried, in soups—almost every way. Cooks utilize the whole green onion, not just the white end.

TUA FUK YAO • *Vigna sesquipedails* • yardlong bean

Cultivated vegetable. A climber that grows almost anywhere. The beans are long (yardlong bean). Served almost always raw with *som tam*. Also cooked in curries.

TUA PLU • *Psophocarpus tetragonolobus* • winged bean

Cultivated vegetable. One of my favorite vegetables. A tender bean usually about 5 in (13 cm) in length or longer. Pea grows it like *tua fuk yao*, letting it grow and climb anywhere. Generally eaten raw as part of the vegetable platter.

YEERA • *Ocimum gratissimum* (Lamiaceae) • shrubby basil or clove basil

Wild edible. Can grow 3 to 4 ft tall (0.9 to 1.2 m); used in stir-fries much the same as *gaproa* only in smaller quantities because of its strong taste.

selected references

All of the books listed here have been treasures for me living here:

Becker, Benjawan Poomsan. *Thai-English English-Thai Dictionary*. Bangkok: Paiboon Publishing, 2002.

Danell, Eric, and Anna Kiss and Martina Stohrova. *Dokmai Garden's Guide to Fruits and Vegetables in Southeast Asian Markets*. Chonburi, Thailand: White Lotus Co., 2011.

Davidson, Alan. *Fish and Fish Dishes of Laos*. Devon, UK: Prospect Books, 2003. (First published in 1975 in Laos.)

Johnson, A.T., and H.A. Smith. *Plant Names Simplified*. Sheffield, UK: Old Pond Publishing, 2008. (First published in 1931.)

Kien, Tran, and David Smyth. *Practical Cambodian Dictionary*. Tokyo: Charles Tuttle and Co., 1995.

Kongpan, Sisamon. *The Best of Thai Cuisine*. Bangkok: Sangdad Publishing, 1987.

Mollison, Bill. *Permaculture: A Designers' Manual*. Tasmania: Tagari Publications, 1988.

Northen, Rebecca Tyson. *Orchids as `Houseplants*. New York: Dover Publications, 1975. (First published in 1955.)

Sato, Yasuyuki. *The Thai-Khmer Village: Community, Family, Ritual and Civil Society in Northeast Thailand*. Niigata, Japan: Niigata University, 2005.

acknowledgements

I want to thank Scott McIntyre for first signing this book and having confidence in me to write this book, the book I first imagined. I very much want to thank Anna Comfort O'Keeffe, Derek Fairbridge and Nicola Goshulak, editors at Douglas & McIntyre. All of you made this a better book, and in the nicest of ways. And thank you to designer Diane Robertson.

In Toronto I want to thank Shaun Smith. In Austin, Texas, I thank the amazing Mick Vann, who answers every botanical question I can come up with. In Grey County, Ontario, thanks to great friends Jon Radojkovic and Richard Spandlick. Thank you for all your care and support.

To Dominic and Tashi, you are the greatest!

And to Pea and Gung, this book wouldn't be a book without you. Thank you for so much good humor and patience.

index

Page numbers in **bold** indicate photographs